DEDICATED TO MY GRANDPARENTS

KOMOREBI

THE ART OF DJAMILA KNOPF

Website: www.3dtotal.com
Correspondence: publishing@3dtotal.com

First published in the United Kingdom,
2020, by 3dtotal Publishing.

Address: 3dtotal.com Ltd,
29 Foregate Street, Worcester,
WR1 1DS, United Kingdom.

Hard cover ISBN: 978-1-912843-21-3
Printing and binding: Everbest Printing
(China) www.everbest.com

Visit www.3dtotalpublishing.com for a
complete list of available book titles.

Managing Director: Tom Greenway
Studio Manager: Simon Morse
Lead Designer: Fiona Tarbet
Lead Editor: Samantha Rigby
Editorial Project Manager: Sophie Symes

ONE TREE PLANTED FOR EVERY BOOK SOLD

OUR PLEDGE

From 2020, 3dtotal Publishing has pledged to plant one tree for every book sold by partnering with and donating the appropriate amounts to re-foresting charities. This is one of the first steps in our ambition to become a carbon neutral company with carbon neutral publications, giving our customers the knowledge that by buying from 3dtotal Publishing, they are working with us to balance the environmental damage caused by the publishing, shipping, and retail industries.

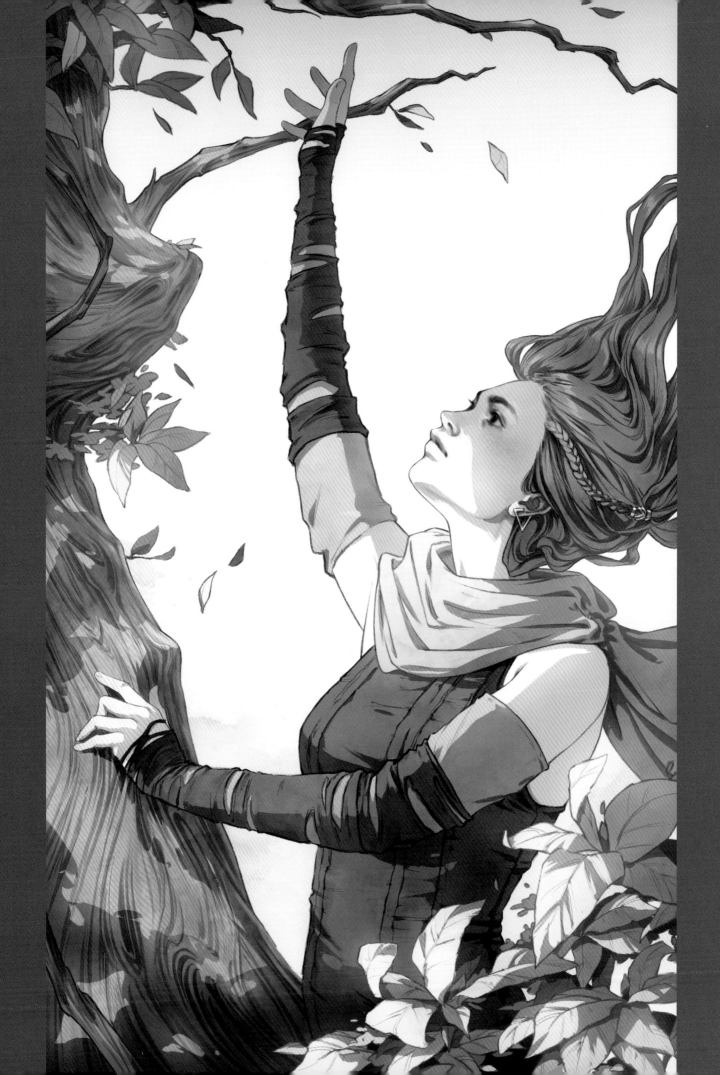

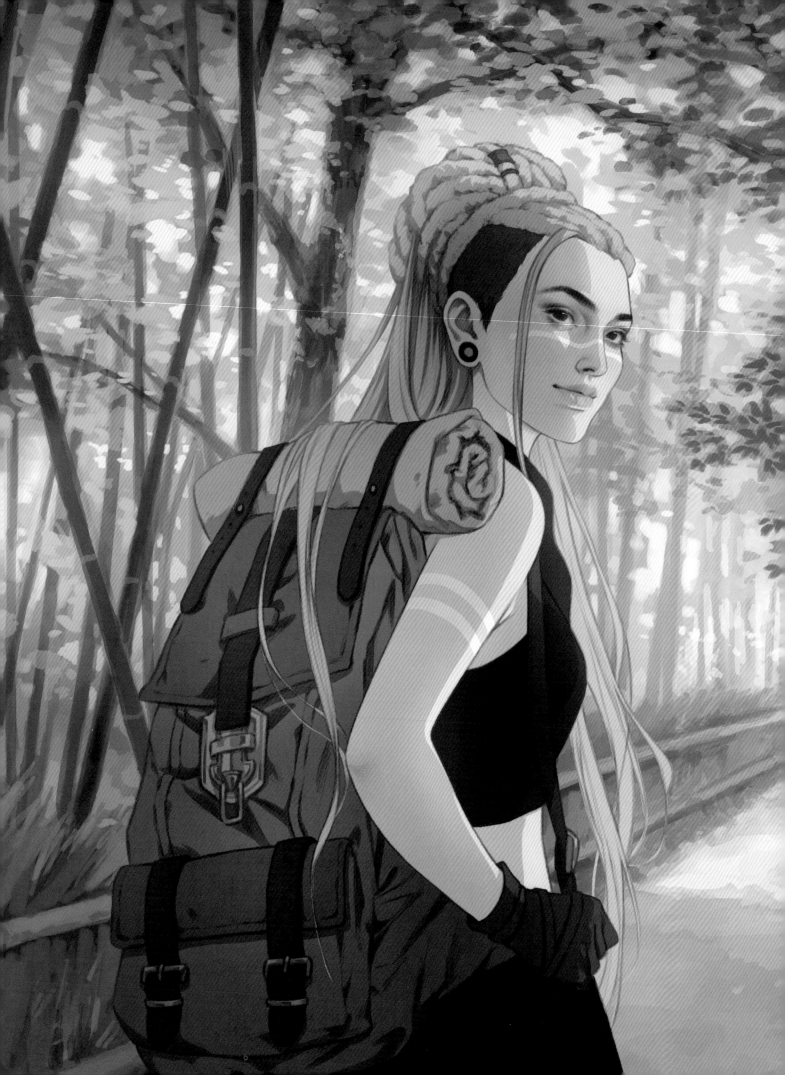

contents

foreword

When I first stumbled upon Djamila's art, I was entranced by the beautiful world she creates through her work. Since that time, I've had the privilege of meeting her at various events. For some reason I expected such a talented artist to have an air of superiority, but she was disarmingly friendly! Following those meetings, I became not only an appreciator of her art but an admirer of her kind, clever, and open personality. So, it is an honor to be able to introduce Djamila's incredible art to you.

The first thing I noticed about Djamila's work is that she not only creates rich and detailed paintings, she offers a glimpse into a whole world. The paintings don't feel like individual pieces as much as moments in a gorgeous universe full of thriving nature, beautiful cities, and fascinating people. As an animator, I notice that her work evokes the richness of a Studio Ghibli film. I can picture people moving in this world, and stories unfolding. Given this, it's only fitting that the chapters in this book are named after physical spaces. Her work invites you to step inside and take a seat next to the characters, joining them in their peaceful moments.

The captivating aspect of her work is not only evident in the spaces she conveys, but also in the subtle details of her characters, architecture, and stylistic elements. They remind us that they live in a world that is different from the one we know – a mystical place that draws inspiration from real life, but where magic and fantasy exist. Her characters feel real and believable, but they know more than we do. Maybe they even have magical powers.

When I met her in real life, it became clear to me that Djamila is not just a skilled artist but also a driven entrepreneur who puts a strong focus on forging a path for herself in which she can express her own ideas and vision. In a world where such skilled artists are tempted to sacrifice their own creativity for bigger projects, she makes a conscious choice to invest her time and energy into her own work. In her art we can see characters acting as protectors, walking alongside animals or holding them delicately in their arms, promising safety and companionship. This is the same energy that she brings to her creative vision: she protects it and nurtures it.

Djamila is someone who searches for her own way, shares knowledge and insights, and gives us all the immense privilege of being able to witness her creativity unfold and grow over time. I hope you will feel as immersed as I did when I first stumbled upon her beautiful work.

LOISH
Lois van Baarle

8

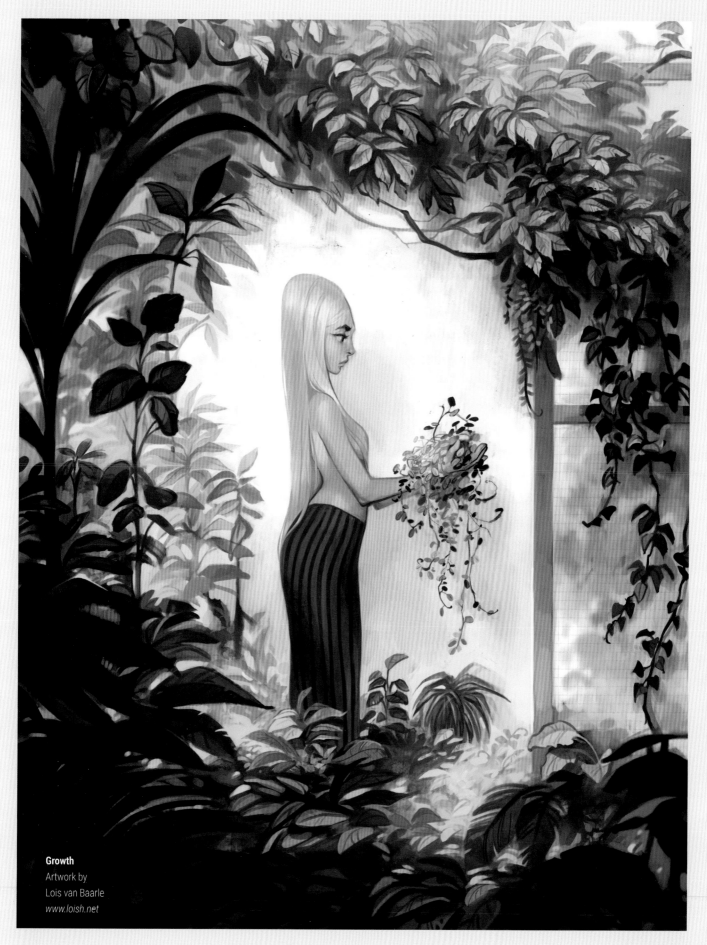

Growth
Artwork by
Lois van Baarle
www.loish.net

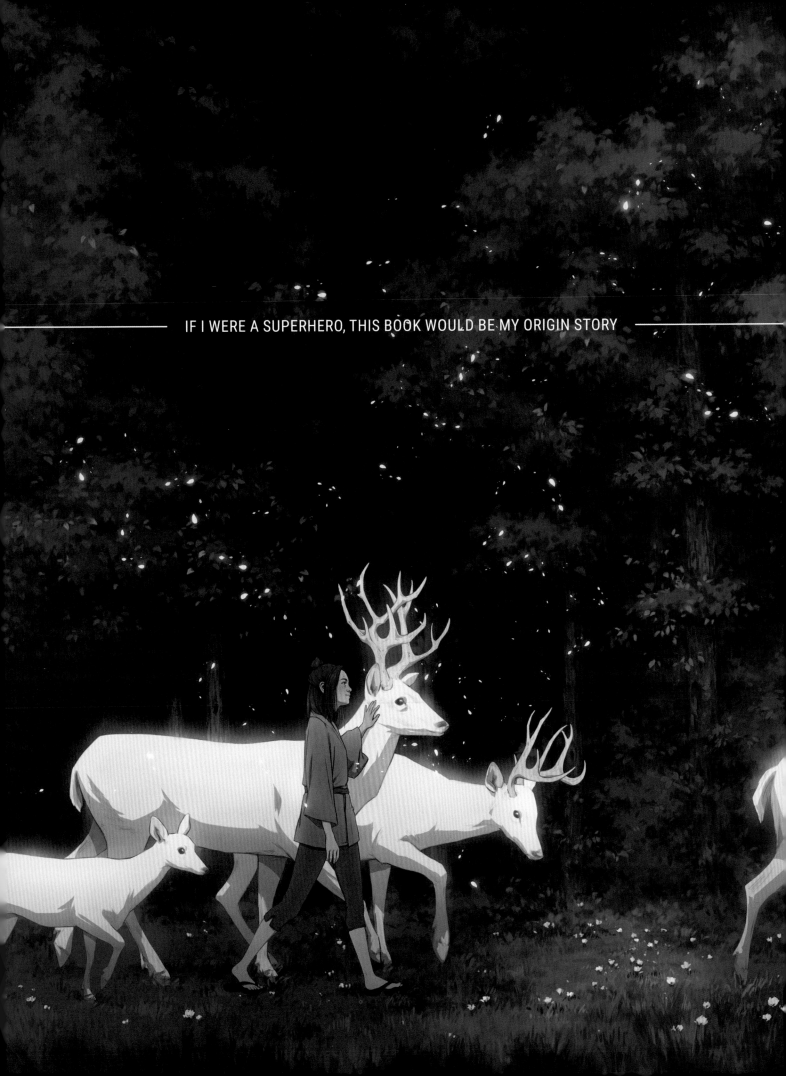

IF I WERE A SUPERHERO, THIS BOOK WOULD BE MY ORIGIN STORY

introduction

One summer, when I was nine or ten years old, I went to the city with my mother, and after having ice cream, we wandered into a bookstore. The first thing I laid my eyes on was a *Sailor Moon* art book. I instantly fell in love with the illustrations, and I couldn't imagine leaving without it. So, I begged my mother to buy it for me, and even though it was quite expensive, she did. Afterward, we sat by the fountain outside and I flipped through the pages, because I couldn't wait until we got home. Every summer, we would come back, have ice cream, visit the same store and my mother would buy one more art book for me. To this day, those art books are still some of my most precious possessions. In part, because of those memories, but also because they inspired me to one day create my own collection of illustrations.

Komorebi has been in the making for a very long time, even before I officially started putting it together. The process began that summer, with my dream of becoming an artist and filling a whole book with my work. *Komorebi i*s more than just a collection of images of my artwork; if I were a superhero, this book would be my origin story. It is the most personal piece of art I have ever released into the world, and writing it was emotional and challenging.

What I enjoy most about my beloved art books are the little snippets of text, in which the artist, Naoko Takeuchi, talks about the stories behind her pieces and what inspired her to create them. Reading those captions made me appreciate the individual pieces of art even more, and somehow, it made me feel a closer connection to the artist and her creations. It was encouraging to discover a real person behind the beautiful images. So, just as Naoko Takeuchi did, I want to share my stories with you.

In this book, I talk about why I first began to draw, what inspires me, and how I use these influences and turn them into paintings. I guide you on a journey through different places in my creative world; some are filled with nostalgia and magic, while others are more mundane and seemingly ordinary. They all offer a glimpse behind the scenes. Through personal anecdotes, explanations, and walkthroughs of my process, I hope to give you a better understanding of why and how I create artwork. And, who knows, maybe my story will inspire you to create your own art book one day.

Djamila Knopf

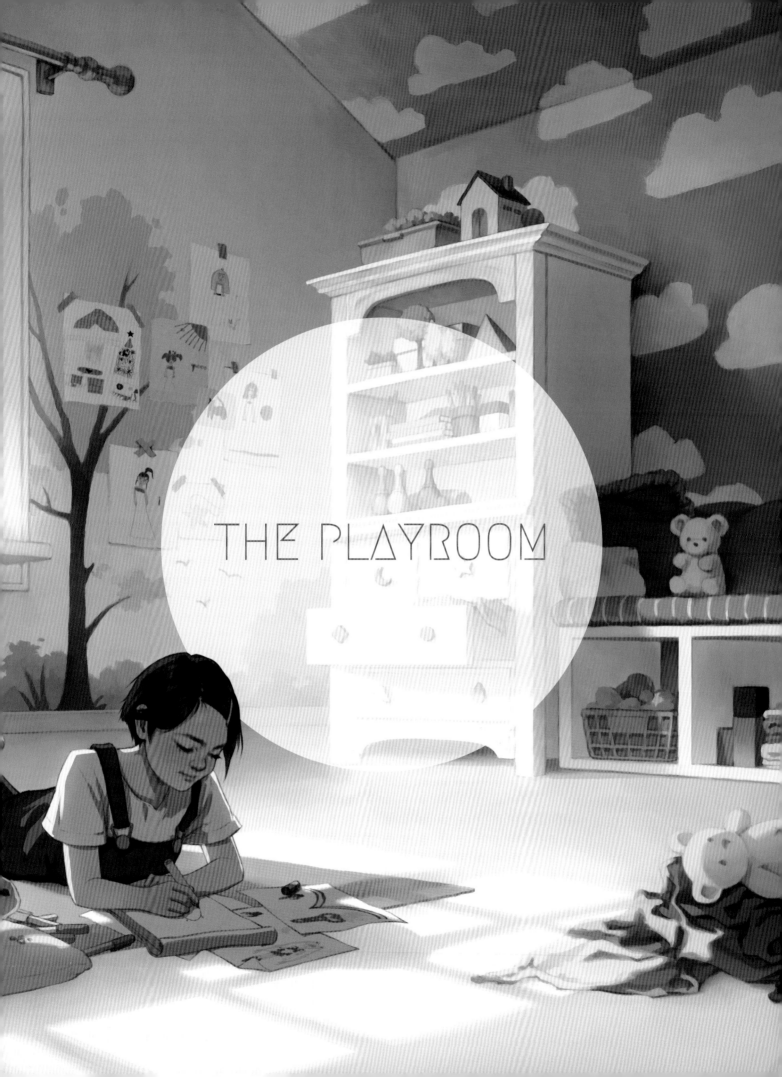

THE PLAYROOM

beginnings

A long time ago, I drew a big mural on my grandparents' wall. They had left me unsupervised, just for a moment, in a room containing only their two birds, a whole lot of felt-tip pens, and a big blank piece of wallpaper right beside me. So naturally, I proceeded to fill my new canvas with a house, some trees, flowers, and blue clouds. I don't remember how my grandparents reacted, but I think it's safe to assume that they weren't thrilled with my creation!

As far back as I can remember, I have always enjoyed drawing. Only on rare occasions would I be seen without my pencil case and stack of crumpled copy paper. I can recall countless days when I would set up my workspace on the floor of the living room, next to my grandpa in his big chair, watching his favorite television shows.

I'm thankful that my family encouraged me to be creative. As I grew older, my grandparents bought me huge binders filled with drawing techniques and tips. They were packed with charcoal, pencils, pastels, and a variety of other materials for me to play with.

Crayons
Coloured pencils and crayons were my medium of choice in my earliest drawings.

Television
Media played such a big role in shaping my taste and aesthetics.

Sailor Moon

was the anime that definitely had the biggest impact on me growing up.

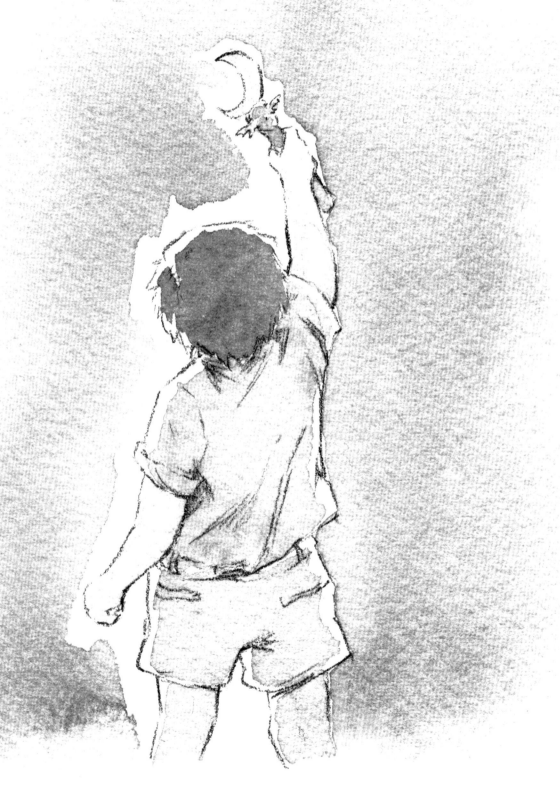

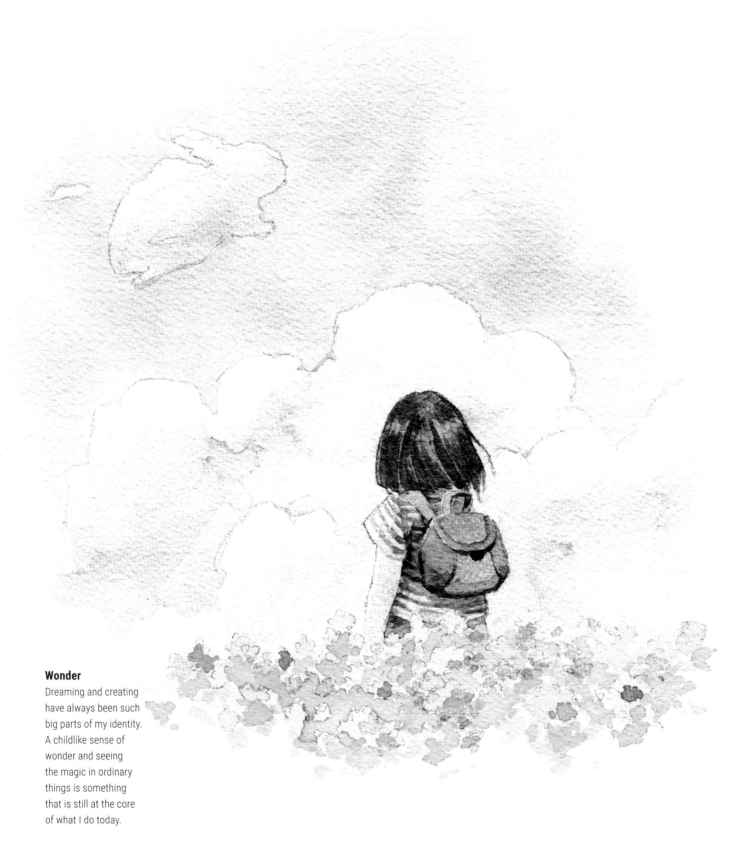

Wonder
Dreaming and creating
have always been such
big parts of my identity.
A childlike sense of
wonder and seeing
the magic in ordinary
things is something
that is still at the core
of what I do today.

stories and animation:
a *lifeline*

While I prefer to focus on the happy moments, my childhood was difficult, to say the least. Mental illness is something that runs in my family and unfortunately, my single mother was not one to seek help, even though she clearly needed it. So, a lot of heavy burdens fell on me when I was very young. I remember overdue bills, eviction notices, and a constant fear of what could happen next. When I was seven, I spent a week in the hospital to get my appendix removed and I was the only kid who loved being there because it felt safe compared to home.

But what helped me through the difficult times were the stories I loved; stories of heroines and magic. I would get up early before school to catch a few hours of my favorite animated television shows, and I would run home in the afternoon to keep watching. But those animated shows were more than just entertainment to me; they were the only thing that could take me to other worlds that had nothing to do with my own.

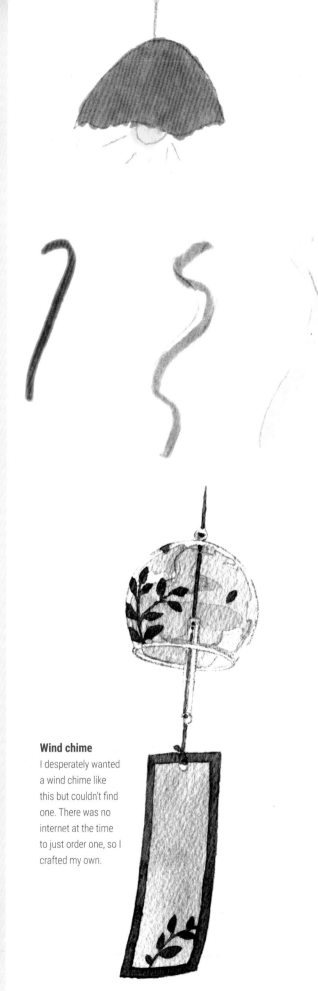

Wind chime
I desperately wanted a wind chime like this but couldn't find one. There was no internet at the time to just order one, so I crafted my own.

I later found out that a lot of the shows I loved had one thing in common: they were animated in Japan. Something about the style and the storytelling immediately captivated me. I enjoyed the softness and beautiful visuals, as well as the long, complex story arcs and the more serious themes. Other cartoons were often too loud and flashy for me, and the story within each episode would rarely carry over into the next, so, I preferred anime.

Aside from anime, I also enjoyed Swedish children's stories by Astrid Lindgren, such as *Pippi Longstocking*, *The Six Bullerby Children*, and *Emil of Lönneberga*. They had a special way of making the ordinary feel exciting. I watched those children have little adventures while living their everyday lives in quaint villages, on farms, surrounded by nature. Their world seemed so approachable, yet somewhat foreign, and I was fascinated by their fictional lives.

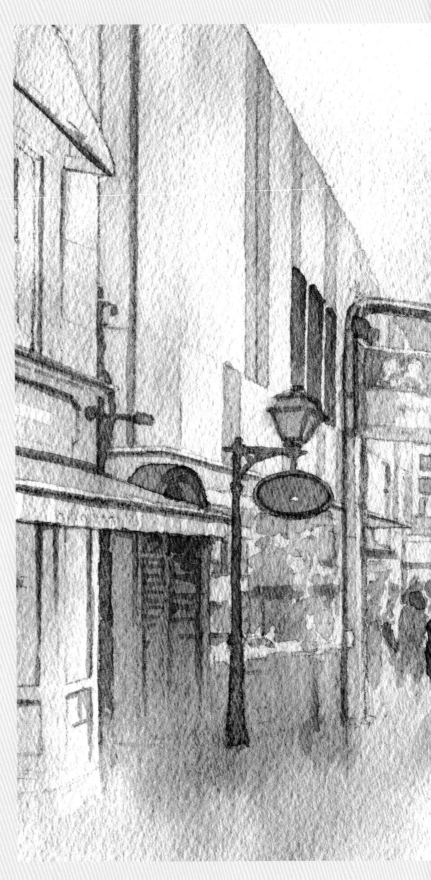

Seeing through rose-tinted glasses
I like to see the world a little bit brighter and more colourful than it actually is. That way, a dull grey street can turn into something vibrant and enchanting.

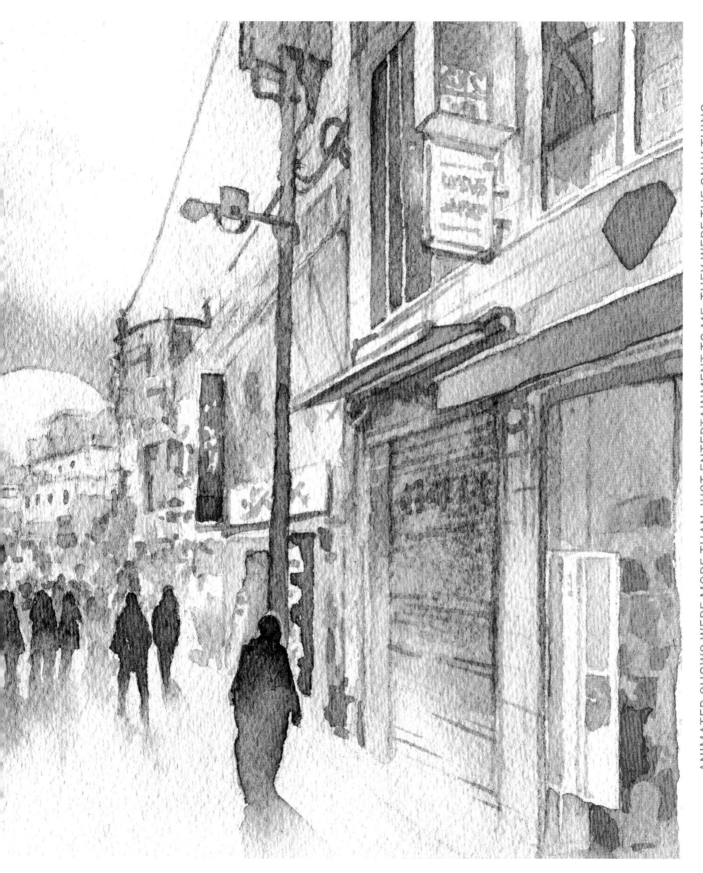

ANIMATED SHOWS WERE MORE THAN JUST ENTERTAINMENT TO ME; THEY WERE THE ONLY THING THAT COULD TAKE ME TO OTHER WORLDS THAT HAD NOTHING TO DO WITH MY OWN

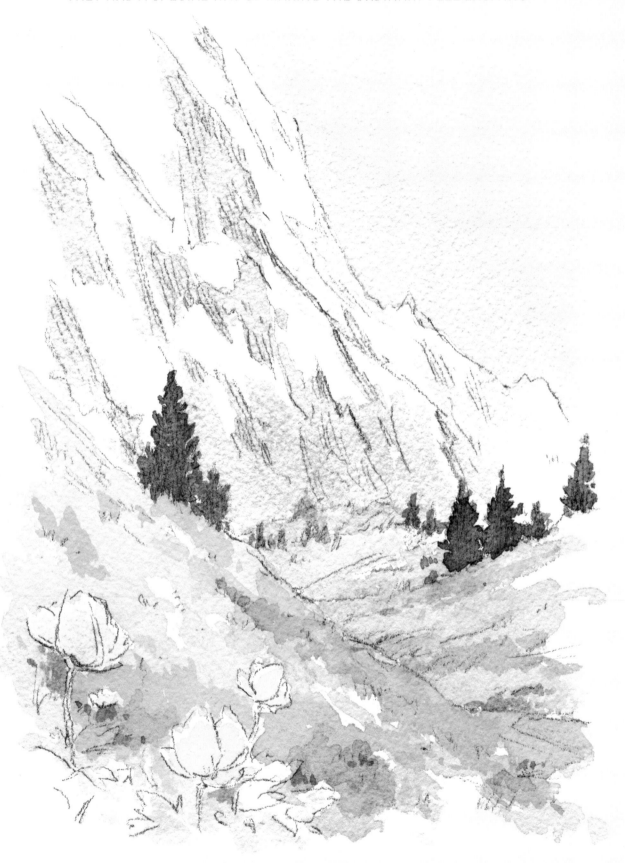

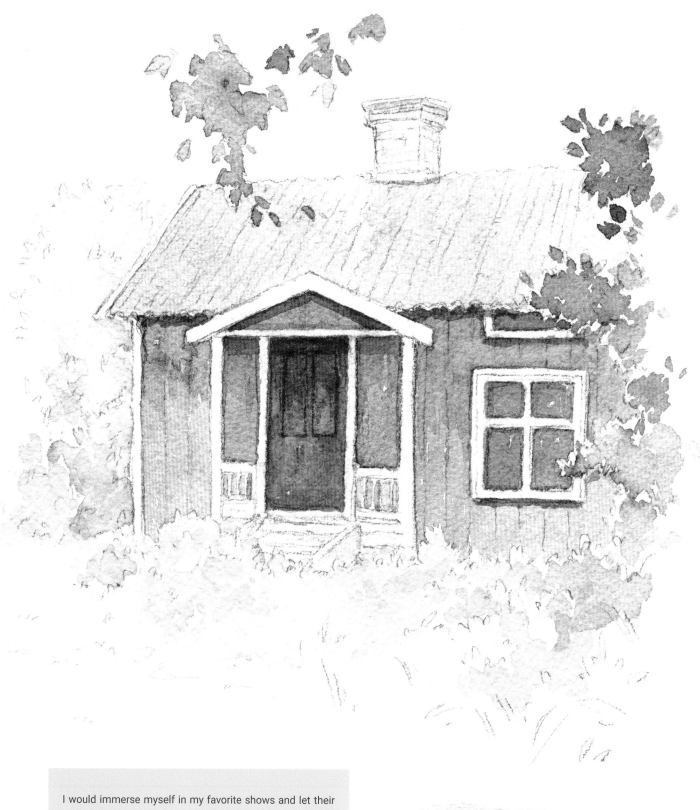

I would immerse myself in my favorite shows and let their reality become my own. I walked the streets of Tokyo with Usagi, picked flowers with Heidi, and won volleyball tournaments with Kozue (Mila) Ayuhara. Often, the mundane moments were the ones that stuck with me the most. I distinctly remember one scene in *Heidi, Girl of the Alps*, in which the old man cut a thick slice of cheese, placed it on a piece of bread, and toasted it over a fire. I ate a lot of toast with melted cheese after that, and I still think about it when I make it today.

pursuing art

If I had to pick one thing that made me want to pursue art as a career, it would definitely be *Sailor Moon*. I was about five years old when I first caught an episode and it instantly made a massive impact on me. I was completely swept away by the story, the characters, the transformation scenes, the colorful cityscapes – pretty much everything about it! For me, it was the perfect anime and it inspired an endless flood of fan art.

Every time I saw a Sailor Scout in a magazine, I would cut them out and cherish and protect that piece of paper as if my life depended on it. I also spent hours replicating the *Sailor Moon* artwork to improve my drawing skills because I wanted to be able to draw characters like those I had admired on my television screen.

As I grew older, I moved on to making up my own characters and stories. But as a five-year-old, my biggest dream was to move to Japan one day and work on anime. Little did I know the level of skill that is required to animate, and how difficult the working conditions can be. Now I realize that I never really wanted to get into animation, I just wanted an excuse to draw all day long.

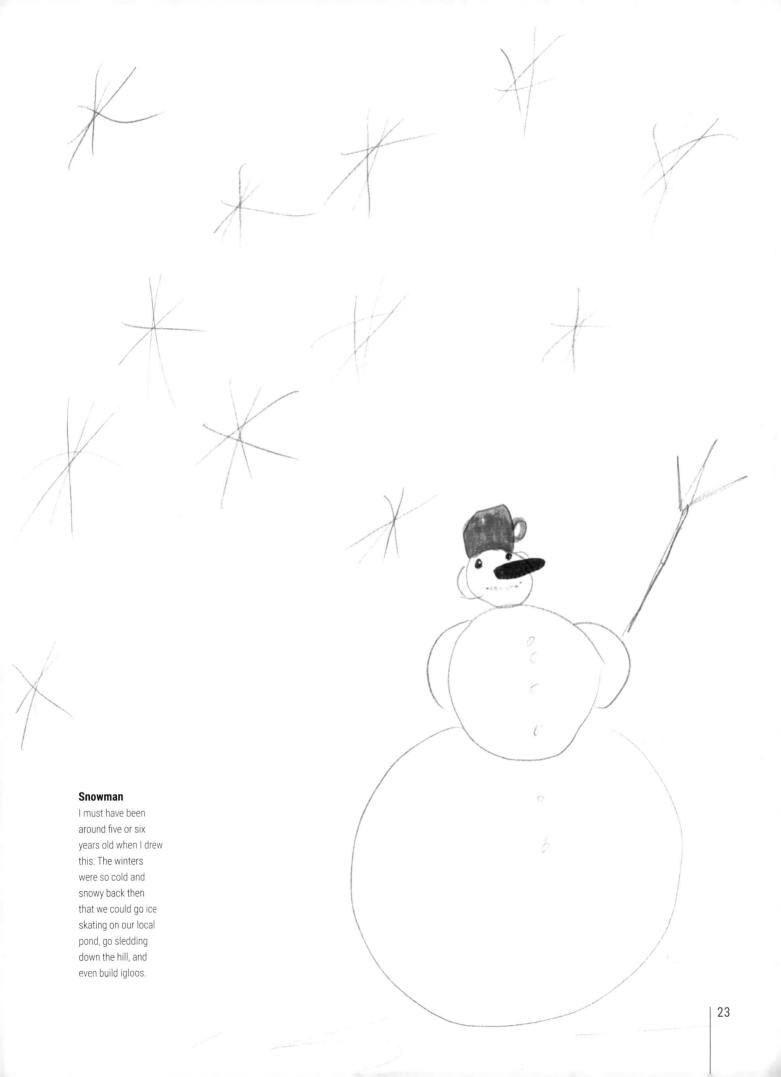

Snowman

I must have been around five or six years old when I drew this. The winters were so cold and snowy back then that we could go ice skating on our local pond, go sledding down the hill, and even build igloos.

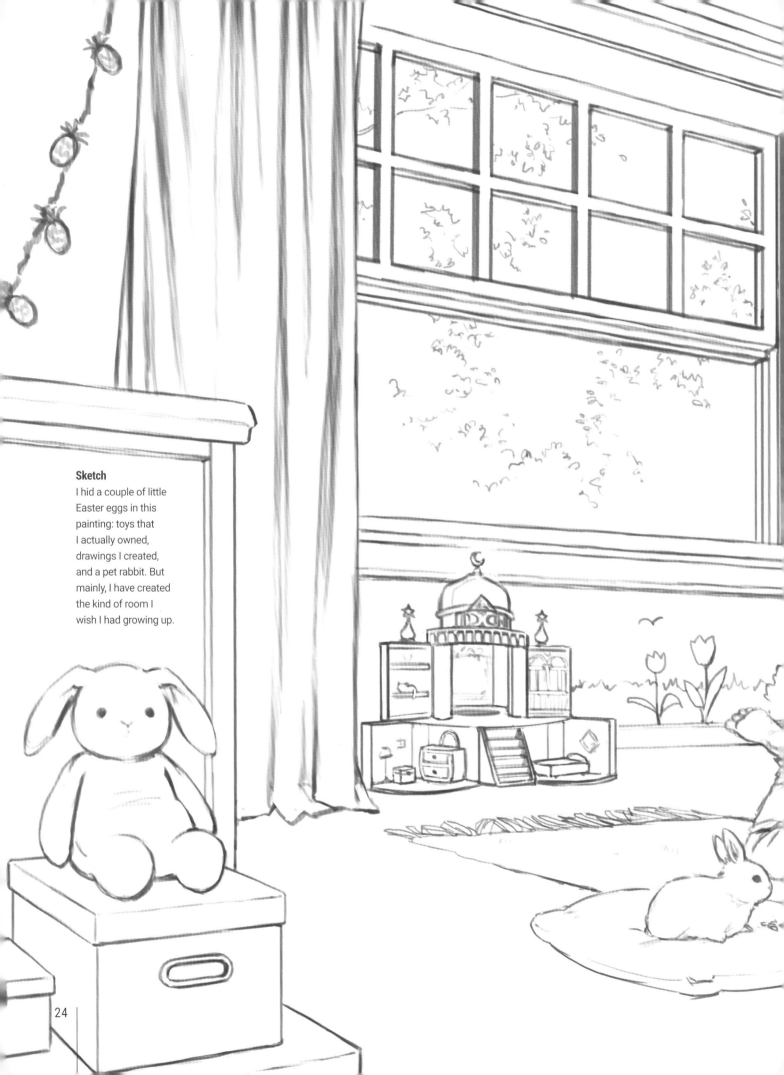

Sketch

I hid a couple of little Easter eggs in this painting: toys that I actually owned, drawings I created, and a pet rabbit. But mainly, I have created the kind of room I wish I had growing up.

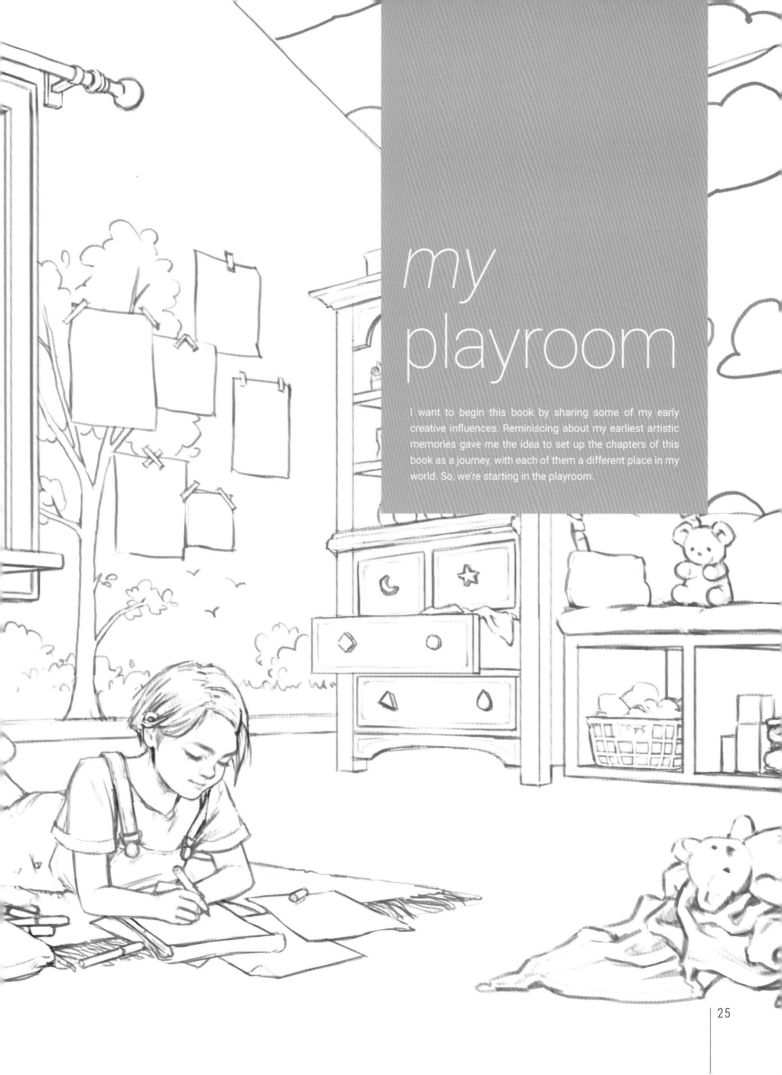

my
playroom

I want to begin this book by sharing some of my early creative influences. Reminiscing about my earliest artistic memories gave me the idea to set up the chapters of this book as a journey, with each of them a different place in my world. So, we're starting in the playroom.

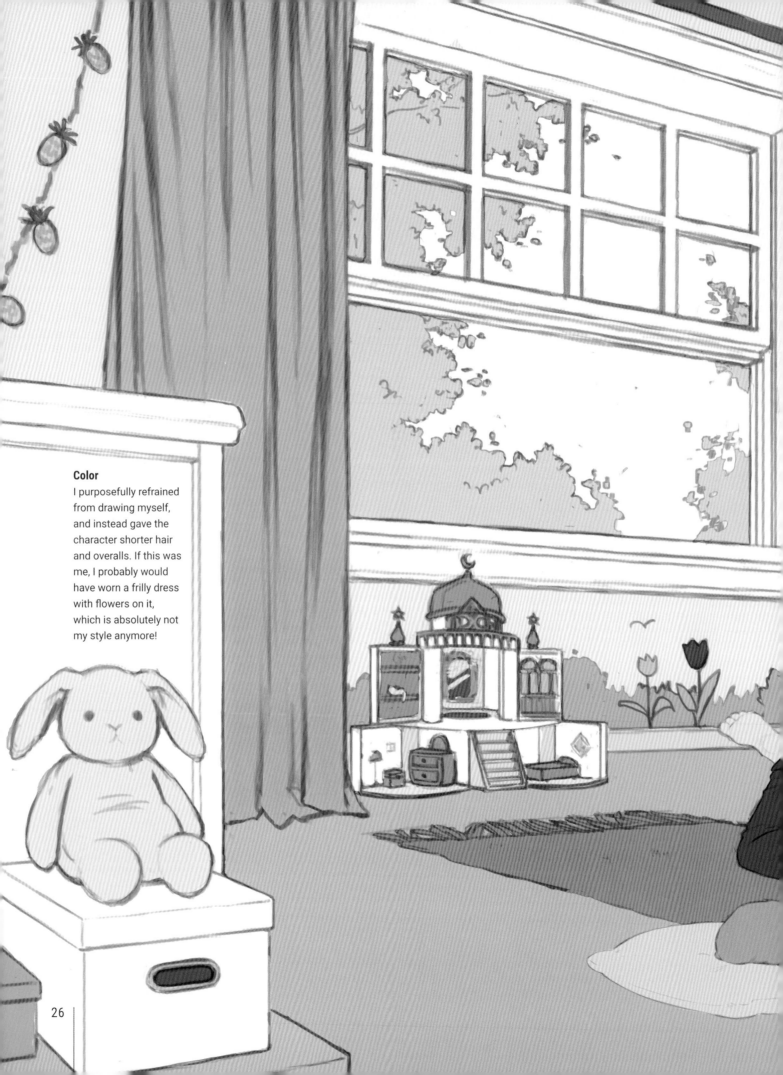

Color

I purposefully refrained from drawing myself, and instead gave the character shorter hair and overalls. If this was me, I probably would have worn a frilly dress with flowers on it, which is absolutely not my style anymore!

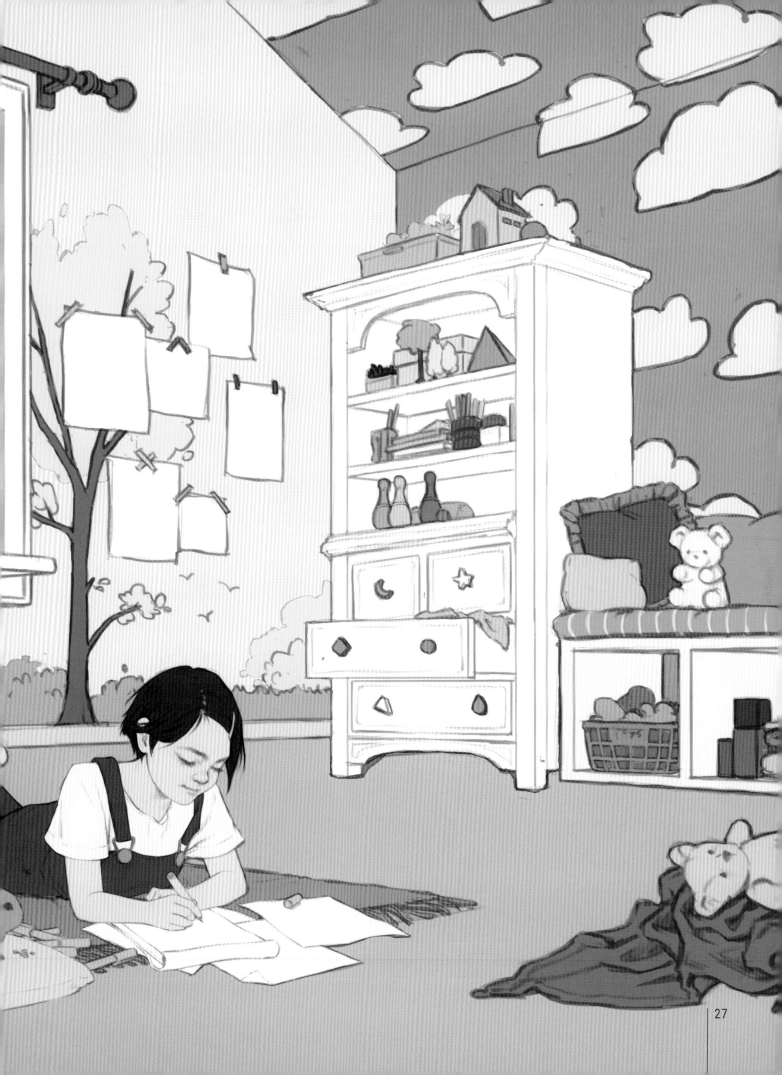

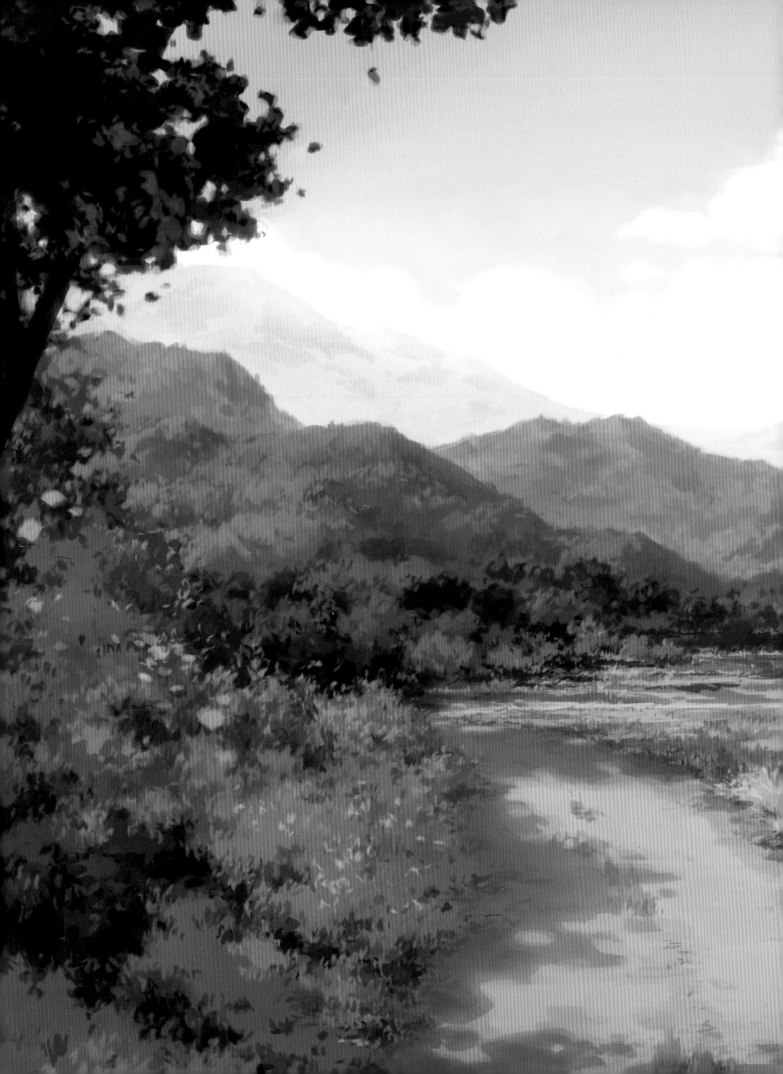

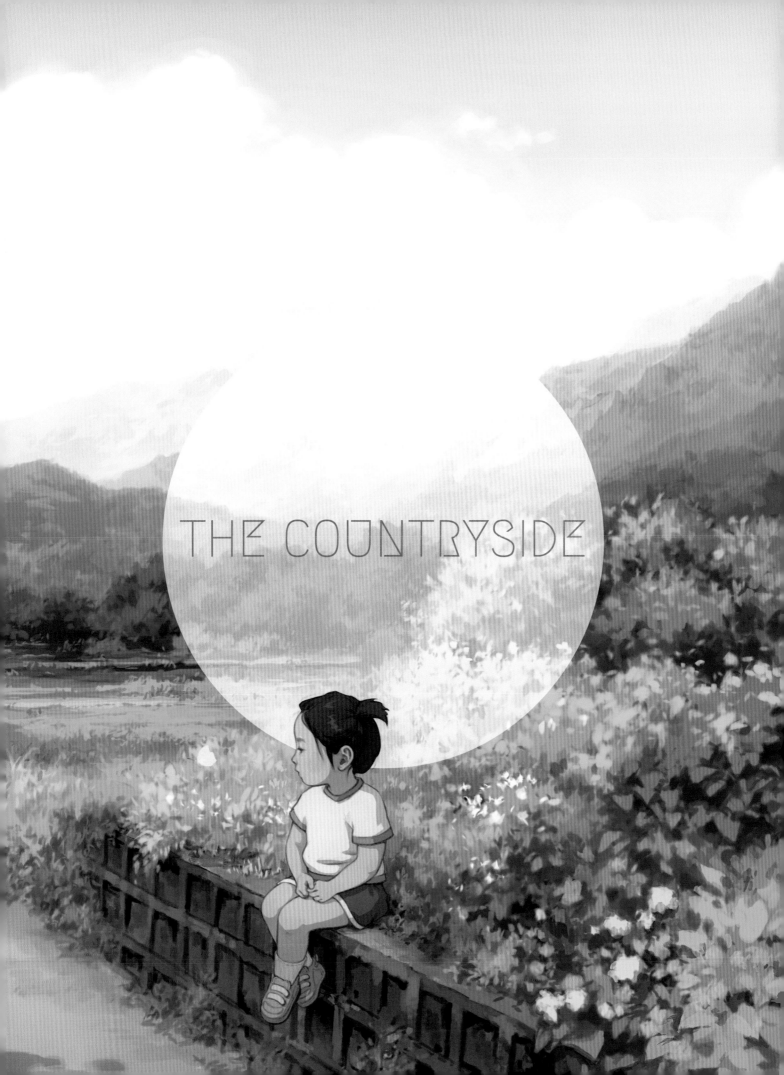

THE COUNTRYSIDE

escape
to nature

What I remember most vividly about my childhood are the summers I spent with my grandparents. They had a little allotment garden that was surrounded by fields on one side, and a forest and a canal on the other. Our cabin was cobbled together from scrap pieces of wood and metal. It wasn't exactly what you would call conventional, but it had a certain charm. What I loved most about it was the string of rainbow-colored fairy lights running all the way around it. All the neighbors had much nicer houses, but to me, ours was more personal and unique.

When you entered our creaky front gate, you had to duck underneath vine tendrils that lined the path from the entryway to the cabin. The garden itself was small, but my grandparents made as much use of it as they could. They grew fresh herbs, all kinds of berries, apples, cherries, tomatoes, green beans, and other vegetables, as well as lots of flowers: peonies, sunflowers, and my favorite at the time — bleeding hearts.

Our garden was also home to a frog family that I loved to visit, and quite a few large spiders, which I quickly learned to avoid. My favorite thing was the big swing that my grandpa had set up for me. He had painted it a deep green, but because I was constantly trying to climb the poles, the paint started chipping very quickly.

Four of Wands

This piece was based on the tarot card that represents freedom, celebration, and excitement. At first I wasn't sure how to approach it because I didn't feel like drawing someone overflowing with joy. I created a design that resonated with me after asking myself what a celebration would look like for me. At the time, writing my master's degree thesis was taking up all of my time and energy, and as soon as I finished all I wanted to do was lie in the grass.

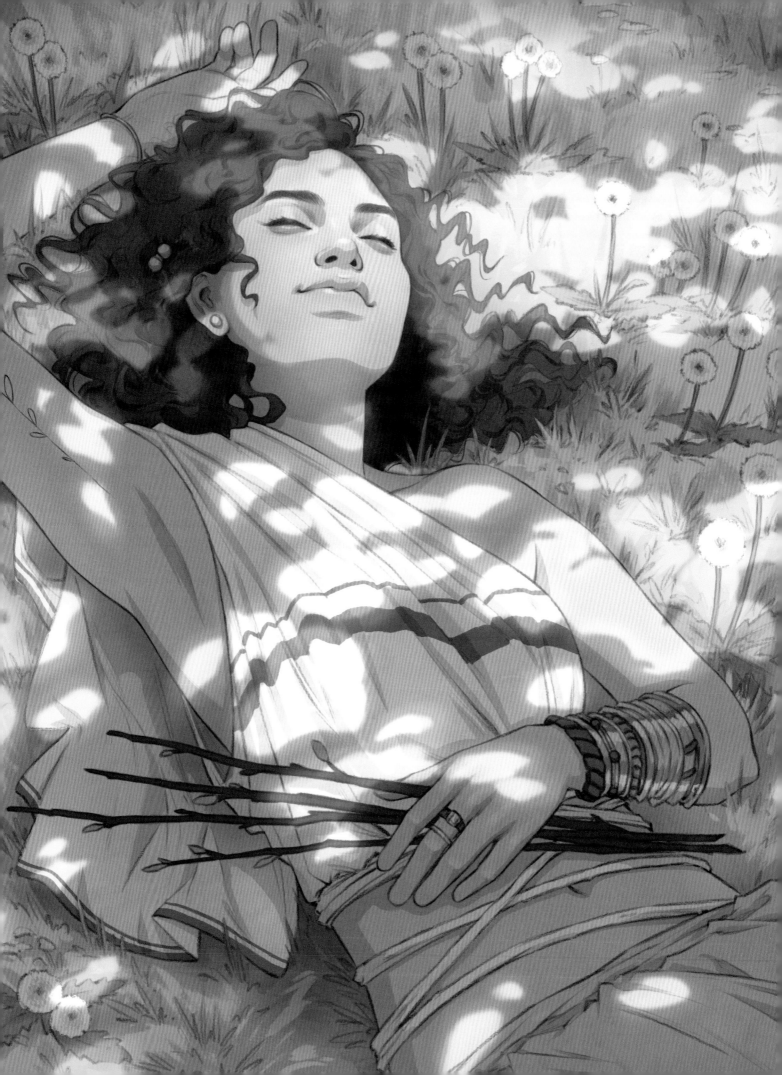

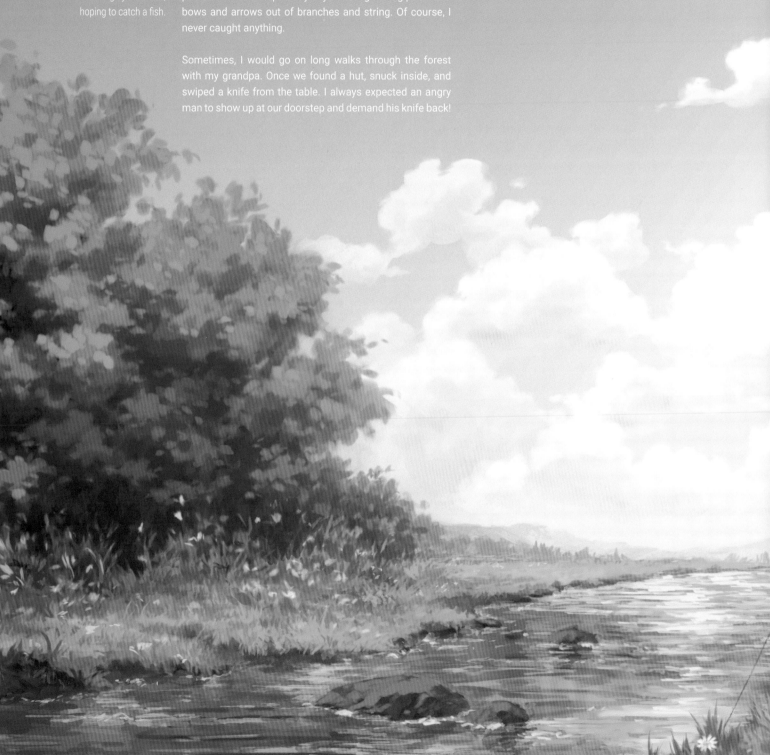

adventures

Childhood Memories
This is the most autobiographical illustration I've ever created. It is an homage to the summers I spent sitting by the water, hoping to catch a fish.

Most of the time I would roam around the fields outside, explore, and invent my own games to keep me entertained. I once thought it would be a great idea to climb on top of hay bales, and as a result, I scratched all the skin on my arms and legs. It was incredibly painful and I never did it again! Playing in the woods along the canal was also a favorite pastime of mine. I spent my days making fishing poles and bows and arrows out of branches and string. Of course, I never caught anything.

Sometimes, I would go on long walks through the forest with my grandpa. Once we found a hut, snuck inside, and swiped a knife from the table. I always expected an angry man to show up at our doorstep and demand his knife back!

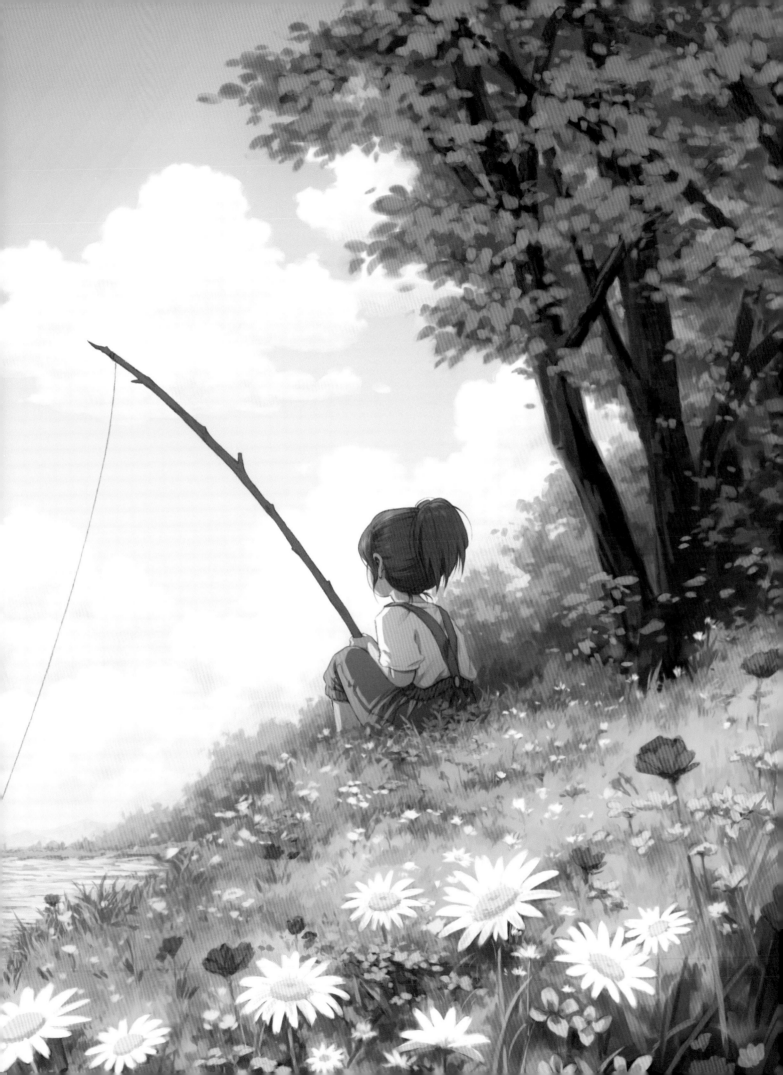

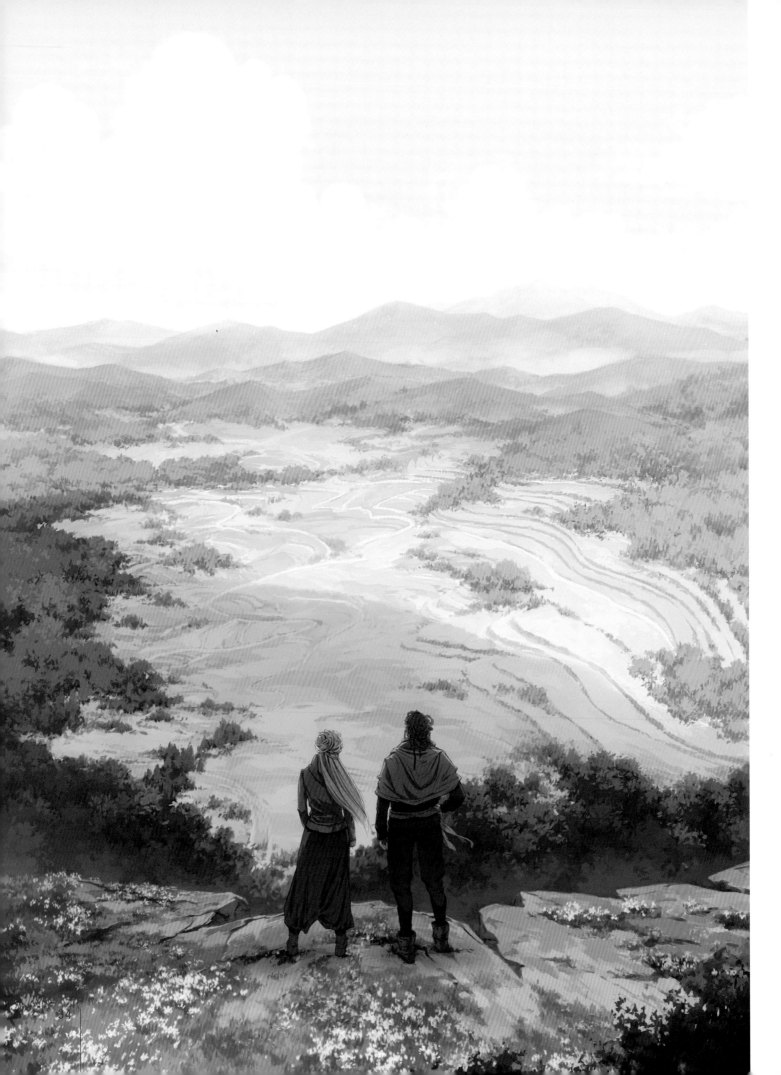

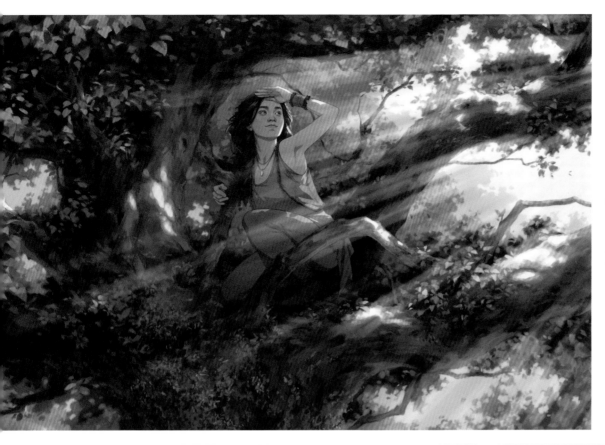

On the Lookout
I used to climb trees all the time. There was a great tree just like this in my schoolyard.

What I Remember (Right)
This piece shows one of the first detailed backgrounds I ever painted, and it helped me build up my confidence to tackle more complex scenes. A little back alley in Gujō Hachiman – the water city in Japan – served as reference.

What Lies Ahead (Opposite page)
With this piece, I wanted to show the uncertainty and endless possibility of embarking on a new adventure.

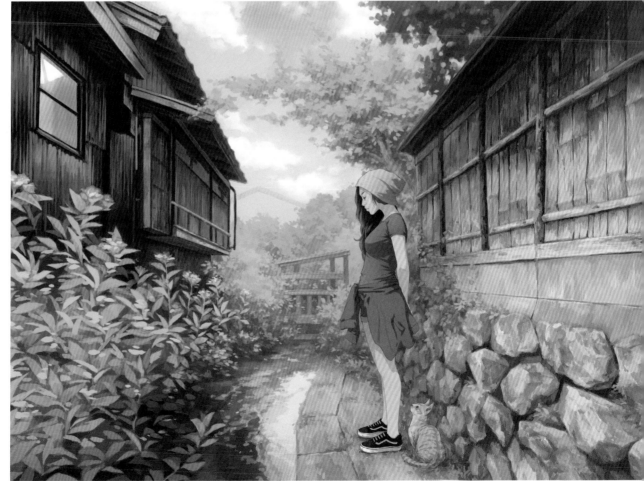

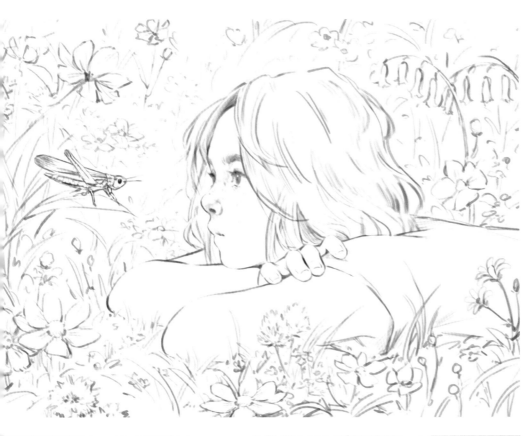

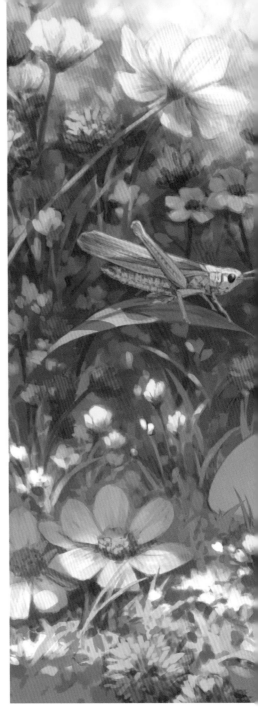

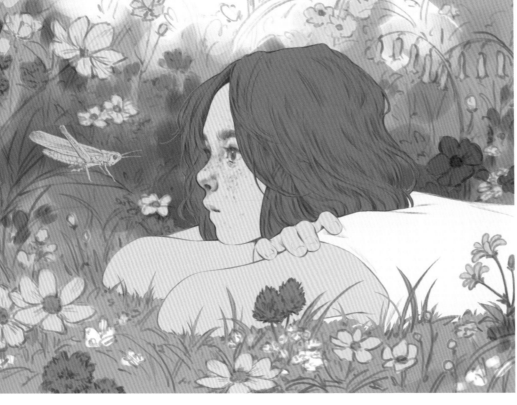

Midsummer

As a child, I used to lie in the grass for hours and hours, watching grasshoppers and other fascinating creatures

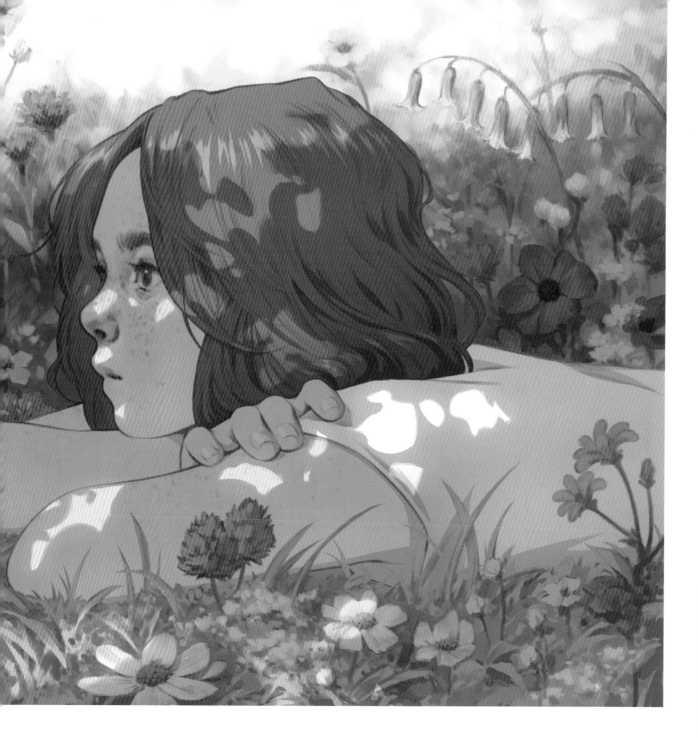

I went on so many adventures in and around our little garden. I was carefree to the point of being careless, which resulted in a multitude of accidents: for example, once I fell flat on my face and broke my entire upper row of teeth, and on another occasion I fell from a tree onto a sharp stone, forehead first!

But after all these years, the pain is not what I remember; it's all the little experiences that made that time in my life special: drinking fresh peppermint tea before bed, being woken by our neighbors' rooster in the morning, running through our sprinklers in the summer sun, picking flowers,

and hunting grasshoppers. And most of all, sitting together with my grandparents after dark, by the glow of the cabin's colorful fairy lights.

My grandparents may not be with me anymore, but I make sure they live on in my illustrations. Those cherished moments are the experiences I want to remember and relive through my artwork. I want to capture how it feels to be a child and what it's like to see the world as a magical place, full of adventures and possibilities. I see art as my superpower and a way to reshape my reality. It's an escape, but it's also an important way of expressing who I am.

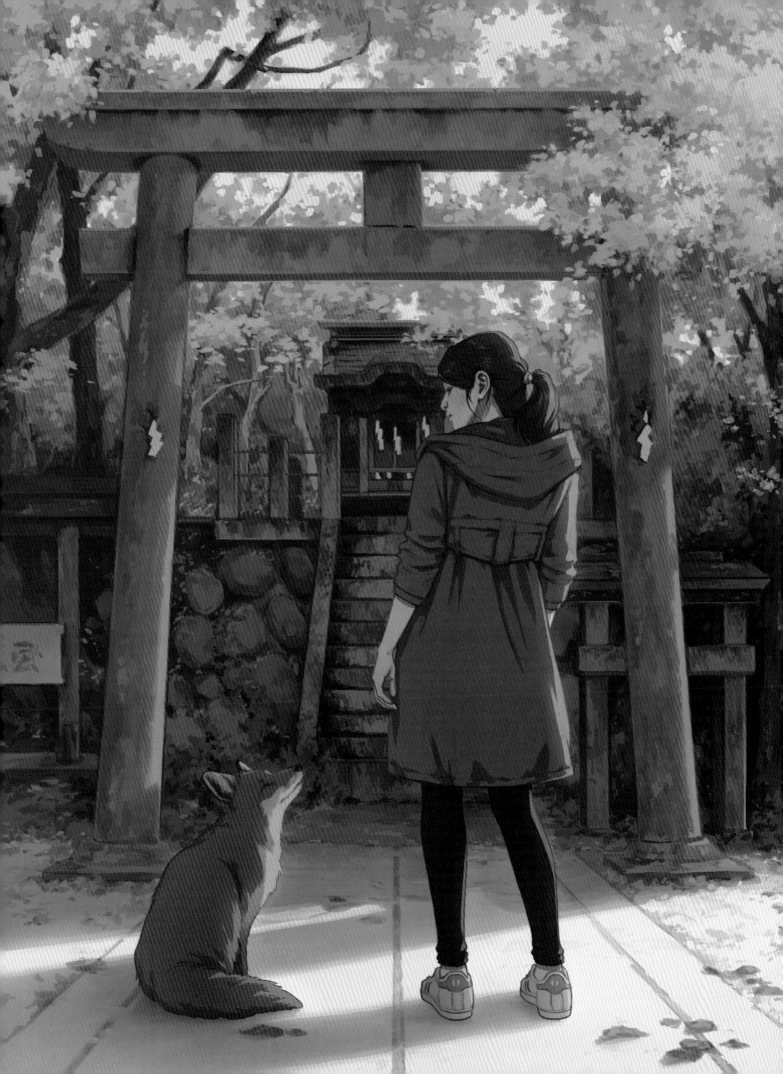

inspiration

Fox Shrine
Interactions between humans and animals have become one of my favorite things to draw.

In my mind, the fox is the watcher and protector of this place and comes to greet visitors, to check that they mean no harm. When I finally decided to paint it, it was autumn. With yellow and orange as far as the eye could see, the colour scheme came together naturally, and as a bonus, it fits perfectly with the fox's fur and the warm sunset lighting.

There is so much beauty out there in the world. It's such a wonderful and strange place, with more fascinating locations, people, art, and culture than ever imaginable. Why stick to the limited library that I have in my head when such stimulating visuals are right at my fingertips?

Nothing has had a bigger impact on the evolution of my art in recent years than creating visual inspiration boards, or "mood boards." There is something so intriguing and powerful about visualizing ideas. Having a visual guide in front of me makes an idea much easier to try out, compared to attempting to follow a vague image in my head that slips away once I try to capture it.

By gathering inspirational images, I get to know myself a bit better and can hone in on the things I care about most at any given point in time. For example, my venture into painting complex backgrounds started when I noticed that I had gathered a lot of illustrations and photos of environments. The strong emotional response I experienced when looking at them convinced me to try and create something of my own.

I have become slightly obsessed with creating and organizing collections of images and can spend hours discovering reference images. They never fail to excite and inspire me, and often open up a whole new direction for my art that I hadn't considered before. Alternatively, it can be equally exciting to delve deeper into a familiar subject matter to learn more about its nuances and details. To me, that discovery part of the art development process is just as much fun as drawing, if not more!

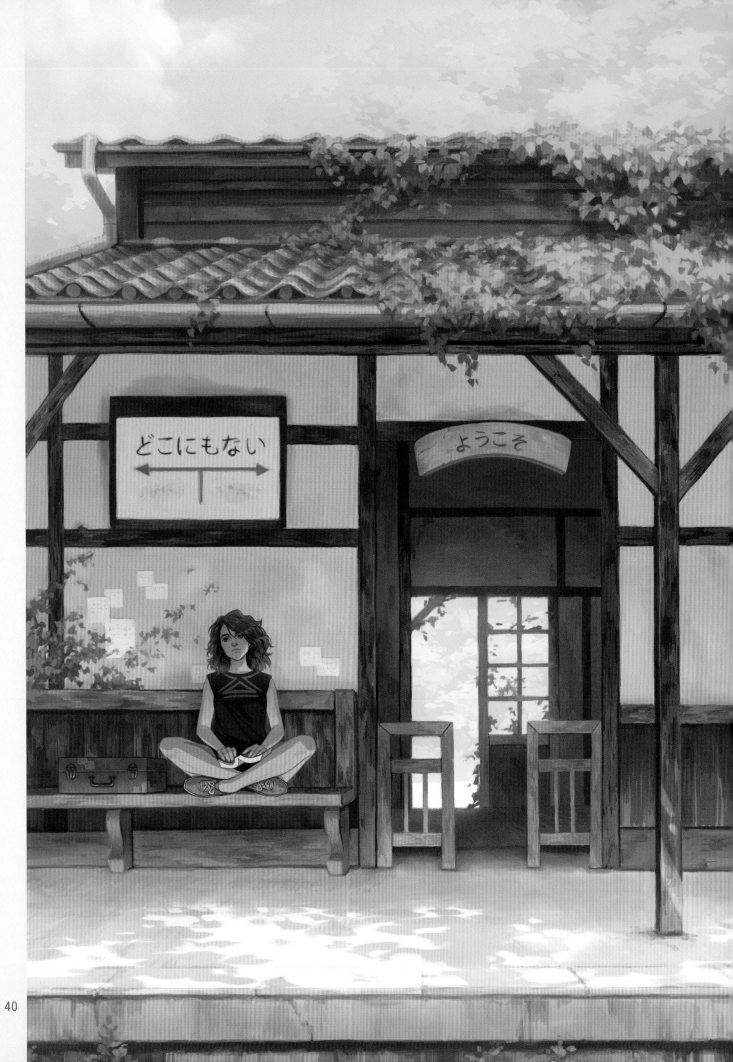

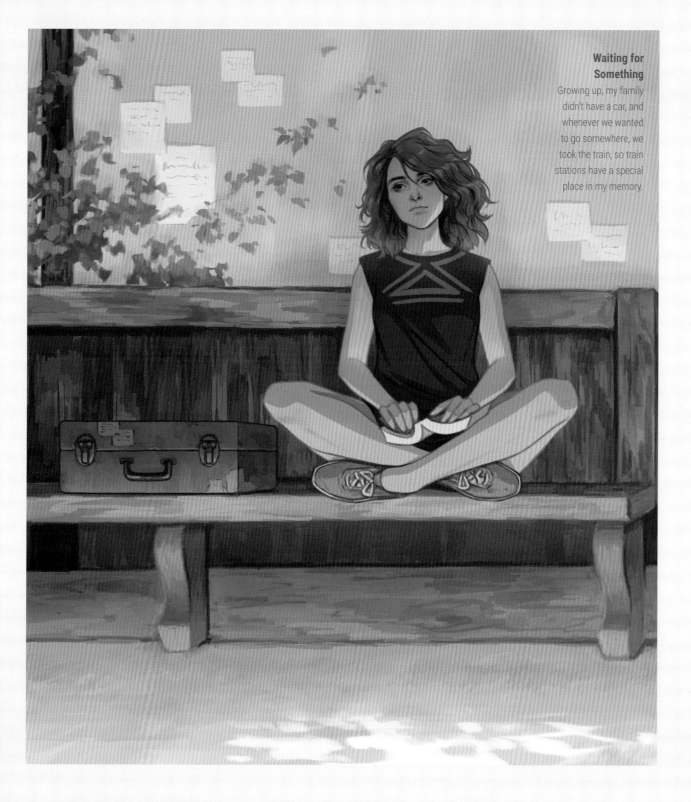

Waiting for Something
Growing up, my family didn't have a car, and whenever we wanted to go somewhere, we took the train, so train stations have a special place in my memory.

Currently, there are certain themes that are particularly prominent in my work: nature, overgrown places, narrow alleyways, dappled sunlight, and natural materials. My interest in natural subject matter has led me to gravitate toward the aesthetics of the traditional Japanese philosophy of "wabi-sabi," which shows an acceptance and appreciation for imperfections and the aging qualities of the passing of time. I prefer textures and imperfections over anything futuristic and shiny.

Overall, I want my artwork to feel calm and peaceful, and I often find myself following quietly thought-provoking themes such as "nature versus concrete," "magic in the mundane," and "animism," which is the idea that all things around us possess a living soul or spirit. I have learned to trust my intuition and to recognize when an idea feels worth exploring, and as a result, I find evolving my art and branching out into new subject matters much easier and more organic.

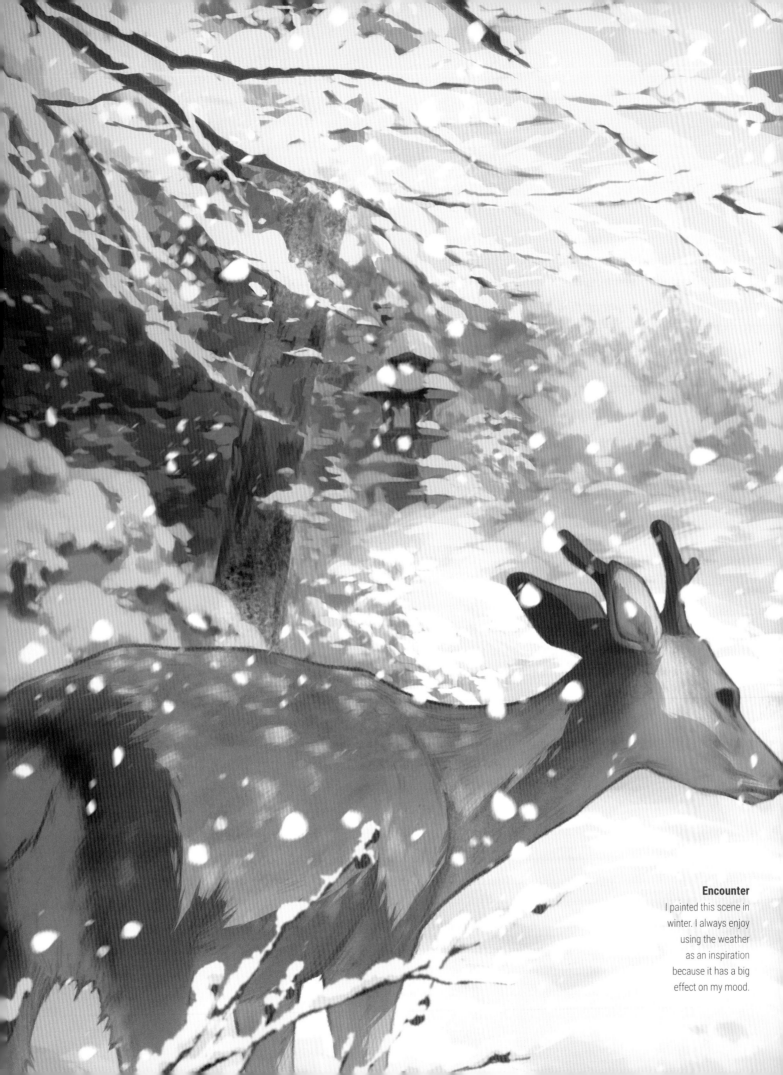

Encounter
I painted this scene in winter. I always enjoy using the weather as an inspiration because it has a big effect on my mood.

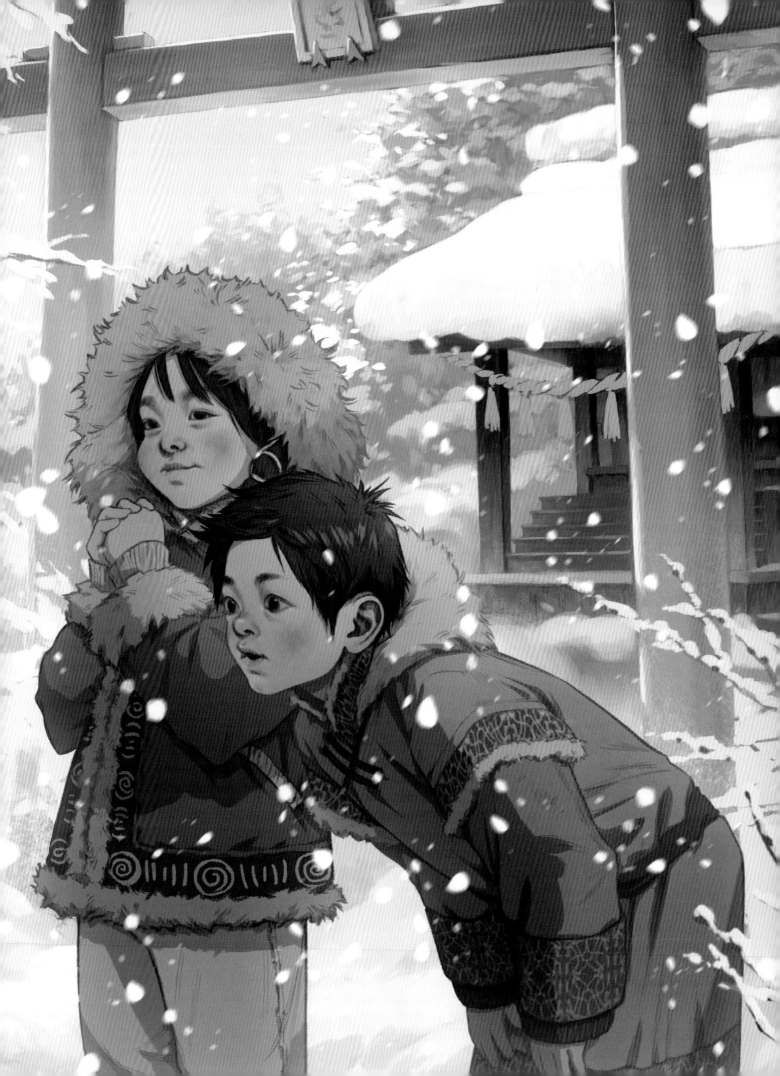

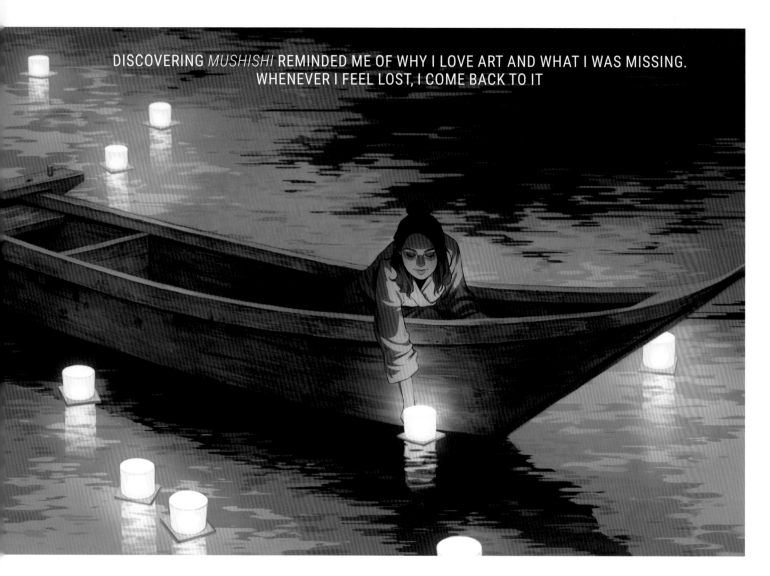

DISCOVERING *MUSHISHI* REMINDED ME OF WHY I LOVE ART AND WHAT I WAS MISSING. WHENEVER I FEEL LOST, I COME BACK TO IT

aspirational creatives

There are so many talented artists that I admire. Without even knowing it, they have helped to shape my taste and guide me in the right direction when I was feeling lost and unhappy with my artwork. Undoubtedly, at the top of my list is Iain McCaig because his pencil drawings are out of this world — he manages to capture so much emotion in his characters, with just a few lines. Besides his technical skills, he is an amazing storyteller and an incredibly positive and energetic person.

Another extremely talented storyteller is Hayao Miyazaki, whose work has been hugely influential to me. *Princess Mononoke*, in particular, is one of my favorite movies and a masterpiece in all respects: story, characters, animation, worldbuilding, and music. It encapsulates everything I love in such a unique and aesthetic way. By far, my favorite aspect of all the Studio Ghibli movies are the detailed hand-painted backgrounds, which is why Kazuo Oga is another artist I greatly admire. And there are so many more: Amei Zhao for her dreamy pastel worlds, Loish for her rich colors and lively characters, Tran Nguyen for her gorgeous surreal scenes, Karla Ortiz with her painterly brushstrokes, and Loika for her exquisite play of light and color.

Over the years, I have come to love and be inspired by many things, and most of them have come and gone. But those that will always have a special place in my heart, aside from Studio Ghibli movies, are the *Harry Potter* books, as well as the anime series, *Mushishi*. They possess a magic that I adore and endeavor to capture in my own work. When I was struggling with a particularly crippling art block a few years ago, discovering *Mushishi* reminded me of why I love art and what I was missing. Whenever I feel lost, I come back to it.

Hope

This is one of the quicker, simpler paintings I've done.

The scene is inspired by Tōrō Nagashi, a ceremony in which paper lanterns are floated down the river, to help guide the souls of those who have passed.

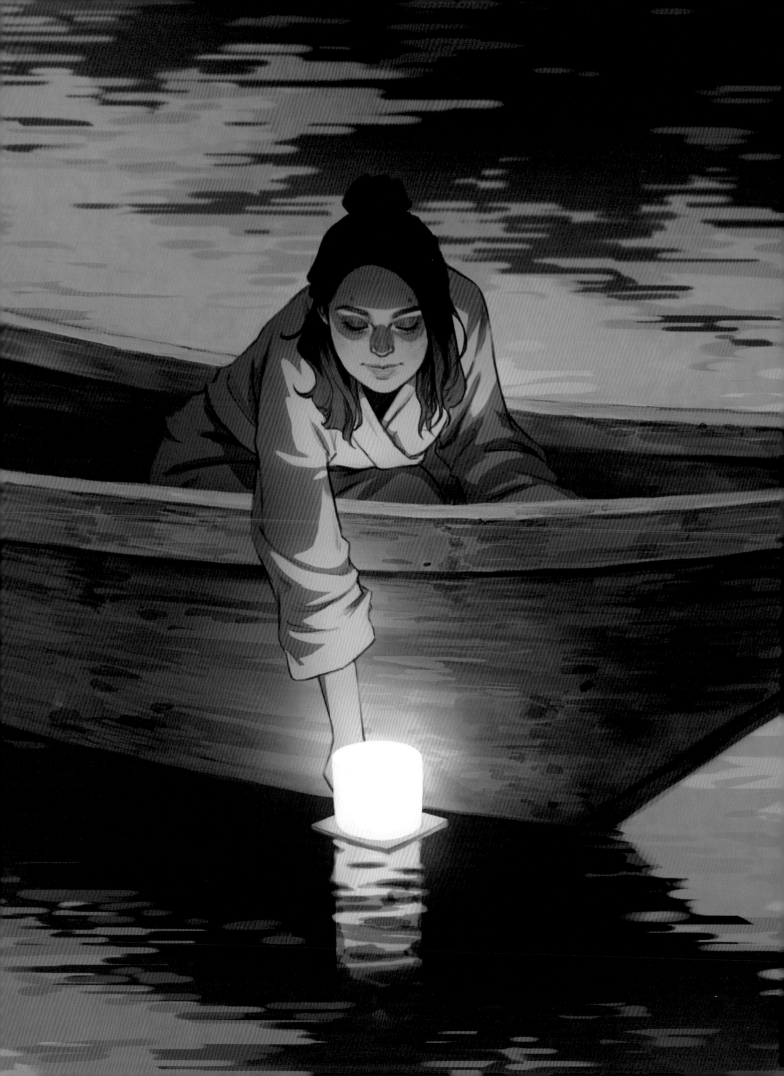

storytelling

I want my art to feel like a frame from an animated movie, with a potential backstory that the viewer could explore. If I'm able to capture such a moment and draw them in, I feel that I have created a successful illustration.

I am extremely passionate about communicating and storytelling through my art because it offers the opportunity to introduce a strong emotional component to a drawing. It allows the viewer to connect with the illustration on a deeper level, and to immerse themselves in it because my story reminds them of their own.

Stories have been around as long as humans have been able to communicate. They are an integral part of our culture and our lives: from cautionary tales to warn us of danger, to sharing our own experiences through narratives. We respond to stories on an emotional level. We connect to them and remember them. We need them.

My stories aren't innovative or new, but they are personal, and they are *mine*.

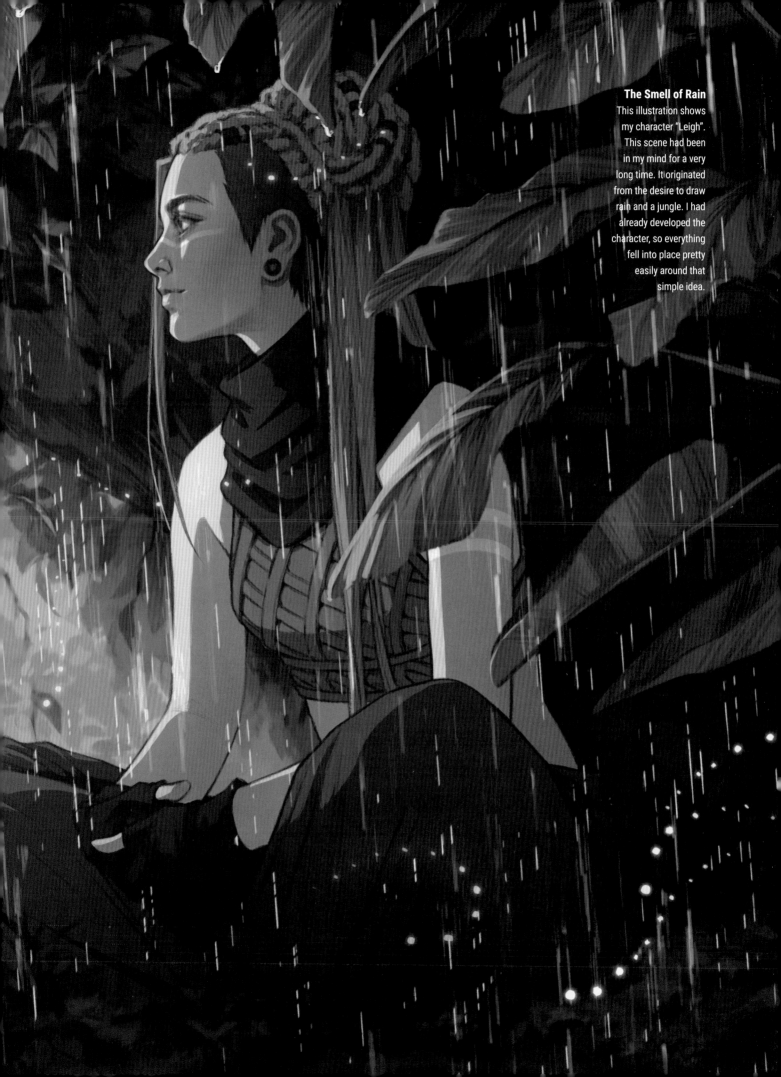

The Smell of Rain
This illustration shows my character "Leigh". This scene had been in my mind for a very long time. It originated from the desire to draw rain and a jungle. I had already developed the character, so everything fell into place pretty easily around that simple idea.

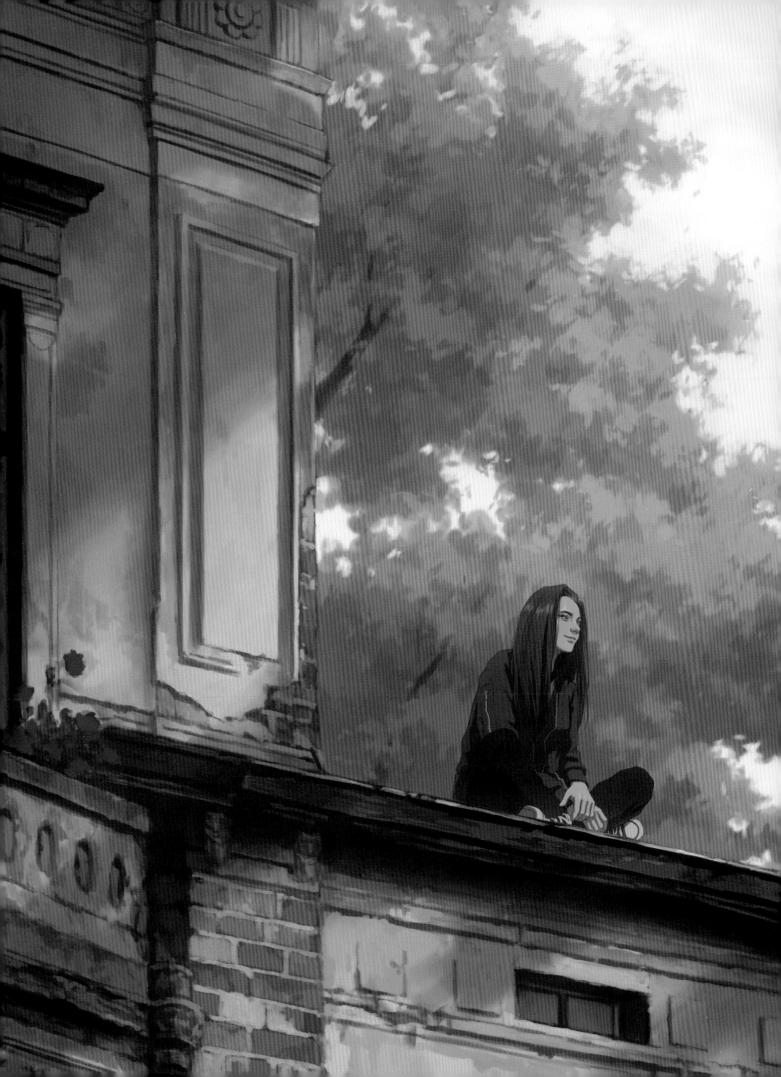

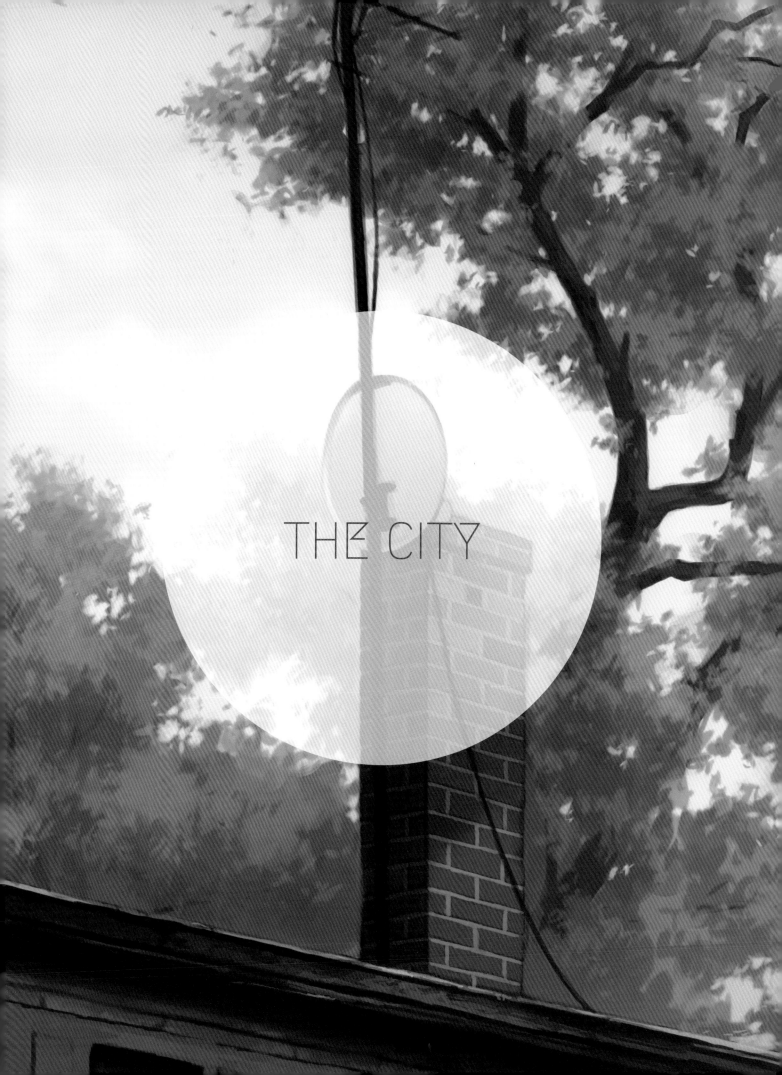

THE CITY

transition

I grew up in a small, historic town filled with towers, churches, and timber-framed houses. It was a nice place to spend the first half of my life, but as I got older, it was time for something new. I became tired of running into the same people and visiting the same places over and over again. Gradually, the town seemed to be getting smaller and as I approached the end of high school, I had outgrown the place.

Every summer break, my friends and I would get a train ticket that we could use to visit different places in the local area, as well as for a trip to Berlin. After many visits, I fell in love with the city of Leipzig. I adored the beautiful old architecture, cafés, restaurants, parks and forests, as well as the people.

After graduating, I didn't want to move to a huge city. Large crowds and noisy streets make me feel uncomfortable, and while skyscrapers are impressive, they're not somewhere I want to call home. Leipzig was just big enough, and at the same time, it was fairly quiet and peaceful. It's a city that is buzzing with creative energy, offering endless possibilities. The ten years I have spent here have been the best of my life. I have met so many people who have become family to me, and I have reconnected with old friends whose own journeys have led them here.

In recent years, the population has been growing. The streets have become dirtier, trams have become crowded, and living space is rarer and more expensive than ever. I might pack my things and move out into the woods someday, but right now I'm still here, watching the city change.

Companions

This abandoned train is one of the many locations my characters "Leigh" and "Seth" explore throughout their journey. Scenes like this give me the opportunity to paint one of my favorite things: overgrown places.

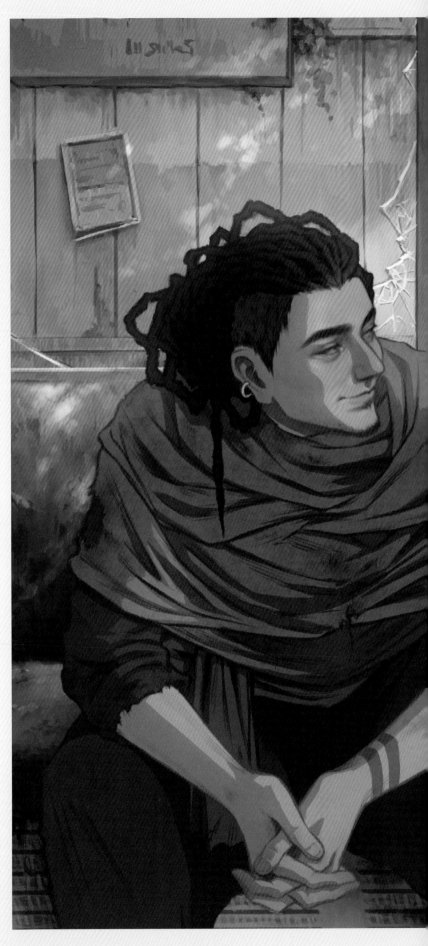

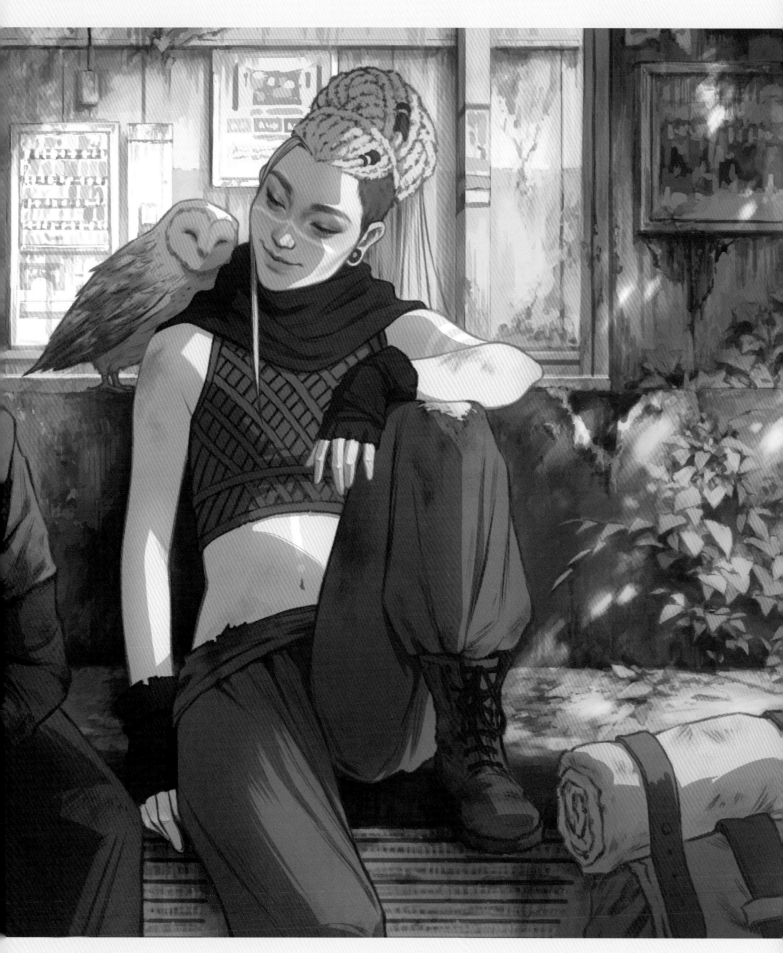

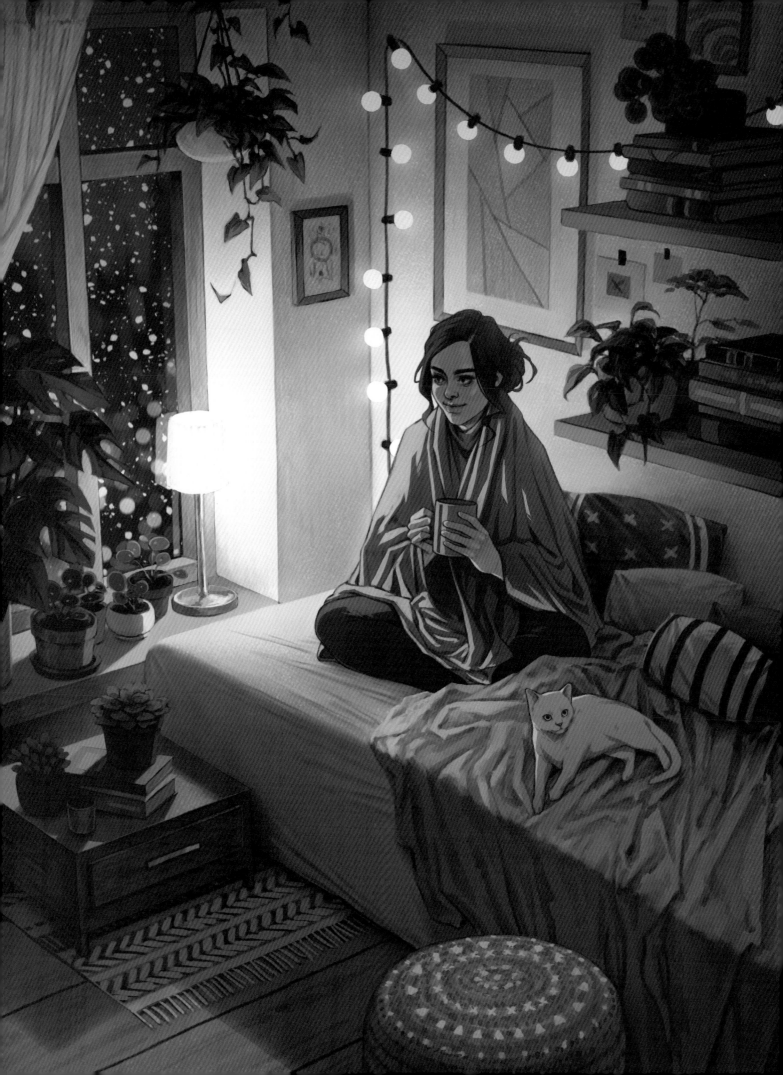

university

When I graduated from high school, for the first time in my life I was able to make my own decisions. And since I wasn't quite sure what I wanted to do, I browsed the university's prospectus for possible subjects to enroll in. Japanese studies seemed to be a perfect option to pass the time until I figured out what my career was going to be! And while I have completely forgotten everything I'd learned in the language classes during my two semesters, I still had much more fun than during any of the following years at university.

Deciding on a new major was a challenge. All I wanted to do was paint, but growing up I didn't think it was possible to make a living as an artist. I considered going in different directions that were remotely related, such as graphic design, fashion design, and even makeup artistry. But, eventually, I made the decision to become an art teacher.

Unlike Japanese studies, the decision to study art education had to be permanent because my student loans would only cover me for the standard period of study, which also meant that I had to catch up on the two semesters I had lost to Japanese studies by shouldering a heavier workload. I also took on a variety of part-time jobs to further support myself. It was challenging, but I'm glad I pushed through and came away with a master's degree in teaching art. It's reassuring to know I have a plan B, should I ever need it.

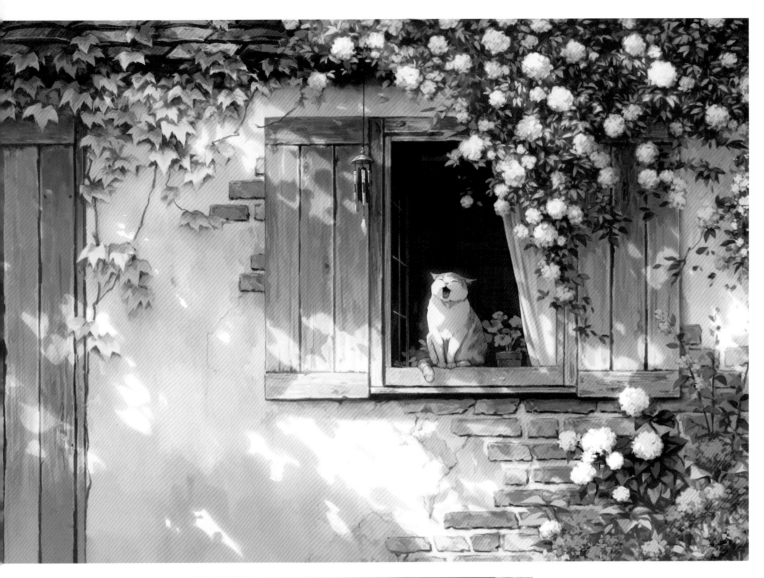

Home (Above)
I painted this piece during quarantine from the coronavirus pandemic in March 2020. It is inspired by the simple wish for normality and even boredom in my life, instead of the unease and uncertainty of the time.

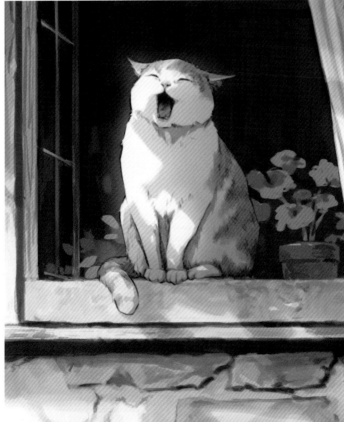

Sunday Afternoon (Opposite page)
For this piece, I wanted to depict a girl walking her dog, and decided to set the scene in front of a little ramen shop. While I was working on the sketch, the upper right-hand corner looked empty, so I added a cherry tree. Any time I paint work that is centered around architecture or interiors, I like to include natural elements or a touch of magic for contrast.

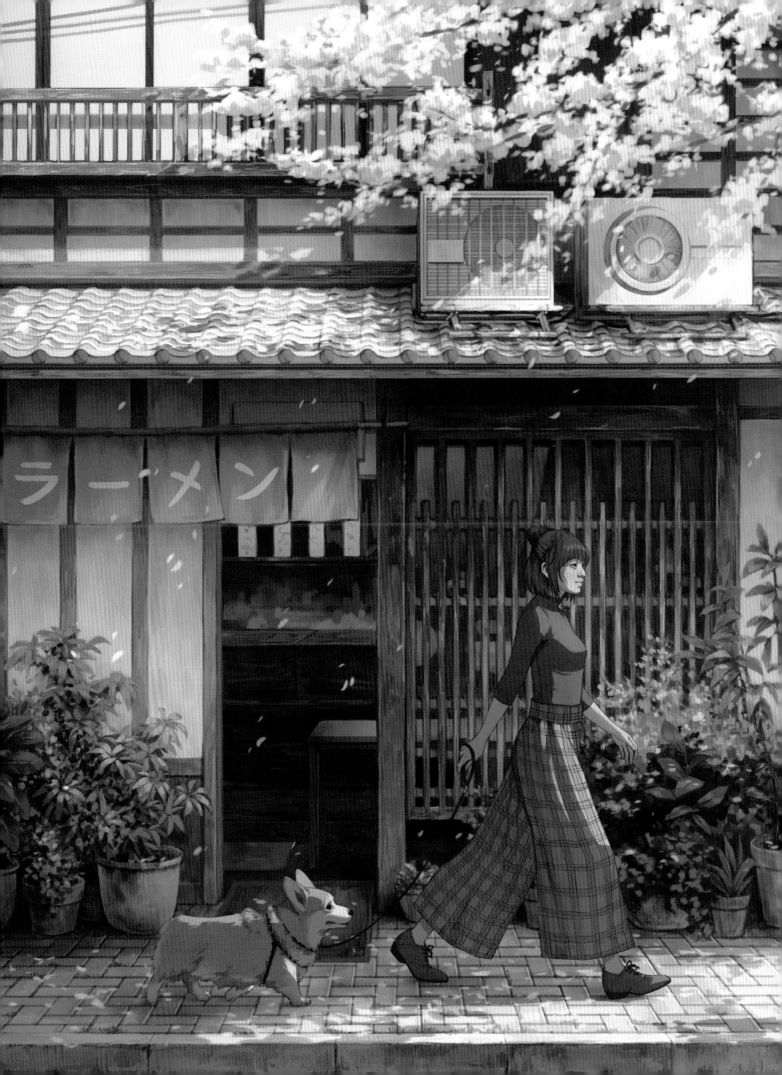

artistic
self-discovery

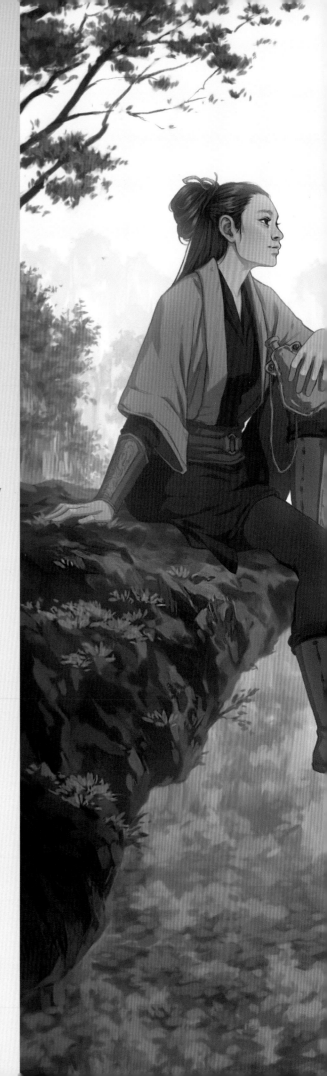

Even though I love art more than anything, my relationship with art education has been challenging. All of my teachers had one thing in common: a distaste for manga and anime. They simply couldn't see past their preconceptions and told me that I should pursue something else. Every time they rejected one of my drawings, it felt like they were rejecting me as a person. Constantly being told that what I liked was "wrong" slowly crushed my self-esteem. I would still draw and improve my skills, but my work was incoherent, and a desperate attempt to give my teachers what I thought they wanted to see. I'm not proud of any of those drawings and I don't recognize myself in them at all.

During the first year of my art education program, I discovered the online art community. Not only that it existed, but that people were making my preferred style of art for a living! So, I started to consider the possibility of becoming a professional illustrator. I soaked up all the online tutorials I could find and bought a stack of books to learn about the fundamentals of art: anatomy, perspective, light, color, and composition. For the first time, I was excited to study and work toward a personal goal that was not just a compromise. I didn't need a teacher to keep me motivated. As a child, I always had to take work home because I wasn't able to focus among a large group of people. Studying at home, in my own time, has always been the better fit for me.

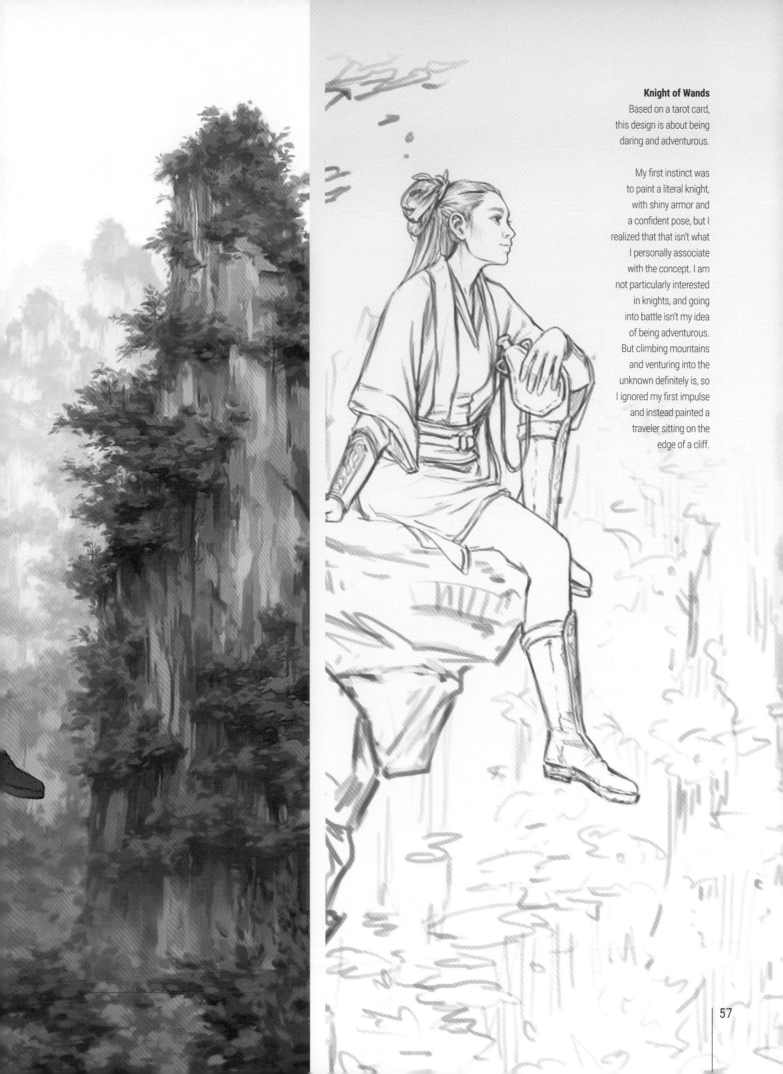

Knight of Wands
Based on a tarot card, this design is about being daring and adventurous.

My first instinct was to paint a literal knight, with shiny armor and a confident pose, but I realized that that isn't what I personally associate with the concept. I am not particularly interested in knights, and going into battle isn't my idea of being adventurous. But climbing mountains and venturing into the unknown definitely is, so I ignored my first impulse and instead painted a traveler sitting on the edge of a cliff.

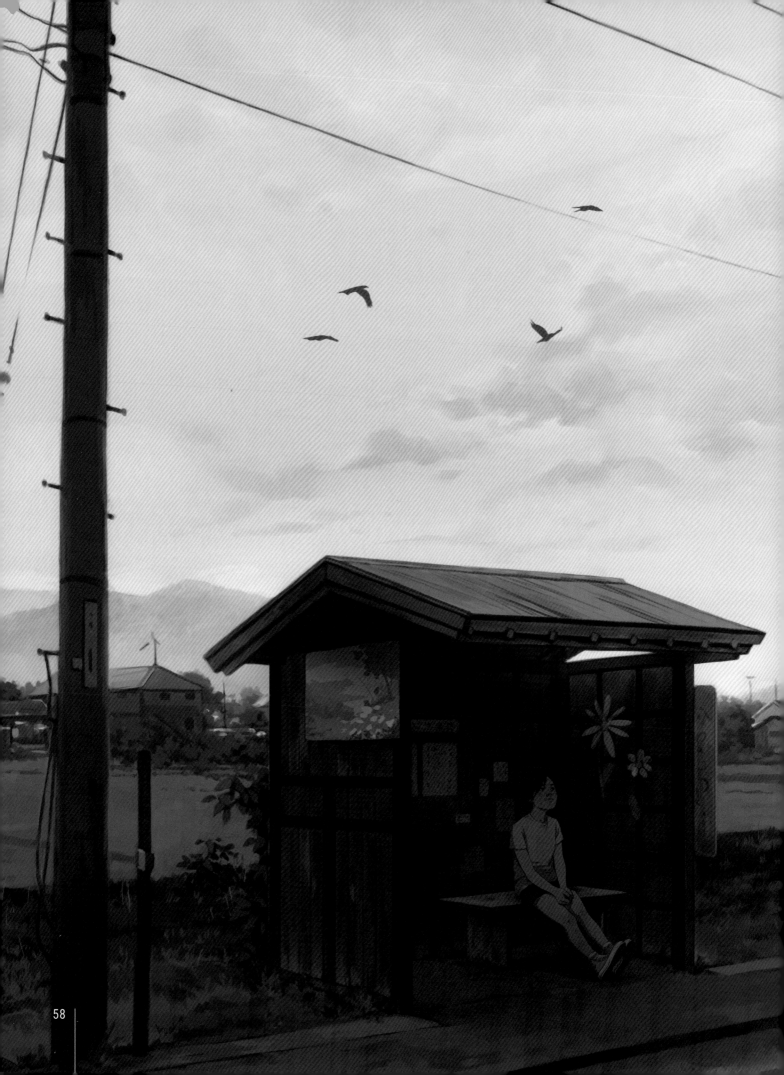

Morning Light
This piece was inspired by rural Japan and the tranquility before the whole world wakes up.

I realized that as soon as I painted over my preliminary drawing, my characters were losing their initial appeal and personality. So, I decided to focus more on drawing. I went back to my old sketchbooks to discover ideas I had abandoned because someone had discouraged me, or I hadn't allowed myself to pursue them.

I purchased a new sketchbook to fill with studies and concepts, and studied the work and techniques of artists whose work relied heavily on strong linework. I drew non-stop: during university lectures and in my spare time. My style began to emerge and it looked much closer to the style I had naturally when I was young. Slowly, I rediscovered the elements of creating art that were important to me. I embraced that part of me that I had locked away for so many years. And drawing and creating felt instinctual and easy, for the first time since I was a young child.

Once I had decided to keep my linework in my final drawings, I became more adventurous in experimenting with color. Because I would always keep my line drawing on a separate layer in my digital file, I was able to try out a lot of different color schemes without worrying about destroying the structure of the illustration. As a result, my artwork became lighter and more saturated. I started having fun with it!

Only by disregarding the expectations of others was I able to create something that I truly enjoyed, in a style that felt completely natural.

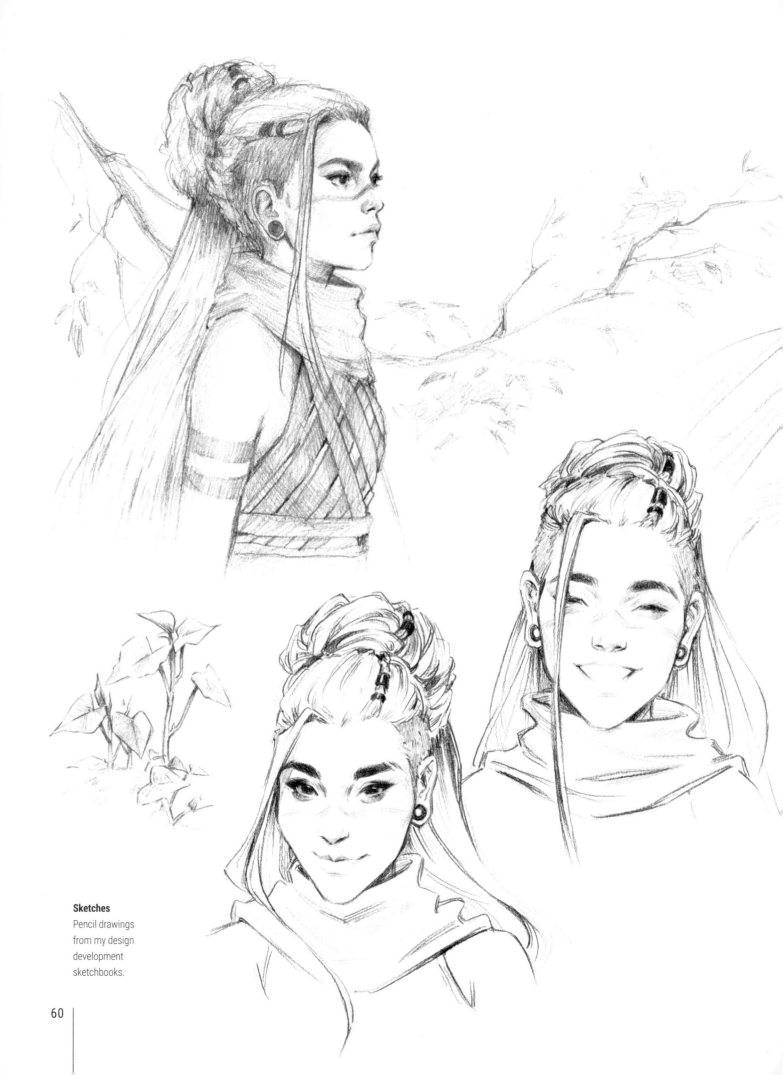

Sketches
Pencil drawings
from my design
development
sketchbooks.

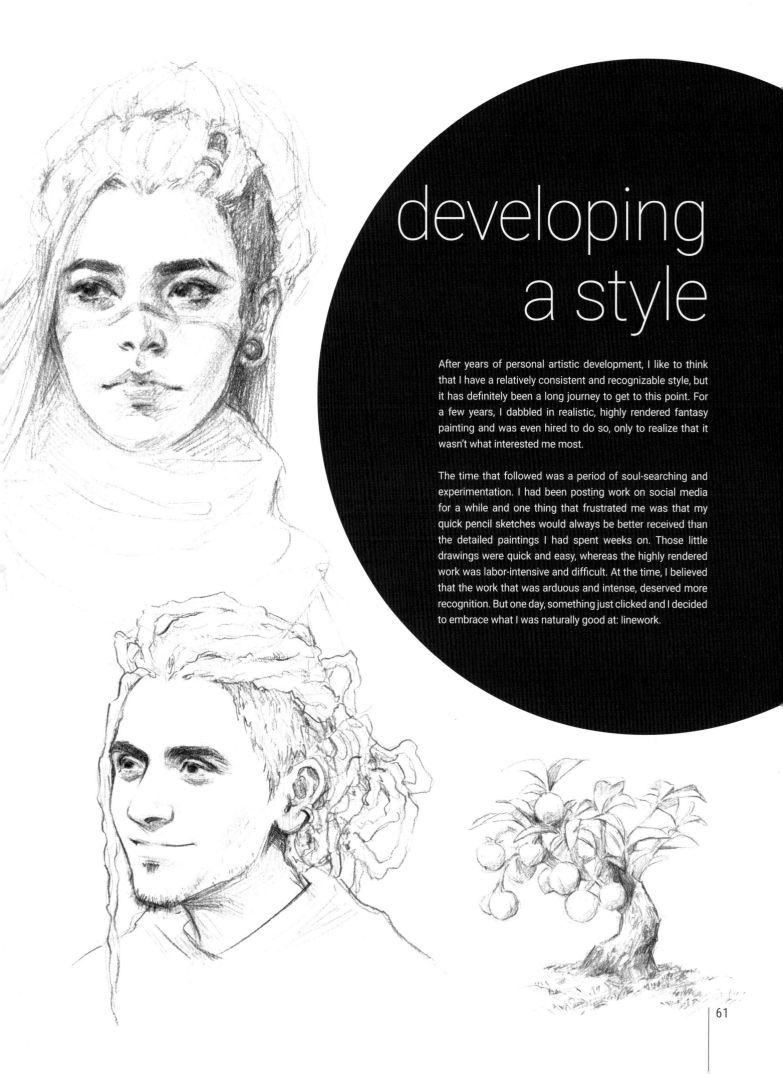

developing
a style

After years of personal artistic development, I like to think that I have a relatively consistent and recognizable style, but it has definitely been a long journey to get to this point. For a few years, I dabbled in realistic, highly rendered fantasy painting and was even hired to do so, only to realize that it wasn't what interested me most.

The time that followed was a period of soul-searching and experimentation. I had been posting work on social media for a while and one thing that frustrated me was that my quick pencil sketches would always be better received than the detailed paintings I had spent weeks on. Those little drawings were quick and easy, whereas the highly rendered work was labor-intensive and difficult. At the time, I believed that the work that was arduous and intense, deserved more recognition. But one day, something just clicked and I decided to embrace what I was naturally good at: linework.

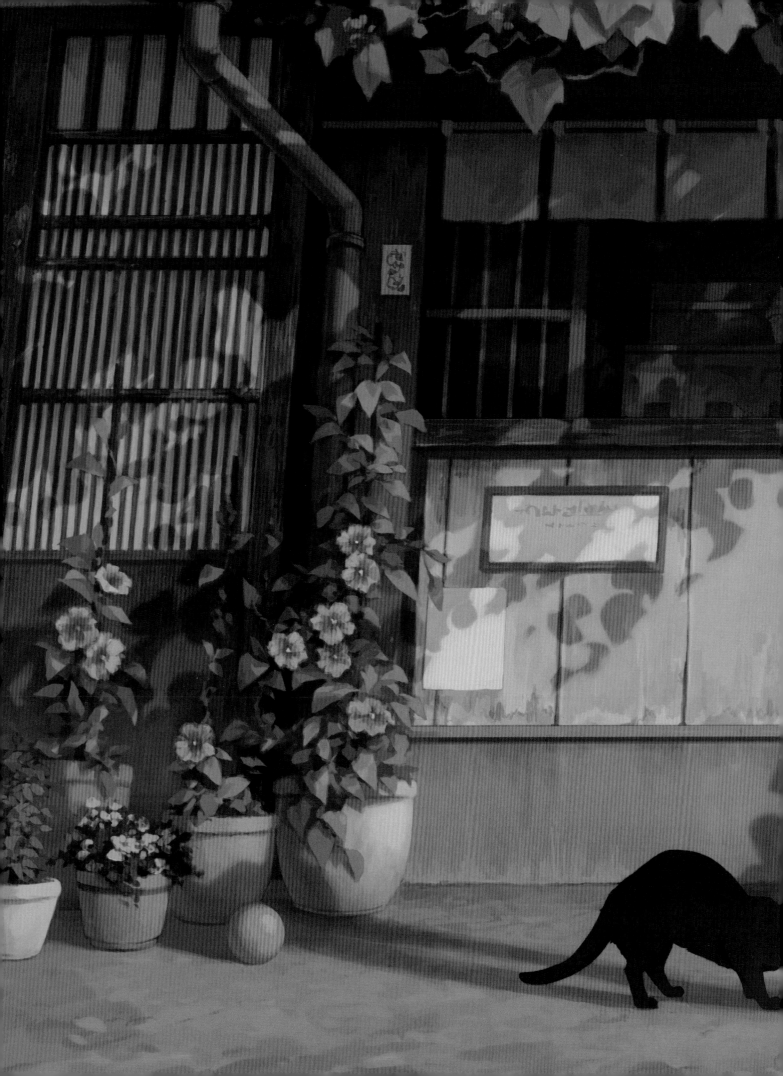

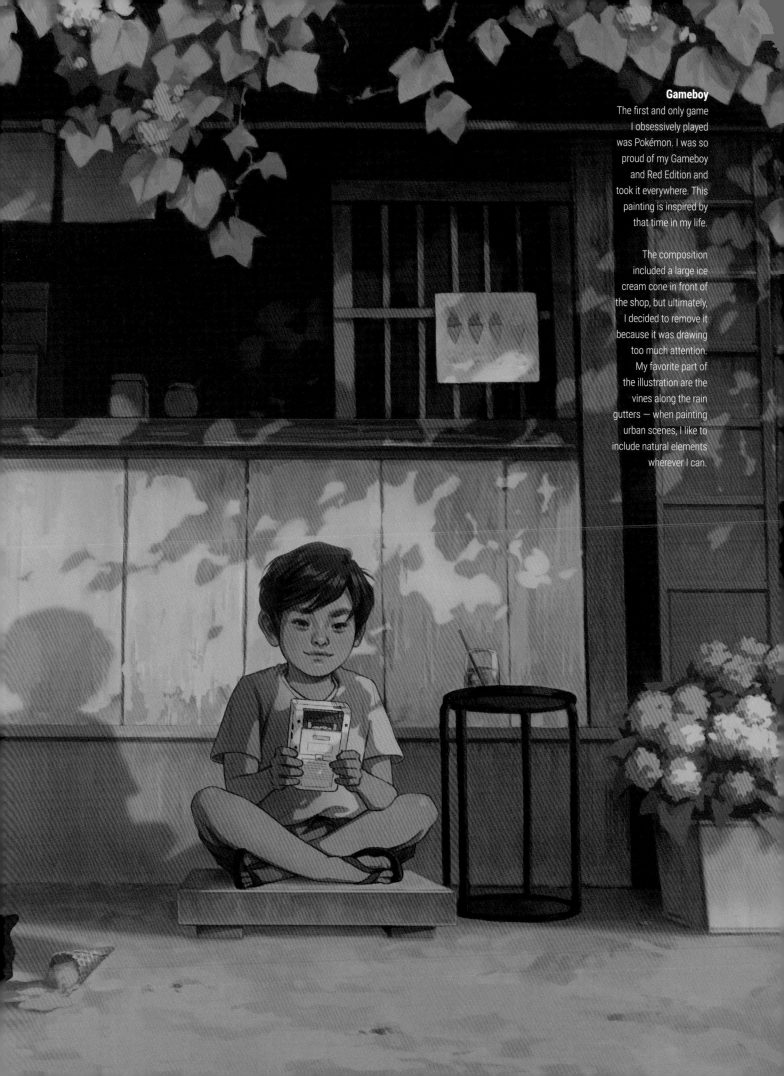

Gameboy
The first and only game
I obsessively played
was Pokémon. I was so
proud of my Gameboy
and Red Edition and
took it everywhere. This
painting is inspired by
that time in my life.

The composition
included a large ice
cream cone in front of
the shop, but ultimately,
I decided to remove it
because it was drawing
too much attention.
My favorite part of
the illustration are the
vines along the rain
gutters — when painting
urban scenes, I like to
include natural elements
wherever I can.

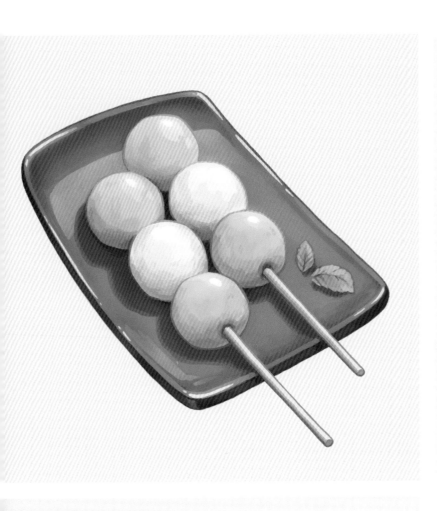

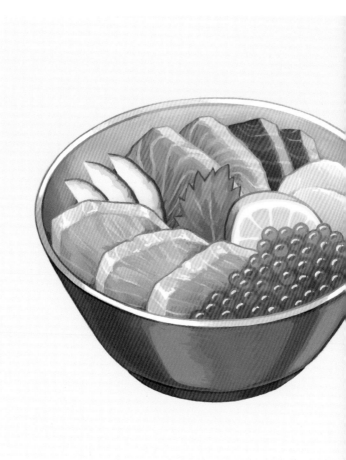

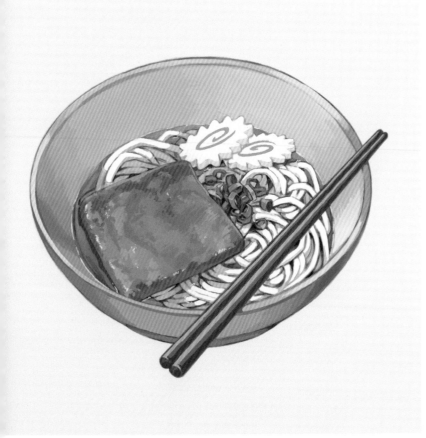

travels

The first time I ever left Germany, I was two years old. My grandparents took me on a trip to Spain. While I was too young to remember any of it, apparently I bathed in the sea, built sandcastles, hiked trails lined with huge cacti, and bought myself a funny hat that I wore in every single photo. I wish I could have taken more of these trips, but my grandparents eventually stopped traveling and my mother and I never had the means to do so.

My next big adventure would have to wait another nineteen years. Finally, during university, I decided to study two semesters abroad, because I would never get a chance like that again. Money was still tight, but my student loans just about covered my expenses. So, I headed out to Dublin. Originally, I was planning on using my time there to work on my art, but the new surroundings, culture, and people made it too easy to just enjoy myself and catch up on everything I had been missing out on. Ireland has become my second home and I still try to visit whenever I can.

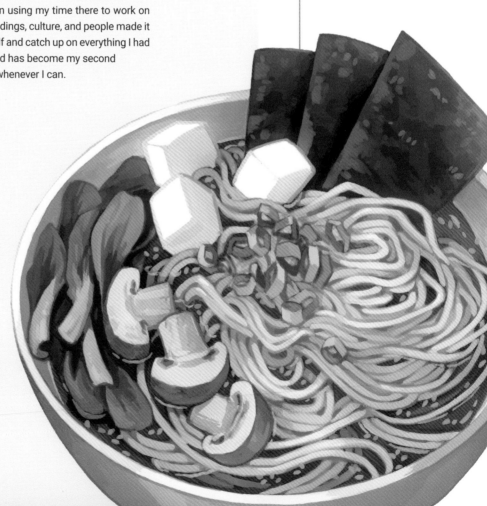

Japanese Food

Dango, Sashimi, Matcha Mochi, Udon (Opposite page, clockwise from top left)
Ramen (Right)

Studies

Photography taken on my trip to Japan and pencil sketches drawn from photographs.

Since then, I've made it my priority to travel to different countries every year. I have been to Scotland, Scandinavia, and the US, among others. And, most importantly, I was able to fulfill my lifelong dream of going to Japan. Seeing all of the things in person that I had only read about and seen in the media felt surreal. While the tourist attractions were impressive, what I loved most was wandering around alleyways, seeing almost every house decorated with flowerpots, and eating in the tiniest bars and restaurants. I was so inspired to make art based on my impressions.

My first trip to Japan allowed me to absorb as much of the culture as possible, but next time, I'm going to capture as much of it on camera as I can. Opening myself up to other cultures and exploring the world is one of the most rewarding things I've ever done. If it were up to me, I would just travel around the world, take photos, and then paint the places I have seen – a dream I'm currently working toward.

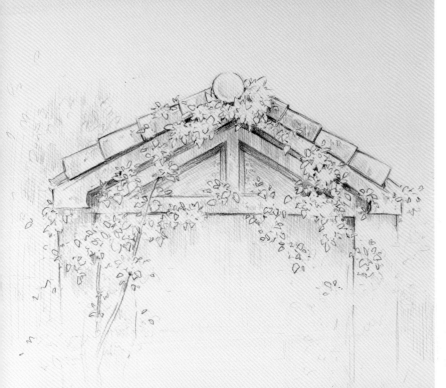

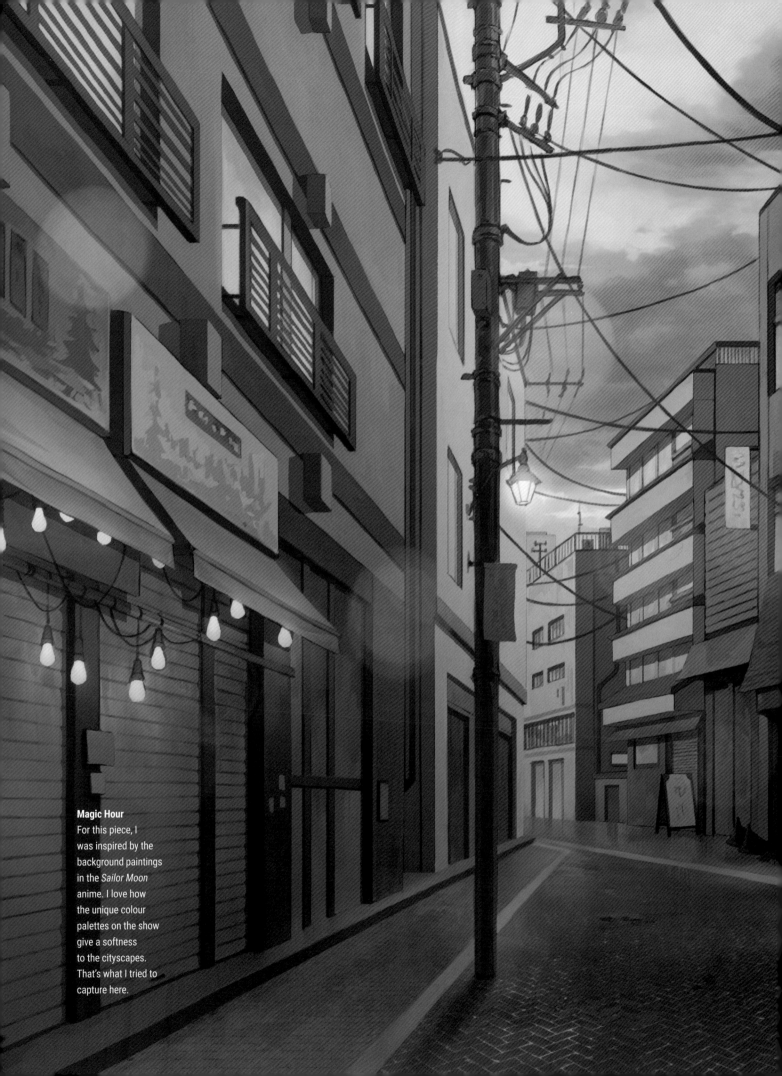

Magic Hour
For this piece, I was inspired by the background paintings in the *Sailor Moon* anime. I love how the unique colour palettes on the show give a softness to the cityscapes. That's what I tried to capture here.

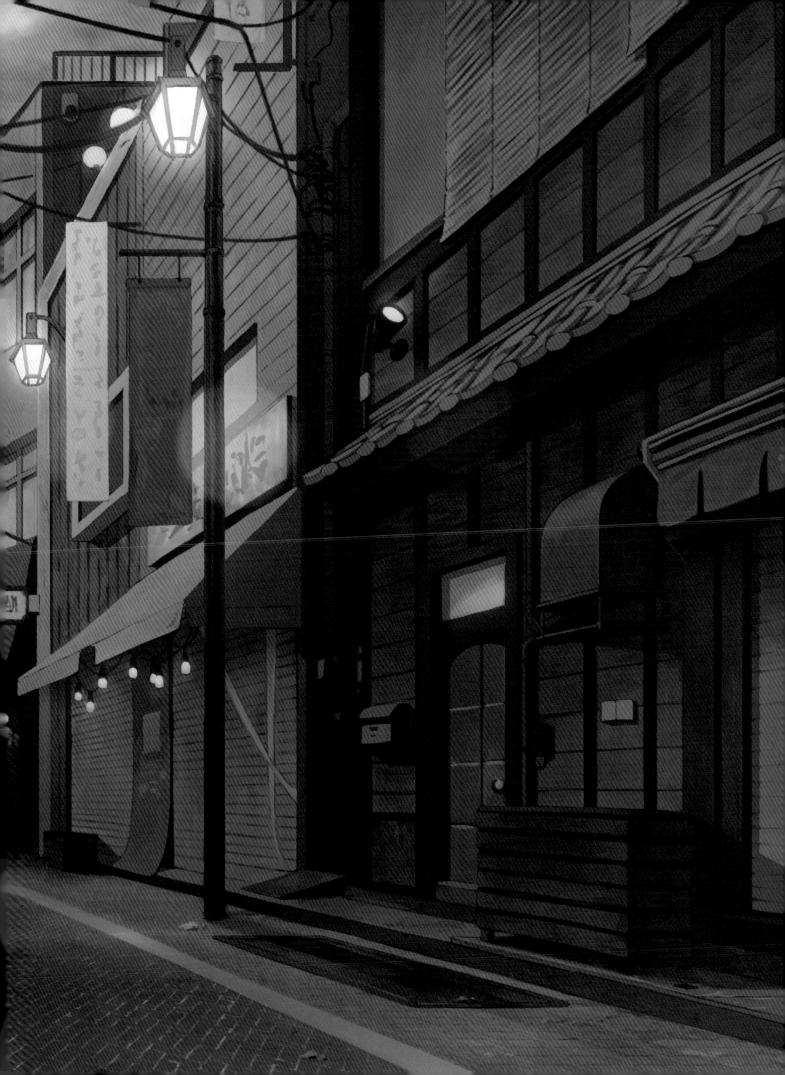

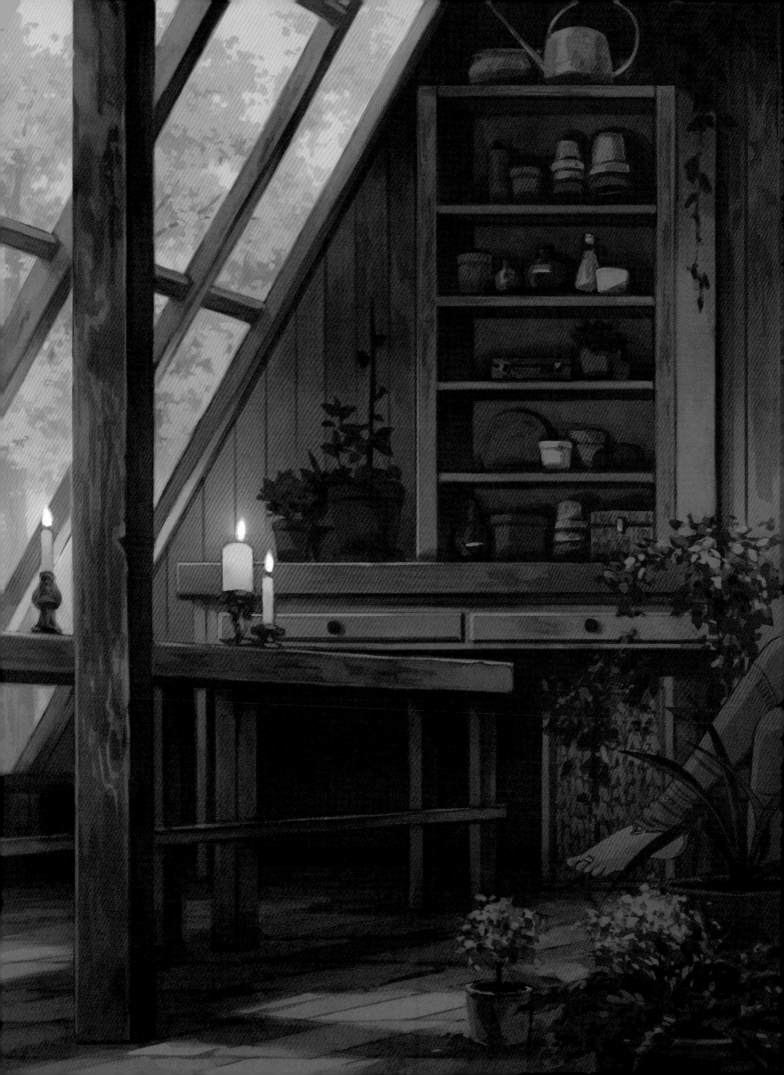

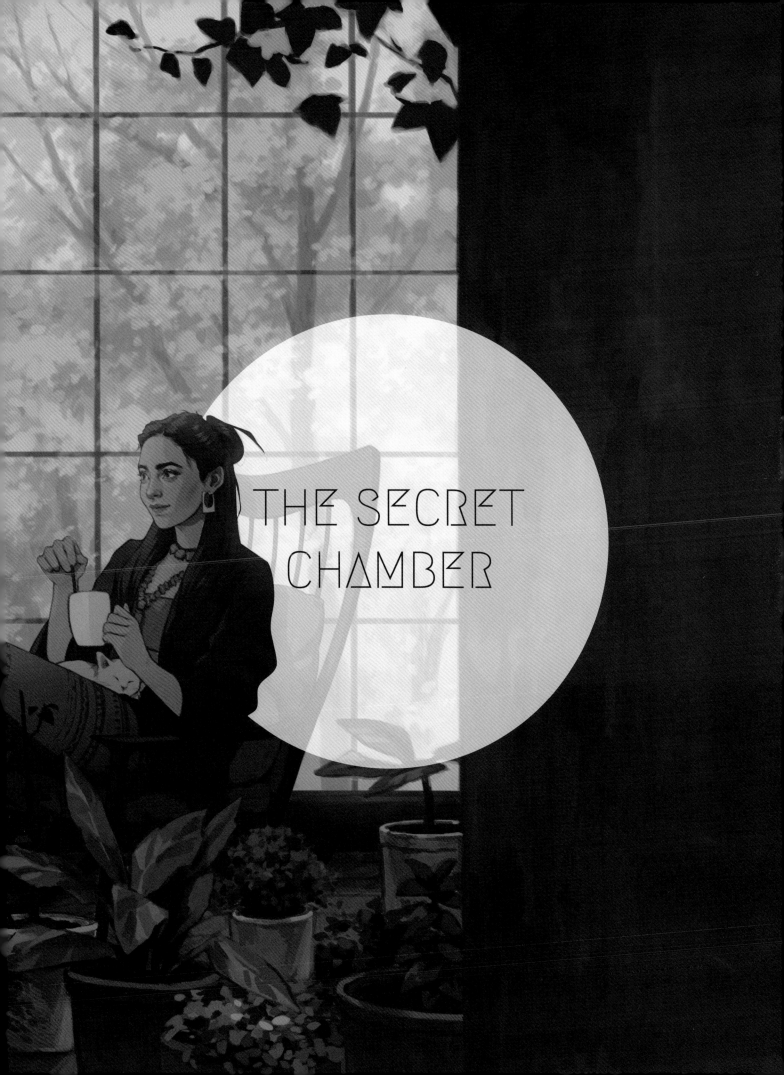

THE SECRET CHAMBER

the fantastic and surreal

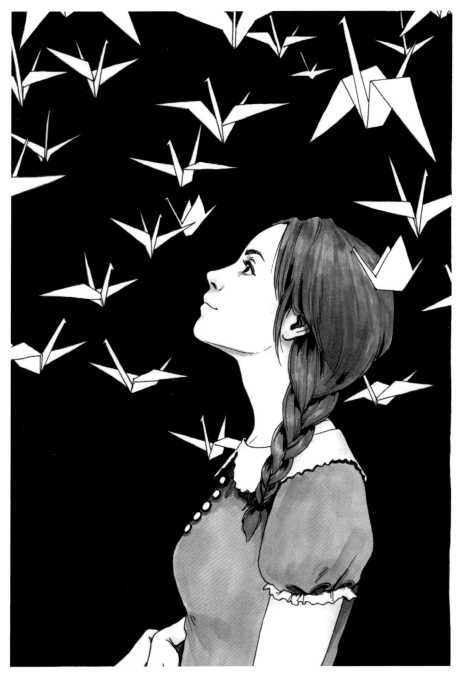

What I love most about art is that there are no limitations. Whether it is communicated through paintings, books, or movies, art allows you to travel worlds and have experiences far beyond the ordinary. It transports you to places – real or imagined – and lets you become a part of them.

There is room for the strange and unusual, the obscure and the fantastic. Art has the power to bend and shape reality. It allows you to fulfill wishes, or to face your worst nightmares.

As a teenager, I was fascinated with surrealism. I remember discovering a painting by Salvador Dalí that depicted elephants on long spindly legs, walking across a barren landscape. I admired how Dalí was able to create something so unsettling, just by altering a few details.

Where the Wild Roses Grow (Right)

Far Away (Left)
I love the simple elegance of origami animals, so I decided to incorporate them into a drawing. Bringing inanimate objects to life is one way to breathe a bit of magic into an ordinary scene.

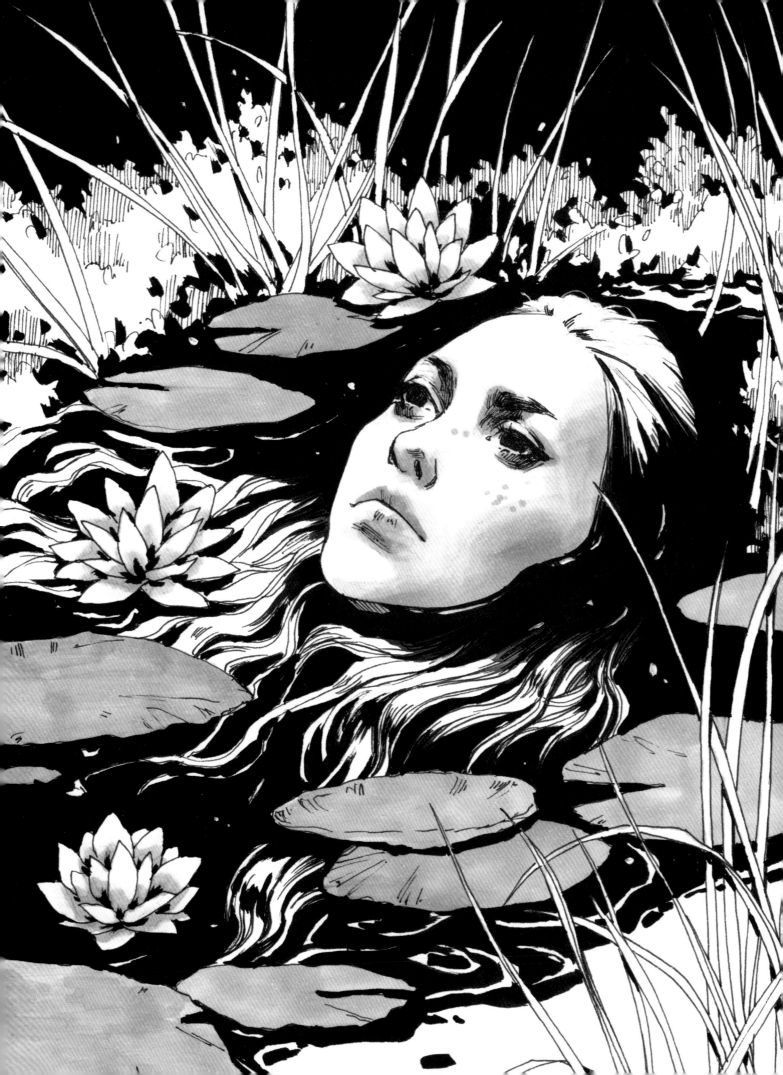

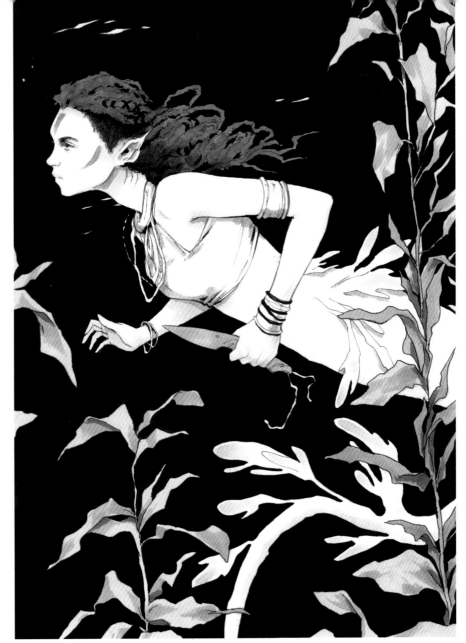

Fierce (Left)
This is the only entry I have ever created for the Mermay social media challenge. I wanted to depict an unconventional mermaid.

Follow (Below)
This piece is based on my idea of a character walking around at night, gathering spirits to put them to sleep.

Night Watch
(Opposite page)
When I was very young, I would walk around town carrying paper lanterns with a group of children. This piece is an homage to that.

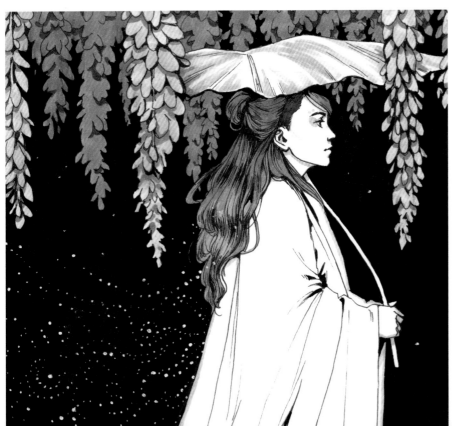

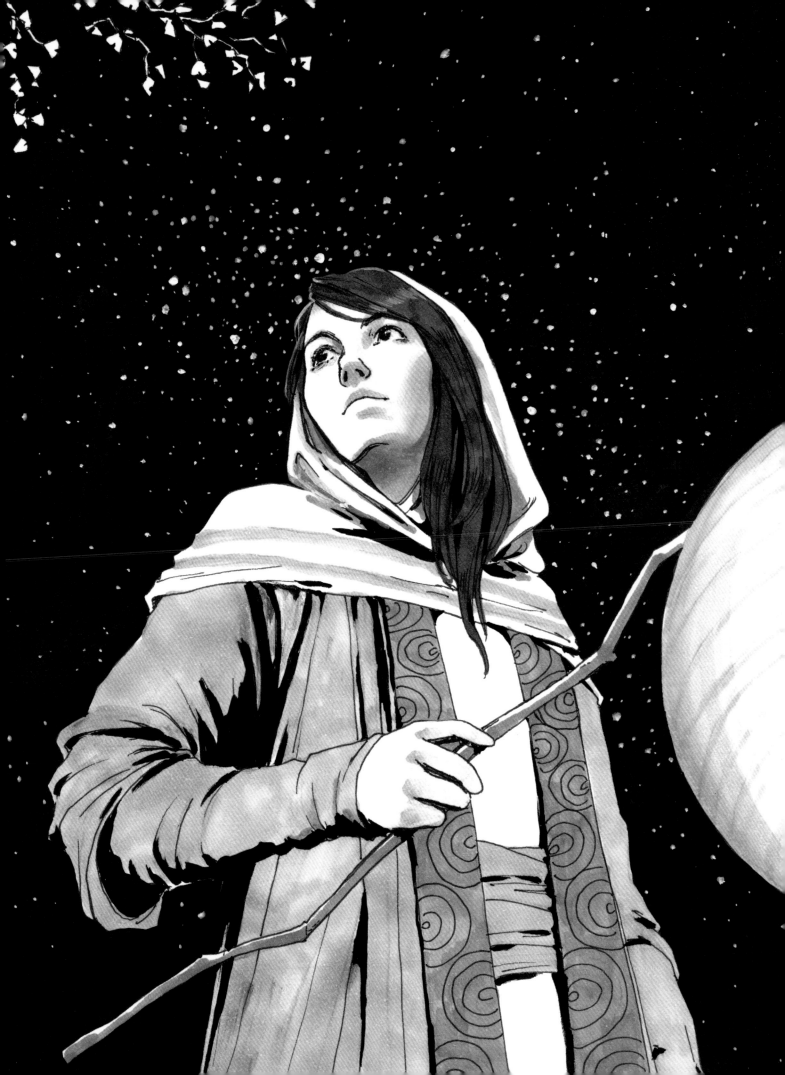

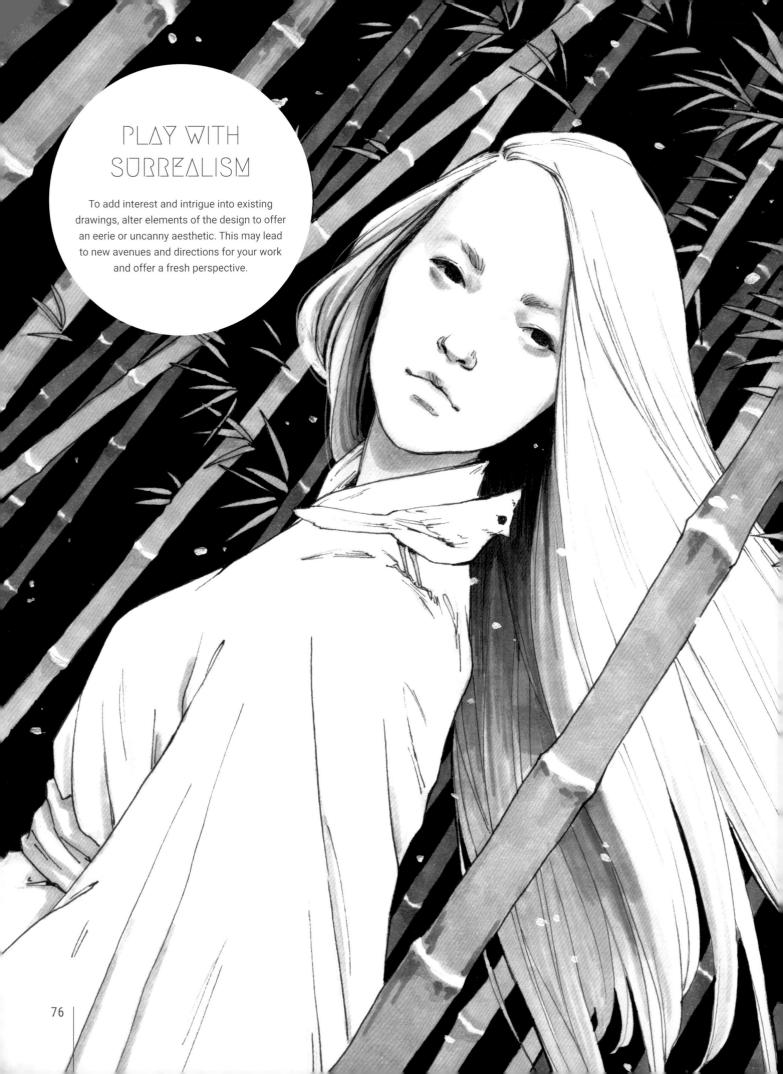

PLAY WITH SURREALISM

To add interest and intrigue into existing drawings, alter elements of the design to offer an eerie or uncanny aesthetic. This may lead to new avenues and directions for your work and offer a fresh perspective.

Geist (Left)
This is my version of
Yuki-Onna, the snow
woman from Japanese
folklore. She is often
depicted with black hair,
but I made her appear
completely white, as if
she were made of snow.

To make the scene feel
a bit more unsettling, I
tilted the horizon line.
The title, *Geist*, is the
German word for ghost.

Neoptera (Right)
My main focus for this
drawing was to design
the character's clothing.
They are inspired by a
Japanese kimono and
the patterns resemble
butterfly wings.

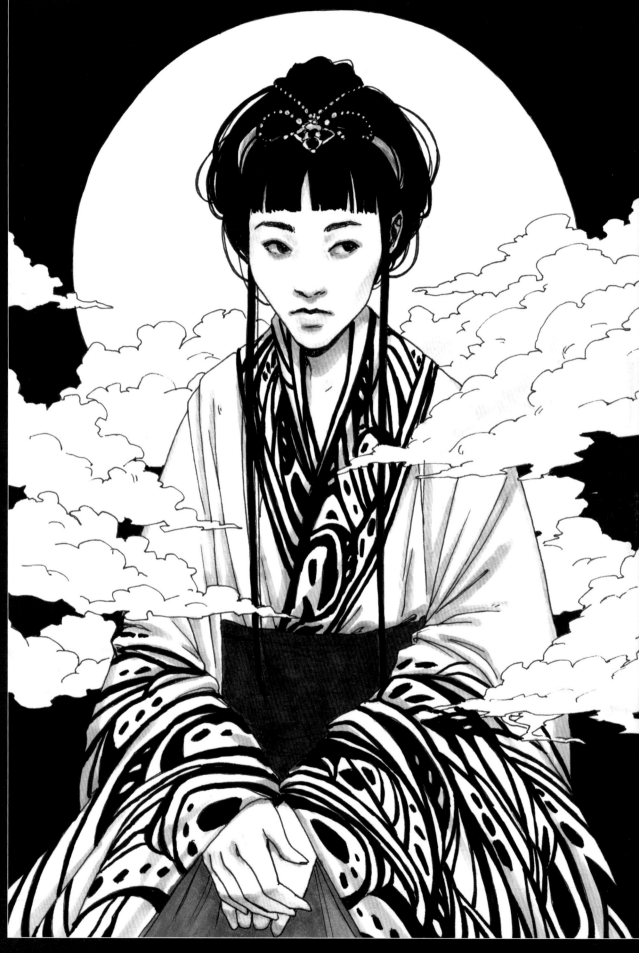

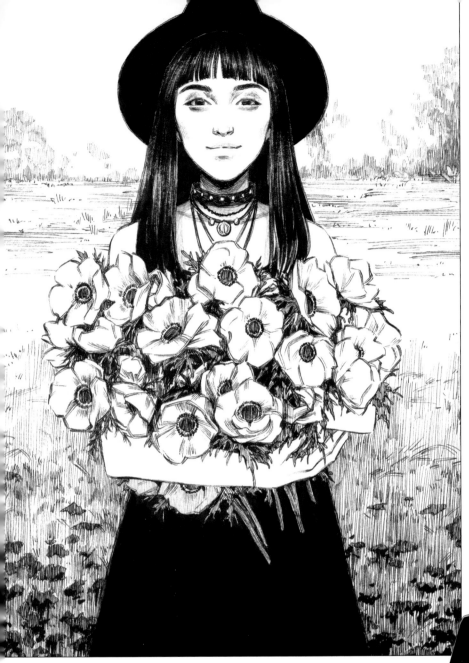

Acorn Witch (Opposite page)
Part of my Botanical Witches series, created as a set of social media prompts. I like how the whole series turned out, but this one is my favorite. Her expression, body language, and design just came together effortlessly — and I love the little squirrels.

telling tales

Most of the work I create is representational, but I still enjoy playing with surreal elements and symbolism. For example, some of my ink drawings, as seen on these pages, are much more experimental than other works.

Stepping out of the realm of possibility opens up new ways of telling stories and finding visuals for abstract concepts. Working with fantastic elements allows you to encode messages about personal experiences into your art, without hitting the viewer over the head with them.

Lavender Witch
To find inspiration for all the different witches, I did some research on the properties of the herbs and flowers I had chosen. Lavender is said to aid sleep.

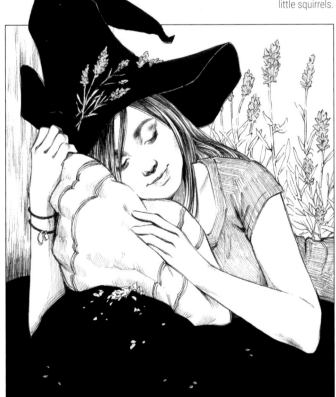

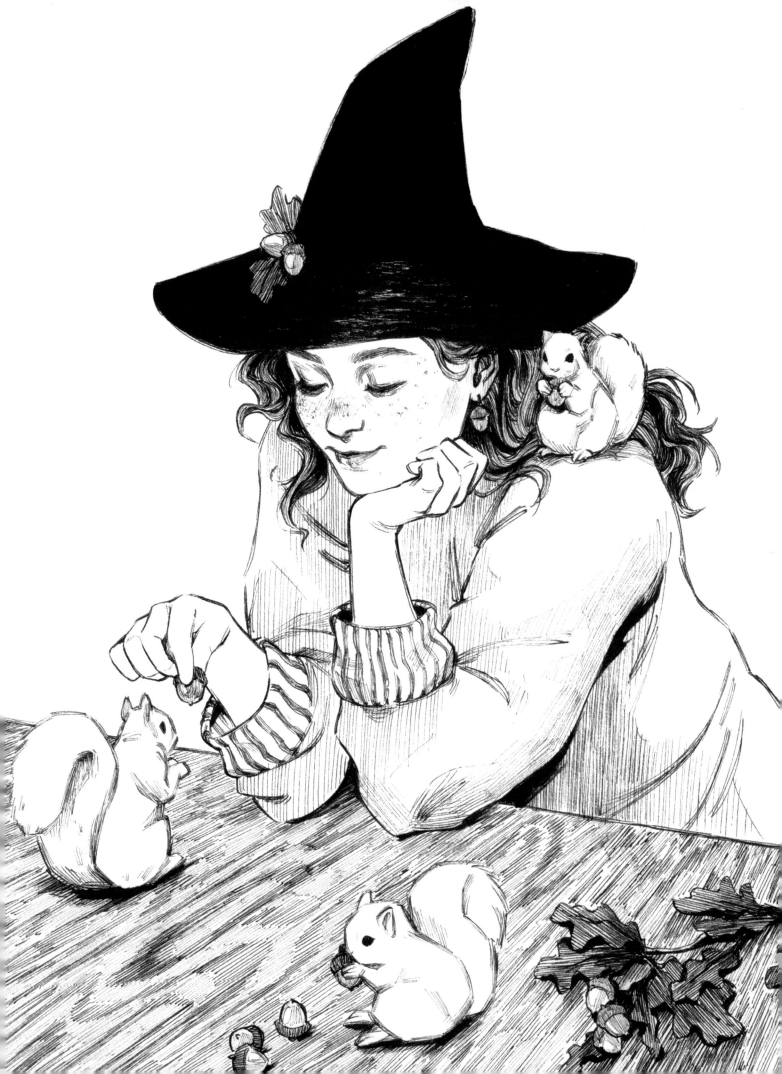

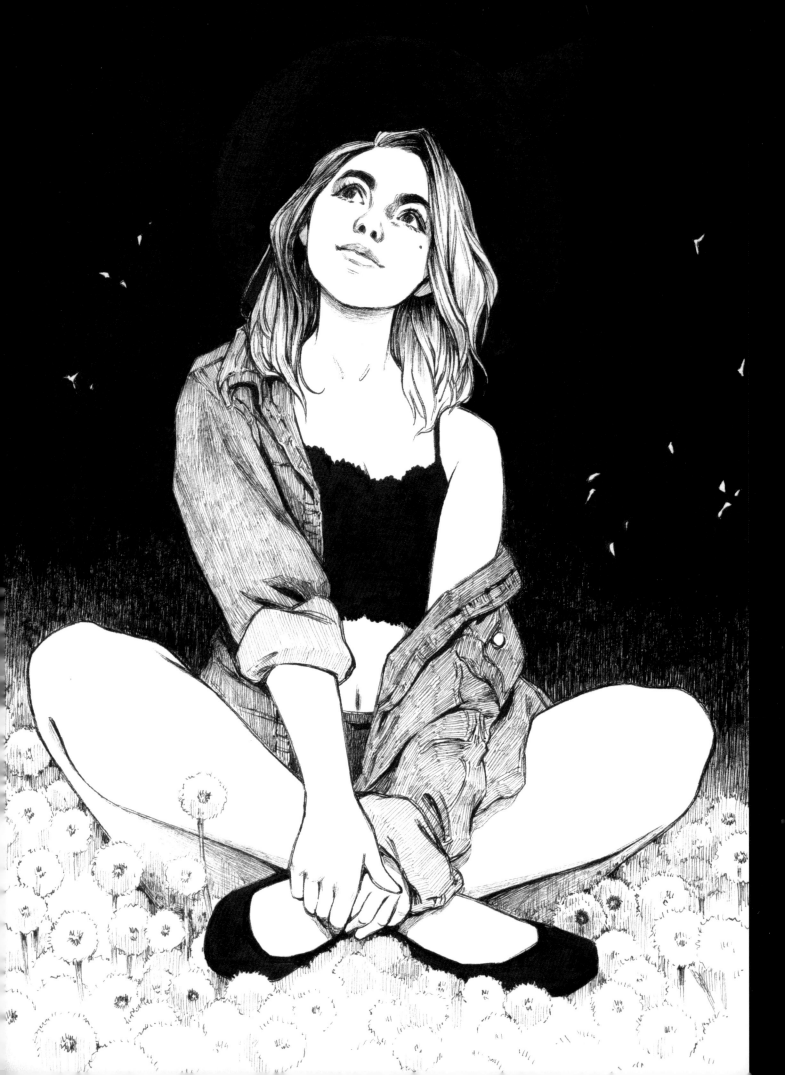

Chamomile Witch
(Right)

Foxglove Witch
(Below right)

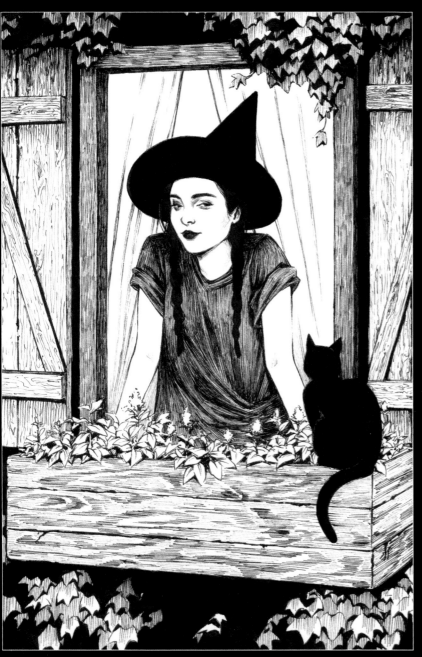

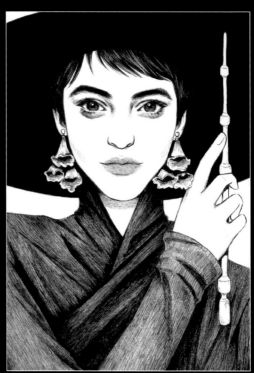

Catnip Witch
(Above)

Dandelion Witch
(Left)

Iris Witch (Below)

She is one of my favorite characters to emerge from the Botanical Witches series. Her design shows a great deal of personality and I would like to develop her a bit further one day.

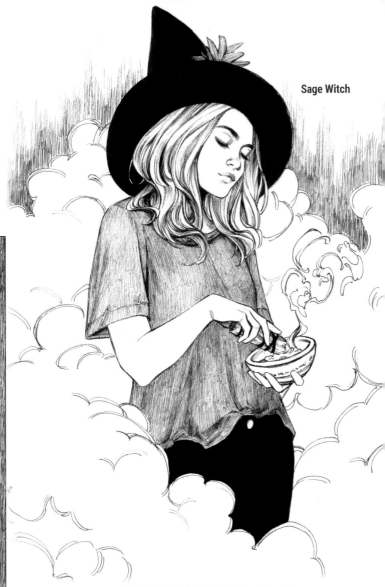

Sage Witch

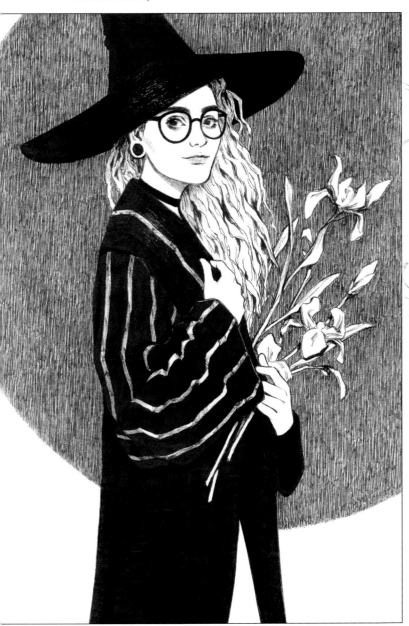

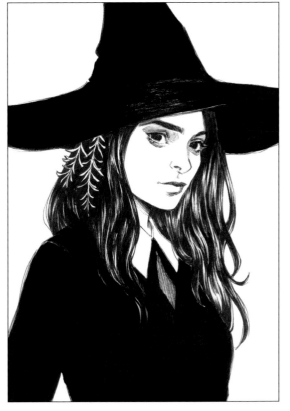

Rosemary Witch (Right)

This is a very simple concept, but to me, she looks like somebody named Rosemary, and that's enough.

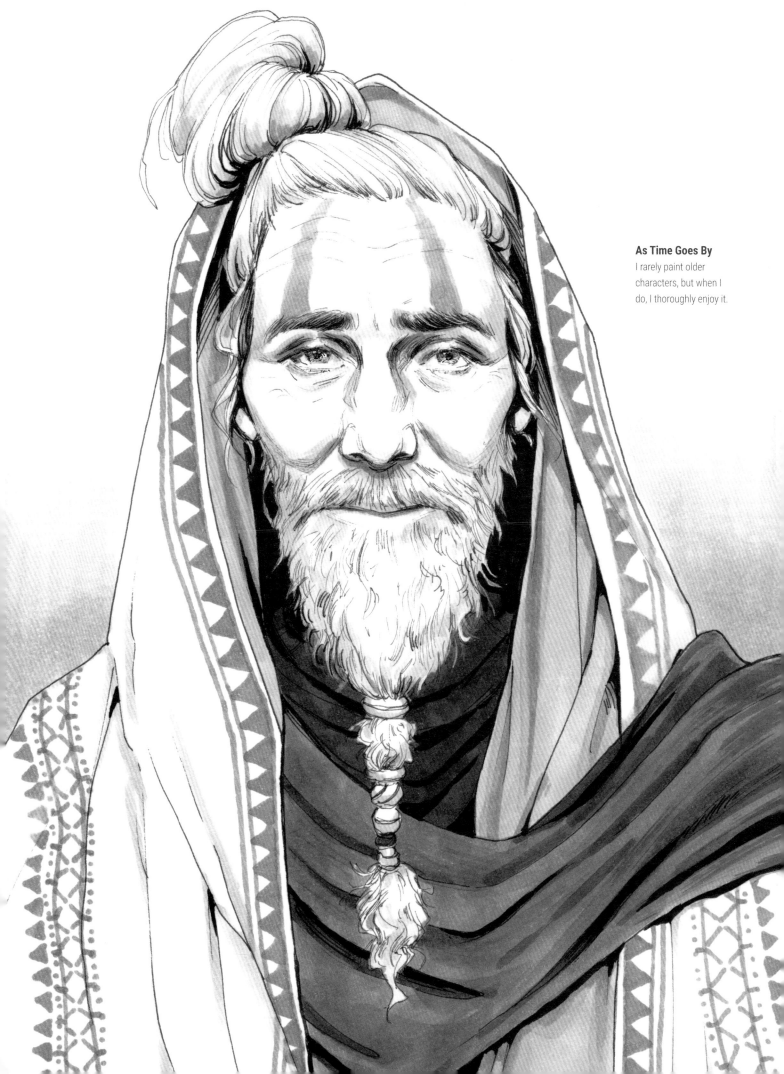

As Time Goes By
I rarely paint older
characters, but when I
do, I thoroughly enjoy it.

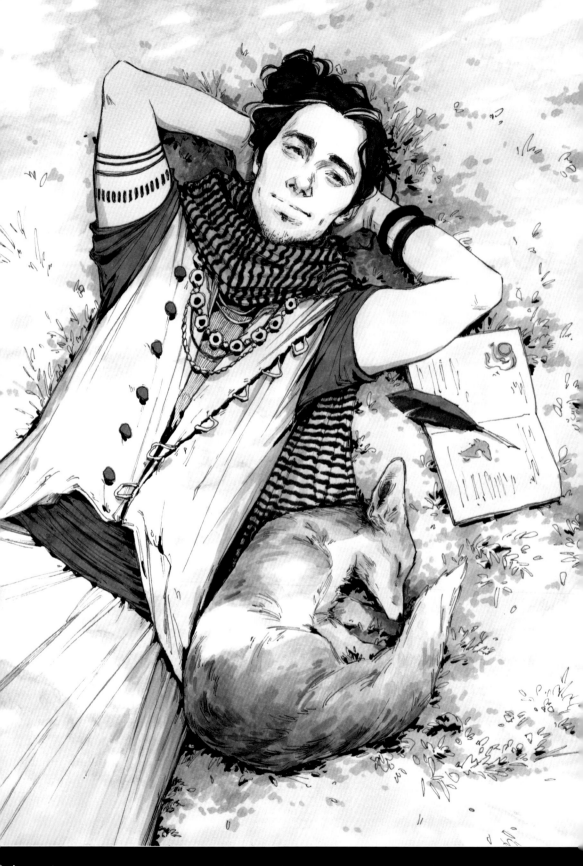

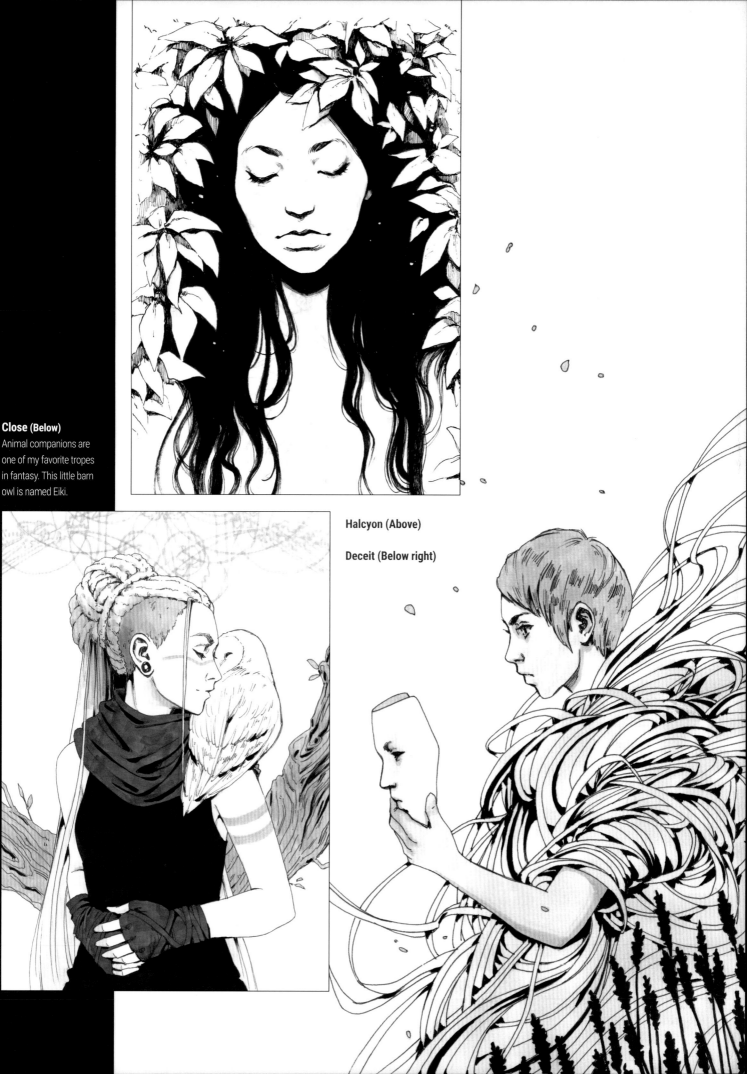

Close (Below)
Animal companions are one of my favorite tropes in fantasy. This little barn owl is named Eiki.

Halcyon (Above)

Deceit (Below right)

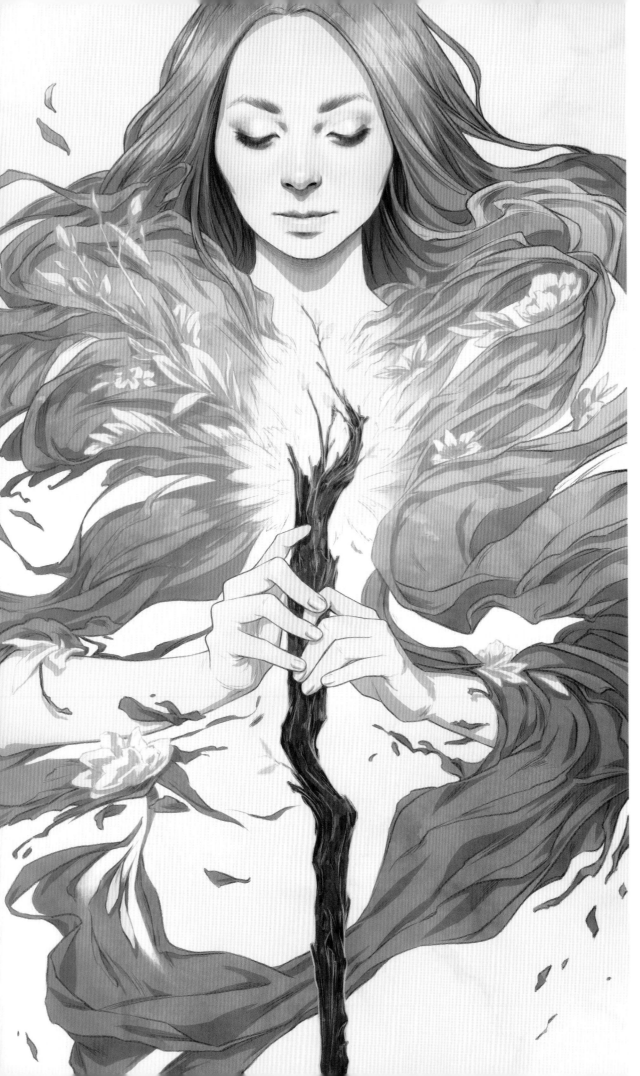

Ace of Wands

This is one of the oldest illustrations in this book, but also one of my best. It symbolizes growth and new opportunities and depicts what I picture the season of spring to look like, if it were a person.

symbolism and tarot

The discovery of subtle forms of visual communication is what led me to develop an interest in the tarot. Surprisingly, it's not the divination practice that fascinates me the most, but the way the cards represent aspects of the human experience in a way that can be universally understood and interpreted.

It might seem backward, but I believe the best way to approach the creation of relatable tarot illustrations is to make them more personal. To craft my tarot-inspired pieces, I tap into my own experiences and influences, rather than asking myself what people usually associate with a certain existing concept. For example, if I want to find a visual representation for creativity, I think back to the times in my life when I have felt creative and what I can remember from those experiences. Or, I revisit memories of the opposite, such as creativity-stifling roadblocks that have held me back.

By being genuine and true to yourself, you inevitably create artwork that speaks to people. Our individual stories may be different, and yet we share so much. We all know what it's like to feel afraid, frustrated, guilty, relieved, hopeful, and happy. I believe art that captures emotions, captivates people.

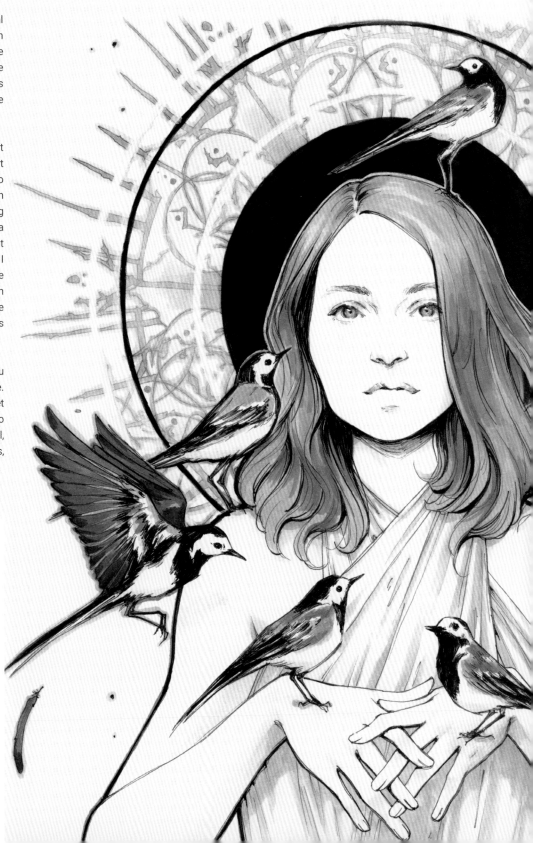

Fleeting
When I look at this piece, I am immediately drawn to the character's eyes. Somehow I managed to give her a haunting look, as if she is staring into the viewer's soul. The wagtail birds found their way into the piece from a nature guide. I was flipping through it and they stood out to me as particularly beautiful.

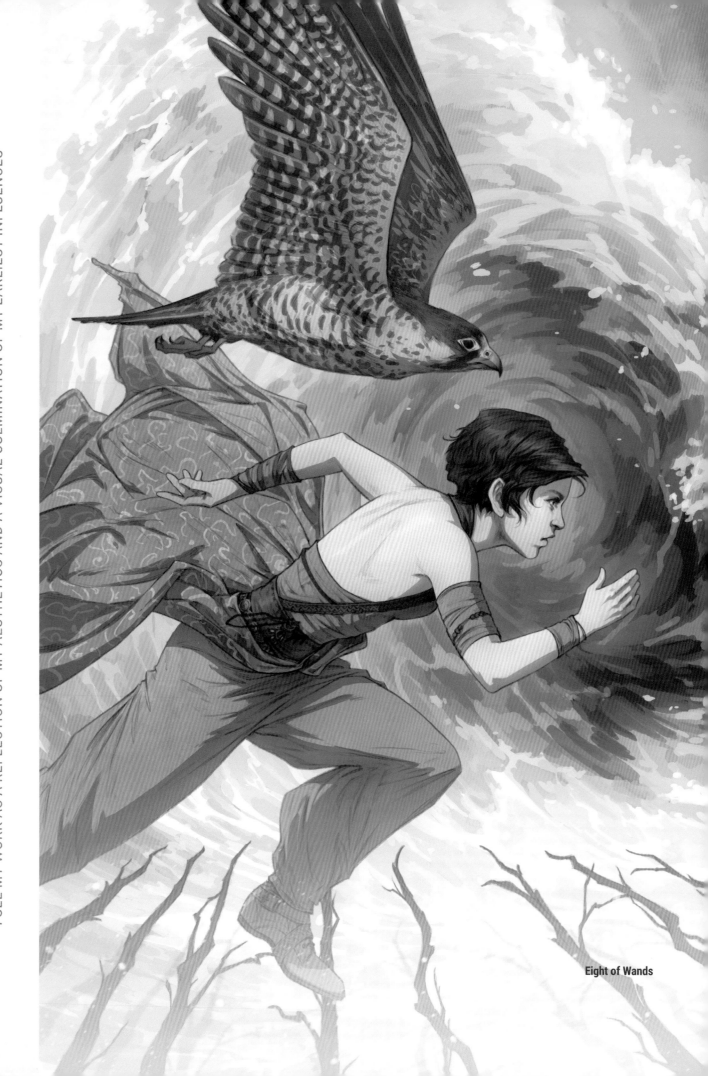

Eight of Wands

It is not necessary to pour every aspect of your personality into your work. I see my work as a reflection of my aesthetics and a visual culmination of my earliest influences, which are the aspects of my life that I'm most interested in painting. But there's also the part of me that laughs at inappropriate jokes and enjoys murder stories, a part that loves singing karaoke and riding roller-coasters, to the point where it's annoying. These are all aspects of me, but they simply didn't make their way out of my everyday life and into my art.

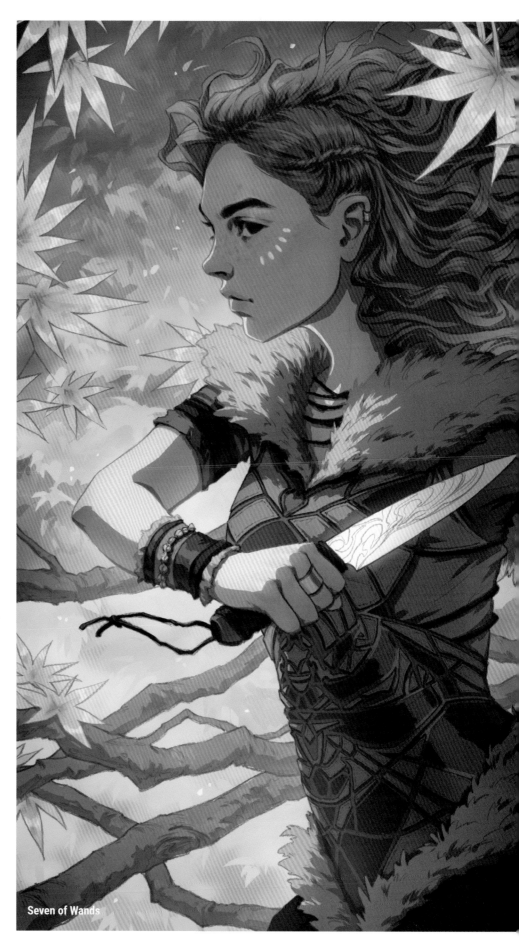

Seven of Wands

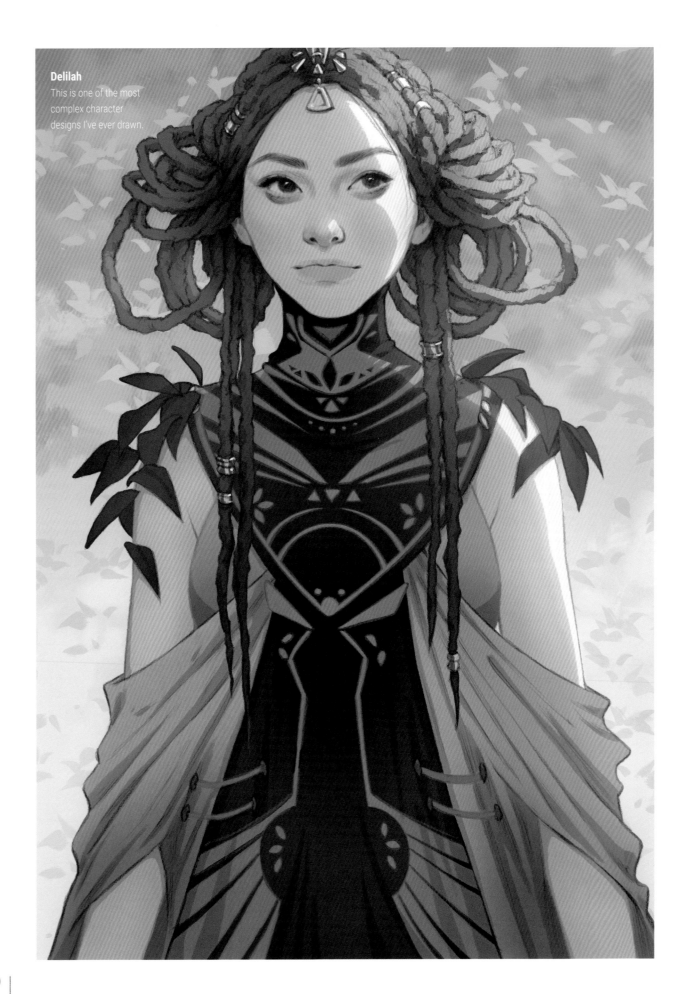

Delilah
This is one of the most complex character designs I've ever drawn.

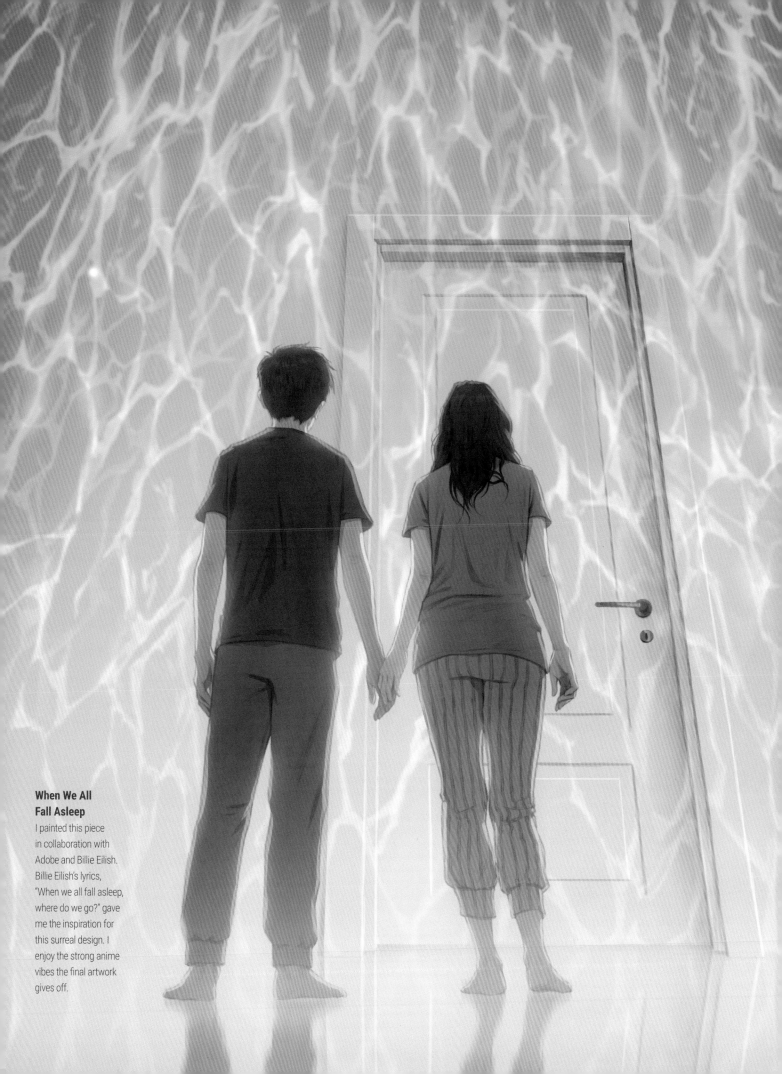

When We All Fall Asleep

I painted this piece in collaboration with Adobe and Billie Eilish. Billie Eilish's lyrics, "When we all fall asleep, where do we go?" gave me the inspiration for this surreal design. I enjoy the strong anime vibes the final artwork gives off.

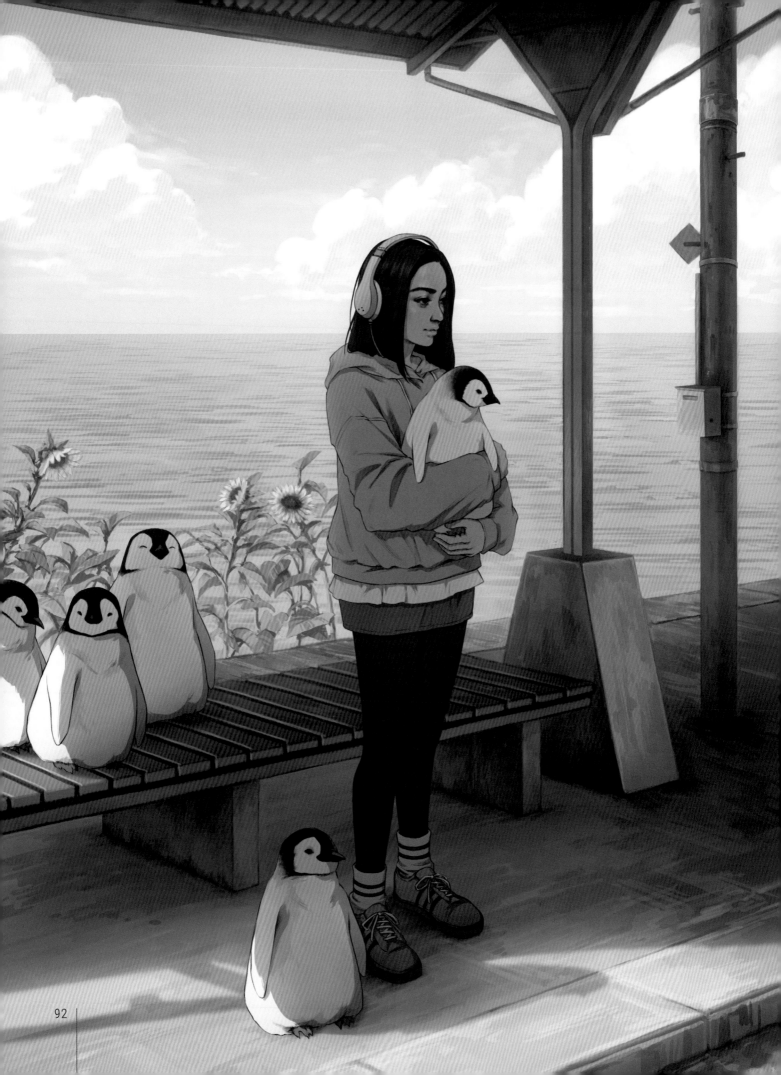

FIND YOURSELF

To make authentically personal art with intrinsic style, take time to get to know yourself and follow your instincts. Developing a style doesn't happen overnight, it is informed by your previous influences and taste. Spend time reminiscing and discovering memories, it might just help you build original art and new creative memories.

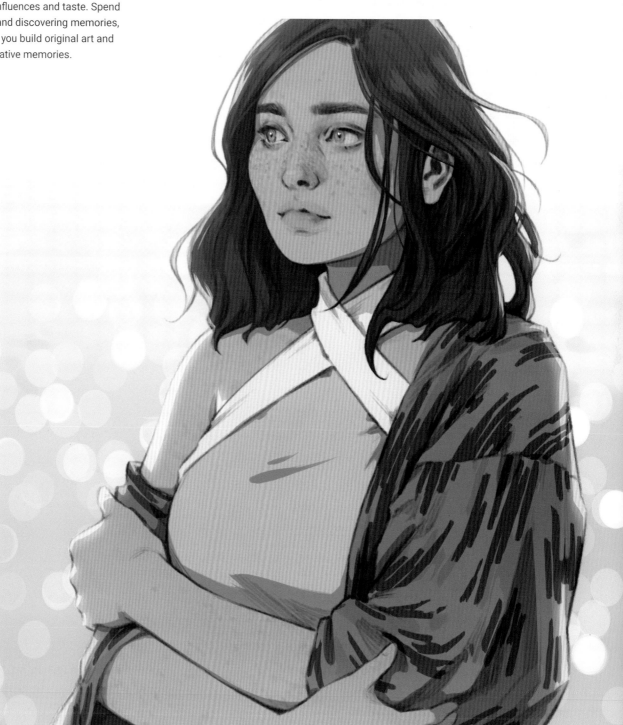

Sea Breeze (Below)
It has become rare for me to paint a single character without a complex background, but for this piece, that's all I wanted.

**Commute
(Opposite page)**
While browsing photos of the sea, I stumbled across a beautiful Japanese train station that is located by the water's edge. Next, I devised the concept that penguins could be waiting for a train, with a girl as their chaperone. Although the design appears to make no logical sense, it still tells a clear and intriguing story.

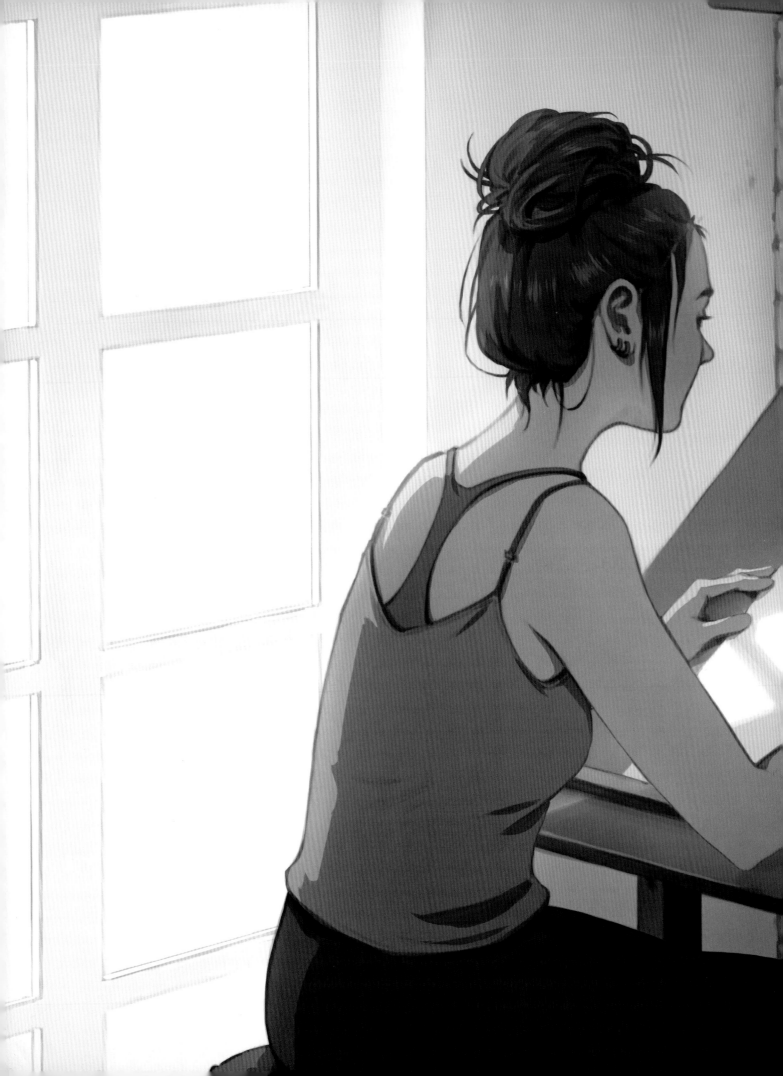

THE WORKSHOP

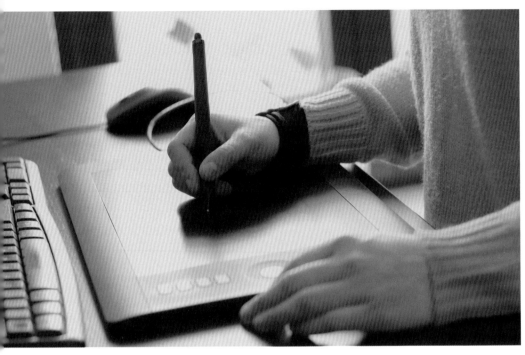

workspace

I cannot work in silence, so my first order of business is always to put on a bit of background noise to keep my thoughts from wandering. Generally, television shows and podcasts are my go-to for long stretches of painting. But for something that demands my full attention, such as writing or sketching, I prefer ambient noises and soft instrumental music. As I write this, I'm listening to crackling fire, the pitter-patter of rain, and book pages being turned while I pretend to be in the Hogwarts library. In reality, I'm standing at my desk. I have owned this desk for a few years now and it has been a lifesafer in fighting my back pain. One year into freelancing, my back had become so painful that I wasn't able to sit for even a minute, but now I am able to switch from sitting to standing multiple times a day, which also reminds me to take breaks and walk around every once in a while.

My setup is simple. I work on a custom-built desktop computer with two monitors. The screen on the right is for painting, while the screen on the left is used for displaying reference material and watching television shows. My weapons of choice when it comes to digital art are Photoshop CS6 and my trusty Wacom Intuos Pro drawing tablet. There's usually nothing on my desk besides the tablet and stylus, keyboard, and a small lamp. I make sure to clear the surfaces before I start my work every morning; if there's clutter around, I find it hard to focus.

I like to surround myself with very few, carefully chosen things. To adorn my workspace, plants are my favorite, especially the pothos vine that I attached to the wall above my desk. I hope one day it will grow all the way around the room. Plants make me happy, and even if the world outside my window is looking bleak during winter, they keep my workspace filled with life.

I LIKE TO SURROUND MYSELF WITH VERY FEW,
CAREFULLY CHOSEN THINGS

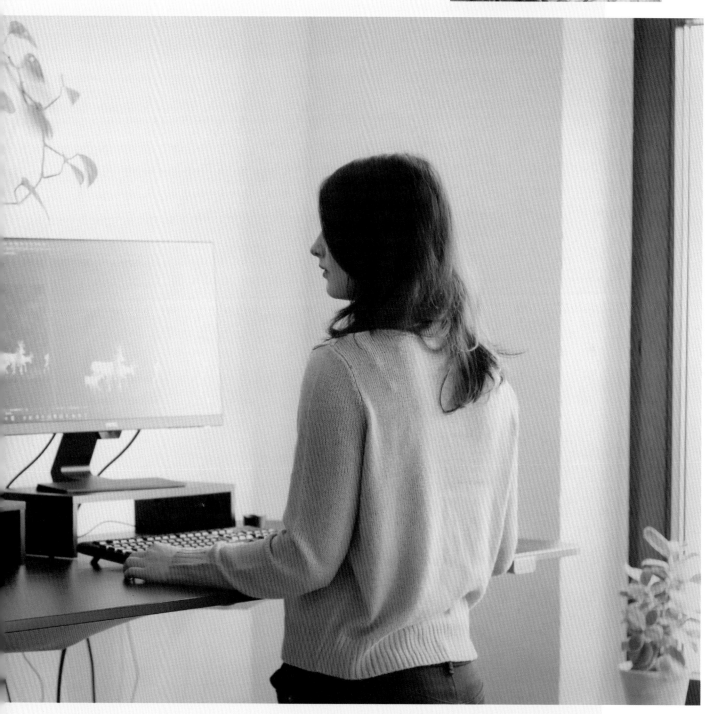

- very long neck
- small, round ribcage
- big sternum
- z-part-wing

3 front
1 back

outer toe
is short

wish bone

Pelvis

→ gap
between pelvis
and ribcage

sternum
HUGE!

primary

secondary

98

the workday

The idea of being an artist might sound glamorous, but in reality, it means spending ninety percent of my time at a desk, painting and hoping that the emails that are piling up will magically answer themselves!

I'm a creature of habit, so my work days follow the same pattern from Monday to Friday. I'm not an early bird, but not a night owl either, so I usually crawl out of bed at around 8:00 am. My favorite thing about working from home is that I don't have to rush myself, and I can do everything in my own time. I love sitting down with a cup of black tea first thing in the morning, watching some videos and slowly waking up until I'm ready to start the day.

Once at my desk, I check my to-do list. I use an organizational app that I have installed on all my devices, so that I can easily feed it information as soon as something new comes up. I usually prepare my daily to-do lists in advance, so that I can get to work right away. The more I can add to the list and get out of my mind, the more energy and focus I have for the task at hand. I usually work from 10:00 am until 6:00 pm, with a couple of breaks in between. I try to paint every day, but make sure I don't work for longer than four hours, because that's how long I can stay focused for. The rest of the day I usually spend answering emails, managing my social media accounts and

my online store, preparing for conventions, and checking off other miscellaneous administrative items on my list.

I have developed a habit of tracking my work hours. The organizational app that I use creates all kinds of charts and graphs that tell me how I spend my time every day. For example, I reportedly worked 1,430 hours in 2019, with an average of 119 hours per month and 5 ½ hours per day, excluding weekends. To get a more detailed breakdown, I set up different projects such as "illustration" or "writing," so that I can assess whether my efforts align with my priorities. I'm happy to report that last year, I actually dedicated most of my time to painting!

Tracking my work hours has made it easier for me to estimate how long certain tasks usually take me. And, most importantly, the tracker creates a clear separation between work and free time. Once I hit pause, I put down my pen and take a break, rather than continuing with the task. I might be working fewer hours than a few years ago, but I'm more productive! And as I don't force myself to paint all day and into the night, I'm usually well-rested, and the hours I spend working are more focused and efficient. I have learned to delegate, to let go of projects that I'm not passionate about, and to better take care of my physical and mental health.

Page of Wands
This piece is inspired by the tarot card that stands for creativity, enthusiasm and confidence. I decided to show an artist at work, because that's what I associate with those concepts.

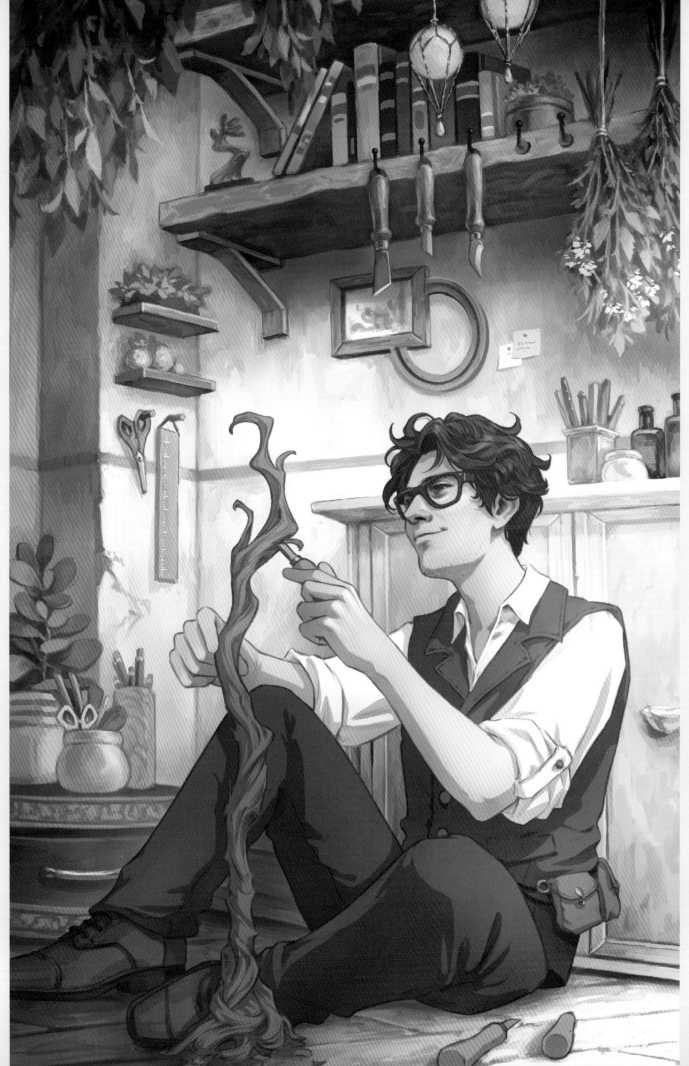

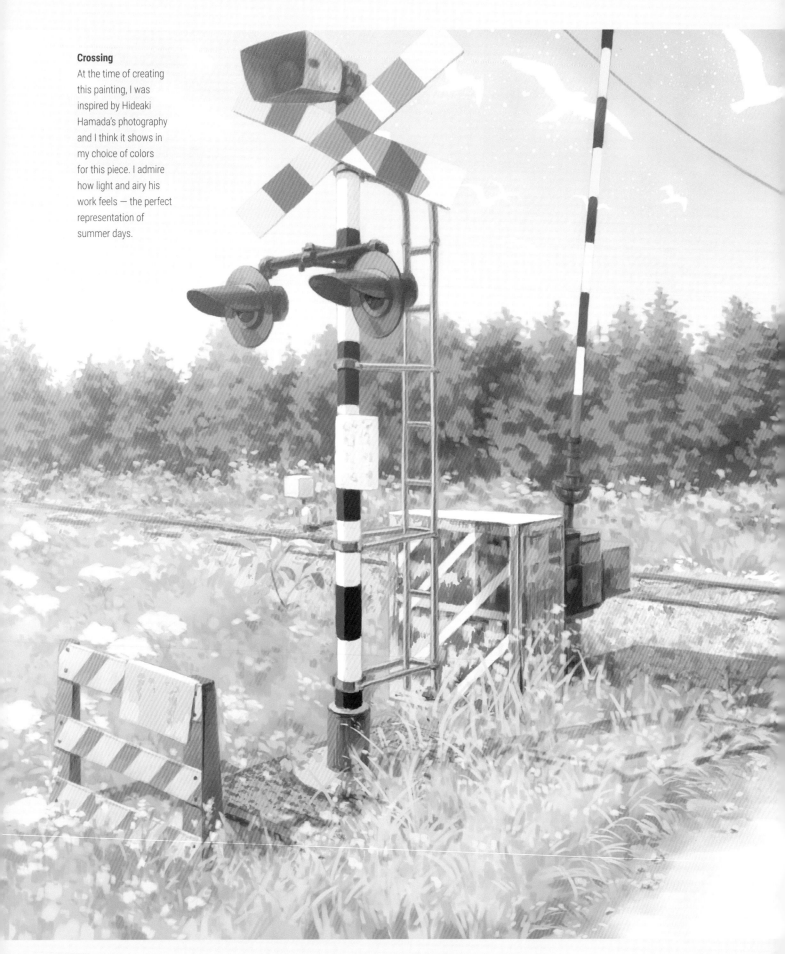

Crossing
At the time of creating this painting, I was inspired by Hideaki Hamada's photography and I think it shows in my choice of colors for this piece. I admire how light and airy his work feels — the perfect representation of summer days.

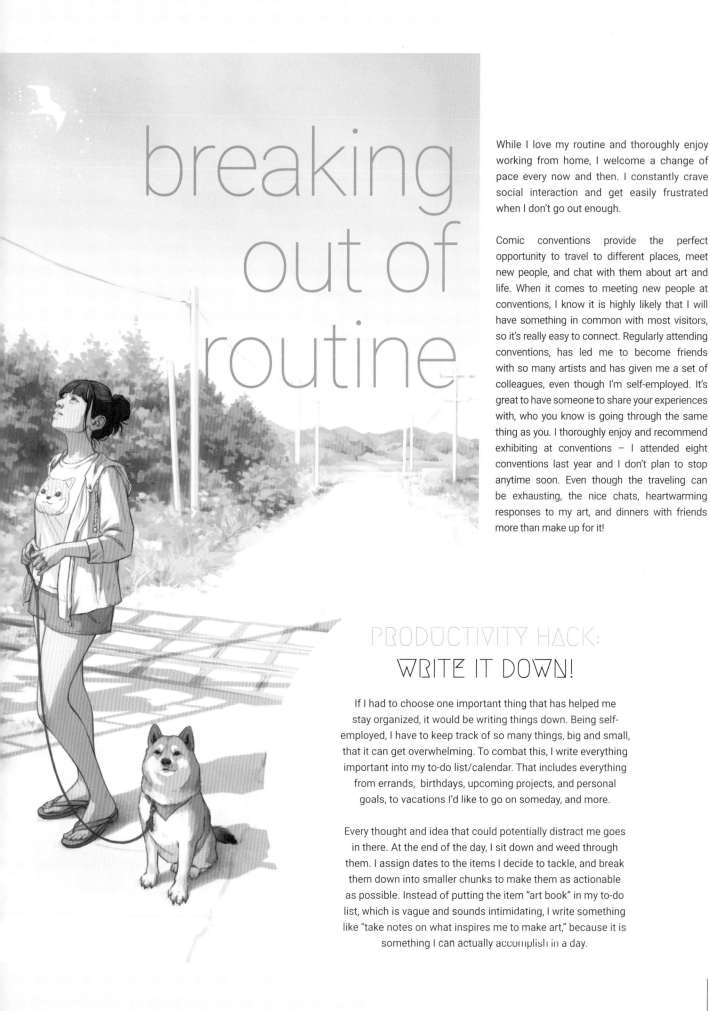

breaking out of routine

While I love my routine and thoroughly enjoy working from home, I welcome a change of pace every now and then. I constantly crave social interaction and get easily frustrated when I don't go out enough.

Comic conventions provide the perfect opportunity to travel to different places, meet new people, and chat with them about art and life. When it comes to meeting new people at conventions, I know it is highly likely that I will have something in common with most visitors, so it's really easy to connect. Regularly attending conventions, has led me to become friends with so many artists and has given me a set of colleagues, even though I'm self-employed. It's great to have someone to share your experiences with, who you know is going through the same thing as you. I thoroughly enjoy and recommend exhibiting at conventions – I attended eight conventions last year and I don't plan to stop anytime soon. Even though the traveling can be exhausting, the nice chats, heartwarming responses to my art, and dinners with friends more than make up for it!

PRODUCTIVITY HACK: WRITE IT DOWN!

If I had to choose one important thing that has helped me stay organized, it would be writing things down. Being self-employed, I have to keep track of so many things, big and small, that it can get overwhelming. To combat this, I write everything important into my to-do list/calendar. That includes everything from errands, birthdays, upcoming projects, and personal goals, to vacations I'd like to go on someday, and more.

Every thought and idea that could potentially distract me goes in there. At the end of the day, I sit down and weed through them. I assign dates to the items I decide to tackle, and break them down into smaller chunks to make them as actionable as possible. Instead of putting the item "art book" in my to-do list, which is vague and sounds intimidating, I write something like "take notes on what inspires me to make art," because it is something I can actually accomplish in a day.

crafting the cover
komorebi

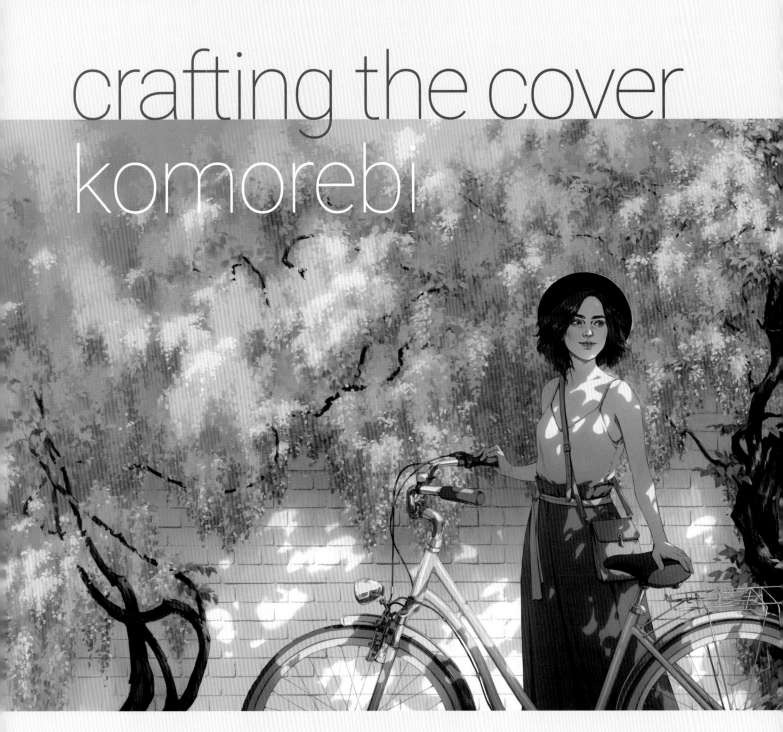

In this tutorial, I outline the creative processes involved in developing the cover illustration for this book – from the very first idea to the final image. I use the same process for every artwork I make, so this tutorial should offer an accurate overview of my approach to starting a new piece, as well as an insight into my favorite techniques. As with most of my full-color illustrations, this piece was created digitally in Photoshop from start to finish.

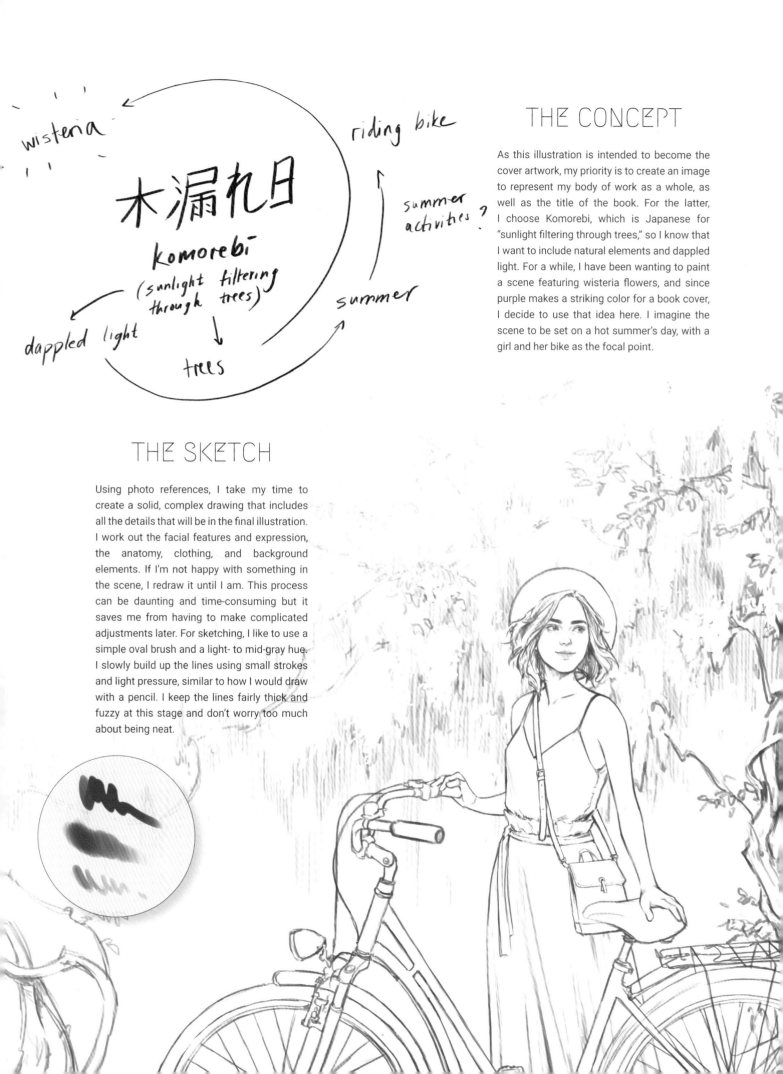

wisteria

riding bike

木漏れ日

komorebi

(sunlight filtering through trees)

summer activities ?

dappled light

trees

summer

THE CONCEPT

As this illustration is intended to become the cover artwork, my priority is to create an image to represent my body of work as a whole, as well as the title of the book. For the latter, I choose Komorebi, which is Japanese for "sunlight filtering through trees," so I know that I want to include natural elements and dappled light. For a while, I have been wanting to paint a scene featuring wisteria flowers, and since purple makes a striking color for a book cover, I decide to use that idea here. I imagine the scene to be set on a hot summer's day, with a girl and her bike as the focal point.

THE SKETCH

Using photo references, I take my time to create a solid, complex drawing that includes all the details that will be in the final illustration. I work out the facial features and expression, the anatomy, clothing, and background elements. If I'm not happy with something in the scene, I redraw it until I am. This process can be daunting and time-consuming but it saves me from having to make complicated adjustments later. For sketching, I like to use a simple oval brush and a light- to mid-gray hue. I slowly build up the lines using small strokes and light pressure, similar to how I would draw with a pencil. I keep the lines fairly thick and fuzzy at this stage and don't worry too much about being neat.

LINE ART

Before I move on to color, I clean up the drawing of the character and her bike using a small pencil brush. I decrease the opacity of the sketch layer, create a new layer on top, and trace the drawing. This time, I am extra careful to create clean lines because they will remain part of the final artwork. I leave the background as it is because I will be painting over the messy sketch later. The characters in my scenes are usually "flat," whereas the background is more painterly and realistic – similar to the drawing style seen in anime. I really like this juxtaposition, because it naturally makes the character and line art the focal point.

BASE COLOR

Instead of leaving the line art black or gray, I color it to give a subtle richness and life to a design. Due to the inclusion of the wisteria flowers, the predominant color in this scene is purple, so I color the linework a shade of purple to match. I repeat this process for the character's line art, but shift the hue toward the pink end of the spectrum. The slight warmth of the pink hue complements her skin tone. I set both layers to Multiply, a blending mode that allows layers of colors to blend and mix together (see Blending Modes on page 110.) Dark hues on the Multiply layer are intensified, while white areas have no effect and become transparent. This mode is valuable for creating transparent line art that you can color beneath.

My next step is to fill the whole background with a light lavender tone to create a base. I then fill in each foreground element. Every element is given its own layer: the skin, hair, hat, shirt, bag, and skirt, as well as different parts of the bike. I opt for muted, pastel tones that won't detract from the purple palette and choose black for the girl's hat to make it a clear focal point.

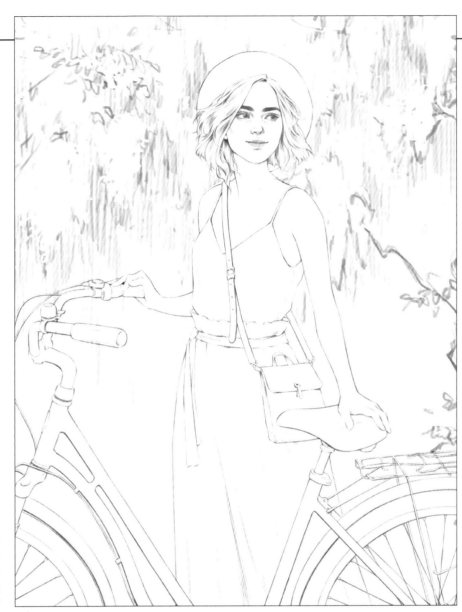

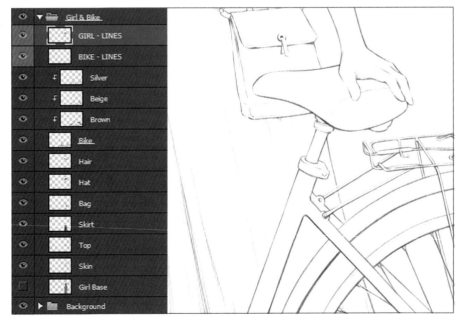

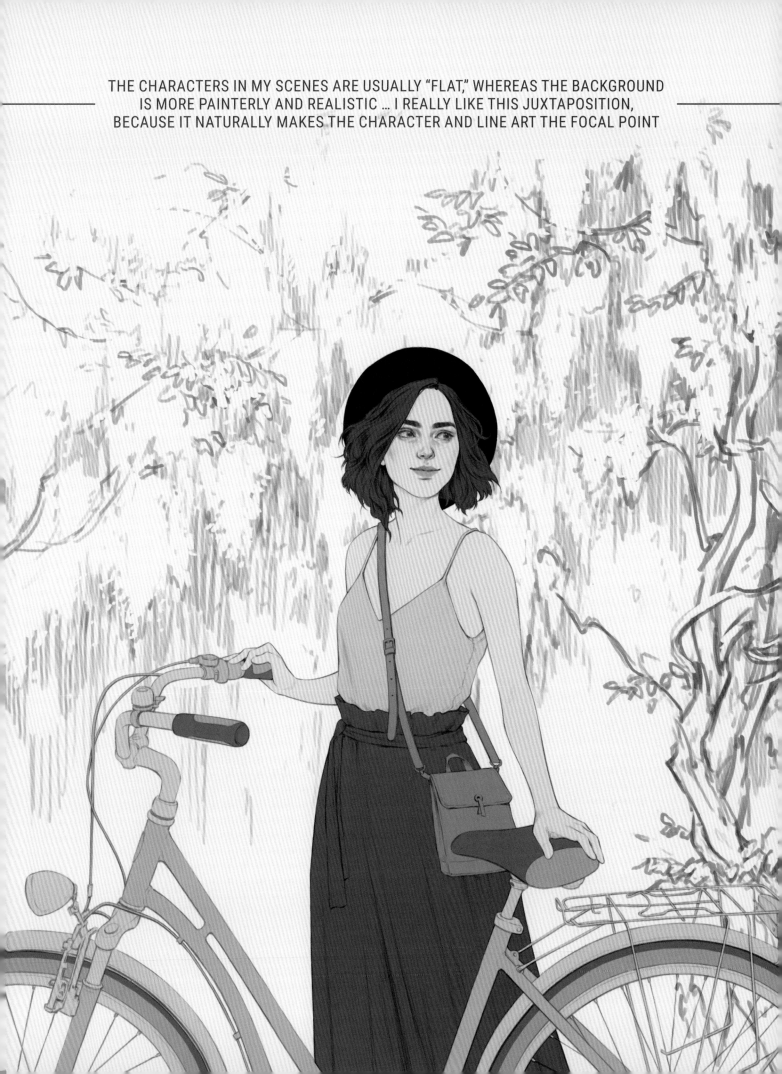

THE CHARACTERS IN MY SCENES ARE USUALLY "FLAT," WHEREAS THE BACKGROUND
IS MORE PAINTERLY AND REALISTIC … I REALLY LIKE THIS JUXTAPOSITION,
BECAUSE IT NATURALLY MAKES THE CHARACTER AND LINE ART THE FOCAL POINT

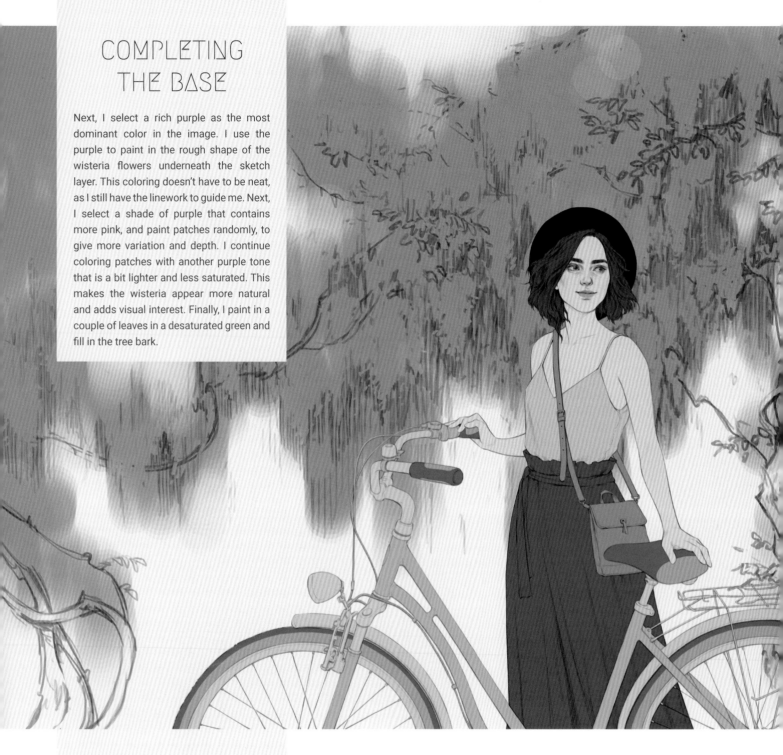

COMPLETING THE BASE

Next, I select a rich purple as the most dominant color in the image. I use the purple to paint in the rough shape of the wisteria flowers underneath the sketch layer. This coloring doesn't have to be neat, as I still have the linework to guide me. Next, I select a shade of purple that contains more pink, and paint patches randomly, to give more variation and depth. I continue coloring patches with another purple tone that is a bit lighter and less saturated. This makes the wisteria appear more natural and adds visual interest. Finally, I paint in a couple of leaves in a desaturated green and fill in the tree bark.

THE RENDERING PROCESS

Now that the basic color scheme is established, I start painting over the sketch layer to render the background. For now, I focus on the environment. The most important tool during the rendering process is the Eyedropper, which can be used to select existing colors from the painting. The easiest way to activate it is by hitting the Alt key while the Brush tool is selected. I have the shortcut set to one of the buttons on my tablet pen, which means I can paint and sample colors without having to reach for the keyboard. I repeat the same action over and over again: I select a color from the canvas, using the Eyedropper; paint a few strokes with it; select a new color; paint with it; and so on. This is the process I use to mix colors and define shapes. I slowly work my way from big to small details to give the painterly render more definition.

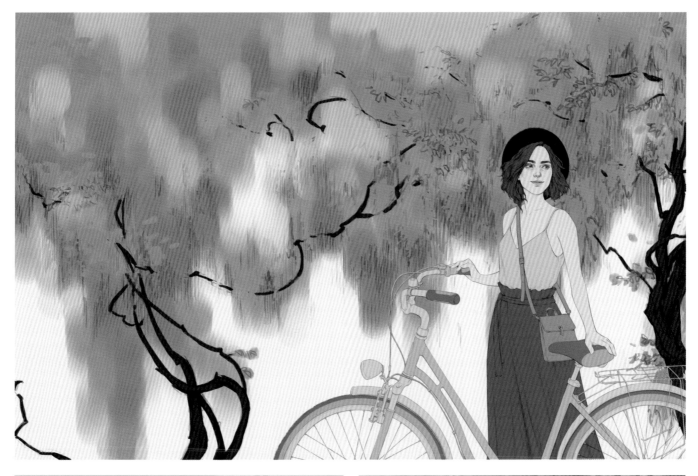

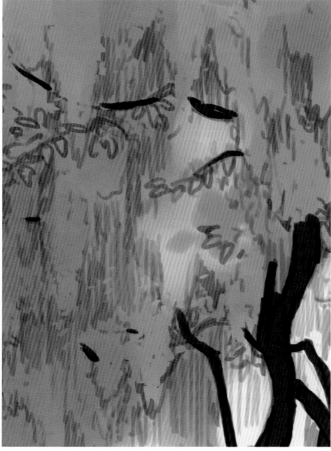

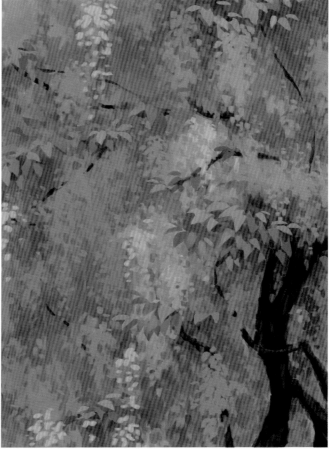

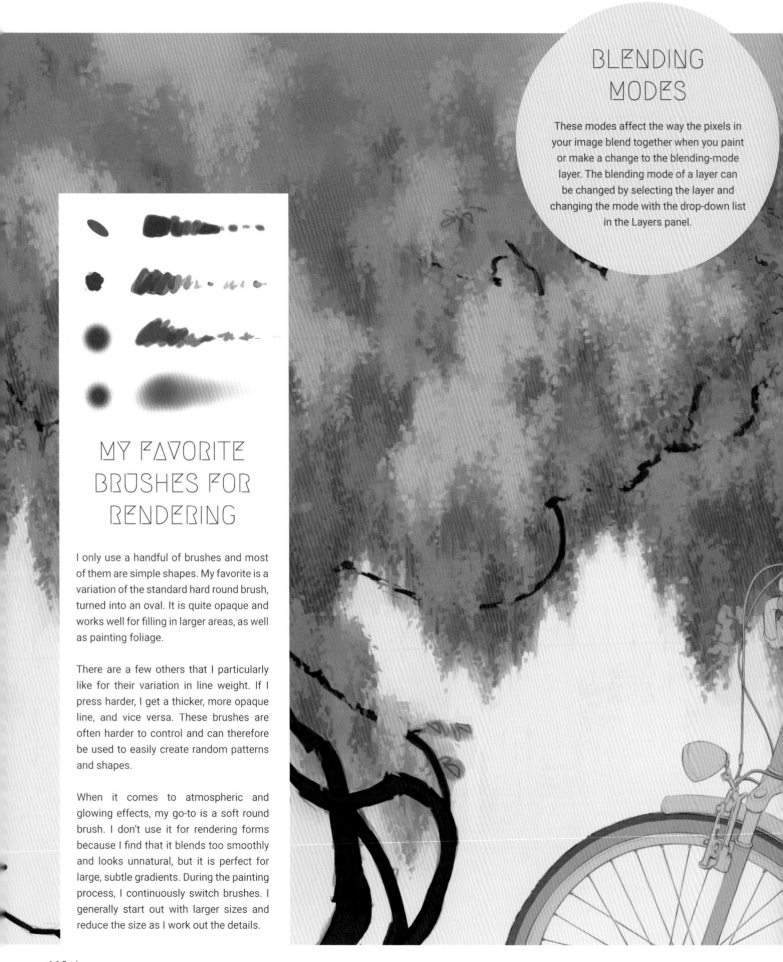

BLENDING MODES

These modes affect the way the pixels in your image blend together when you paint or make a change to the blending-mode layer. The blending mode of a layer can be changed by selecting the layer and changing the mode with the drop-down list in the Layers panel.

MY FAVORITE BRUSHES FOR RENDERING

I only use a handful of brushes and most of them are simple shapes. My favorite is a variation of the standard hard round brush, turned into an oval. It is quite opaque and works well for filling in larger areas, as well as painting foliage.

There are a few others that I particularly like for their variation in line weight. If I press harder, I get a thicker, more opaque line, and vice versa. These brushes are often harder to control and can therefore be used to easily create random patterns and shapes.

When it comes to atmospheric and glowing effects, my go-to is a soft round brush. I don't use it for rendering forms because I find that it blends too smoothly and looks unnatural, but it is perfect for large, subtle gradients. During the painting process, I continuously switch brushes. I generally start out with larger sizes and reduce the size as I work out the details.

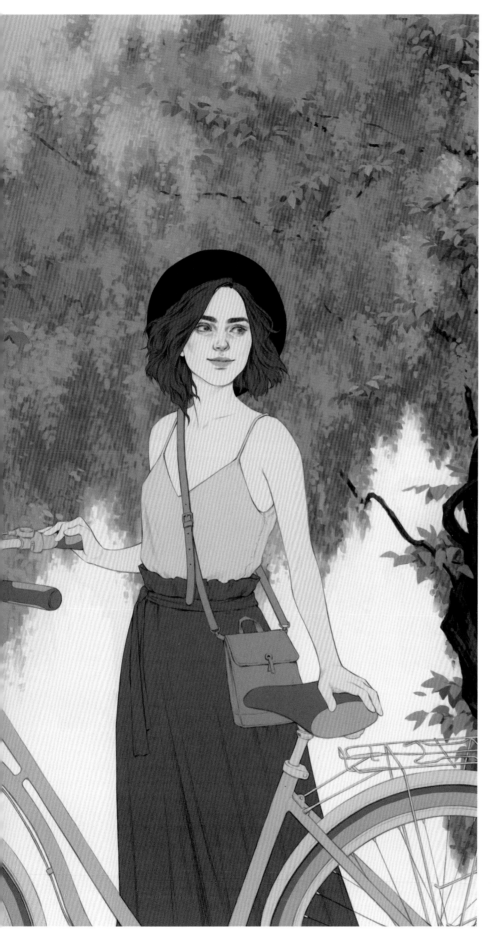

ADDING TEXTURES

I often paint backgrounds in more detail because I love painting textures. It adds a level of realism to the piece that I can't achieve with flat colors. Most of the textures I use are created naturally as a by-product of the painting process. I simply apply tiny brushstrokes and try to mimic the appearance of certain textures, such as the fuzziness of the small individual petals of the wisteria flowers or the smoothness of the leaves in between. Occasionally, I import a texture to speed the process up. For the brick wall, I use a royalty free image, set the layer to the Darker Color blending mode, and apply it to the background. This action compares the base and blend colors that make up the image, and it keeps the darkest of the two, resulting in a darker hue for the pattern. I then erase the parts of the image that I want to remain unaffected.

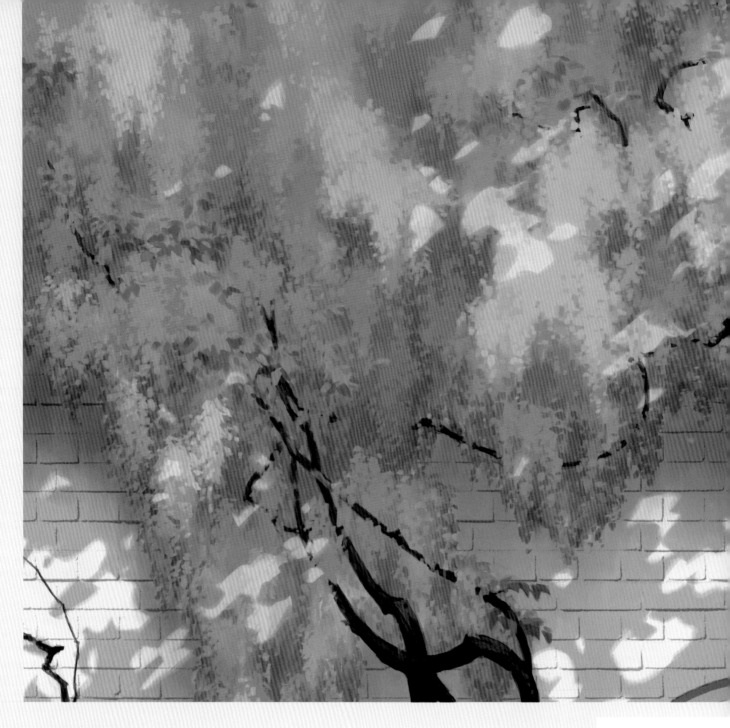

INTRODUCING LIGHT
AND SHADOW

Up to this point, I have been treating the elements in the scene as if they were lit from above by a big, diffused light source. The forms look three-dimensional, but there is no dramatic lighting to speak of. So, now is the time to add direct sunlight and introduce a clear separation between light and shadow. I fill the background with a light bluish hue, set it to Multiply, and then erase out parts that will become spots of sunlight. This works very well on the wall, but as the flowers are already quite dark, I paint in lighter spots on a layer set to a blending mode of Soft Light, which gives the painted areas a subtly lightened finish.

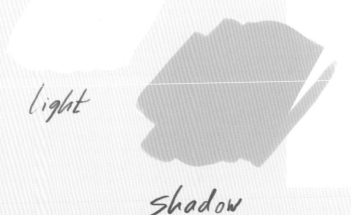

light

shadow

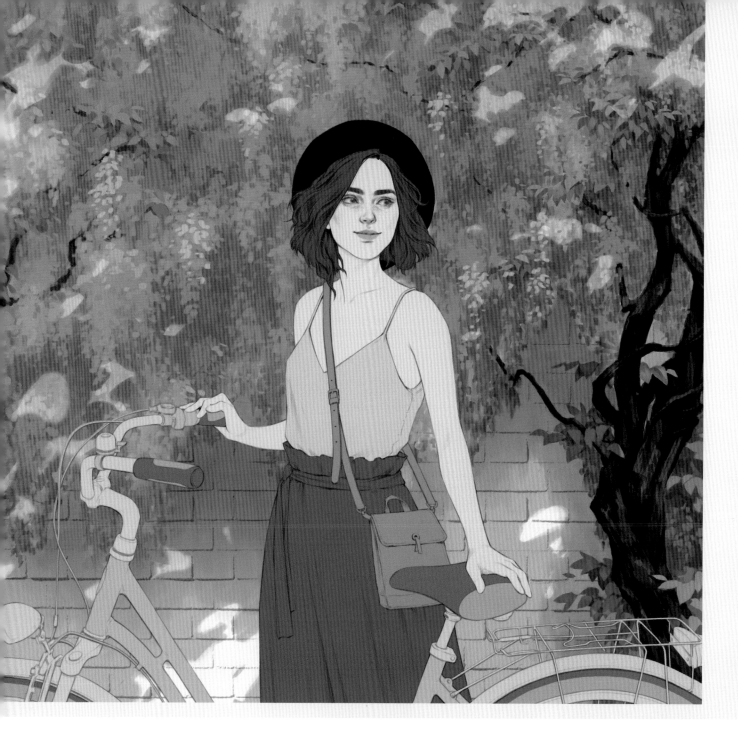

MΛGIC GLOW

This is one of my favorite little tricks to bring the image to life. I select the soft round brush and pick a light orange or peachy color. Then I create a new layer, set it to Overlay, a layer blending mode. Overlay will darken midtone values, while a light Overlay will brighten midtone values. The bright highlights and dark shadows on the layers beneath remain intact, creating a visually punchy finish.

I then paint along the edges, where light and shadow meet, because this area is usually more saturated. This allows me to introduce more color to the light and make it appear warmer.

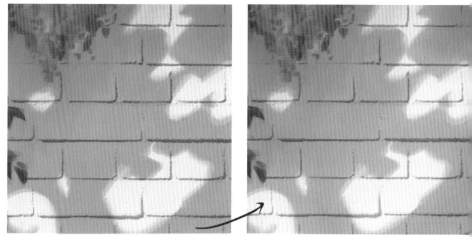

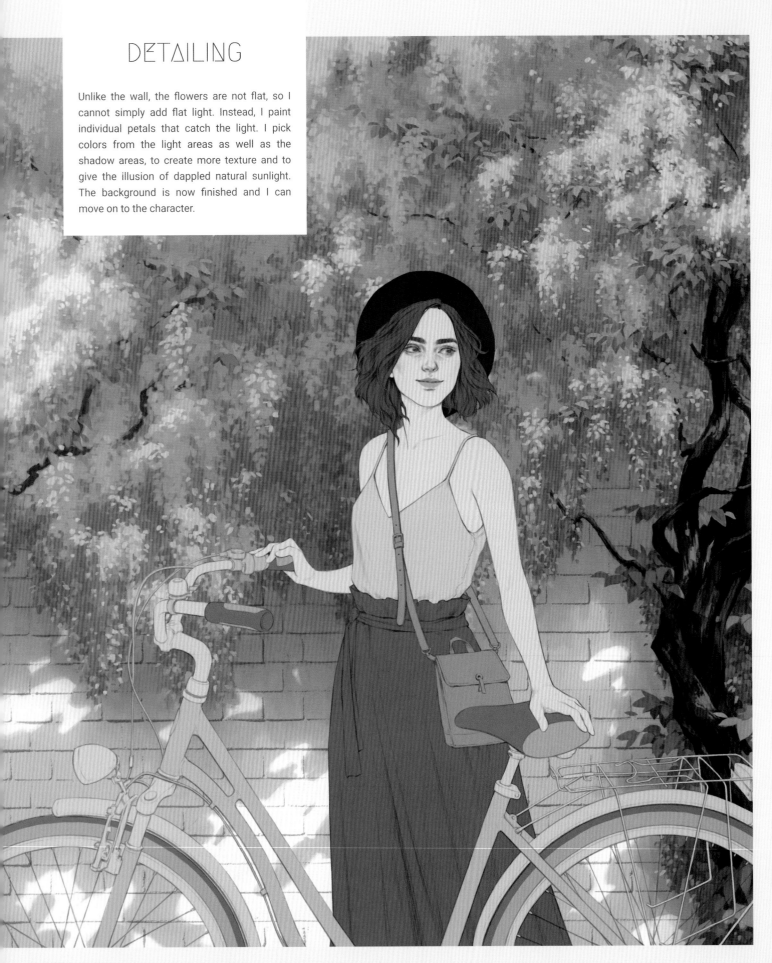

DETAILING

Unlike the wall, the flowers are not flat, so I cannot simply add flat light. Instead, I paint individual petals that catch the light. I pick colors from the light areas as well as the shadow areas, to create more texture and to give the illusion of dappled natural sunlight. The background is now finished and I can move on to the character.

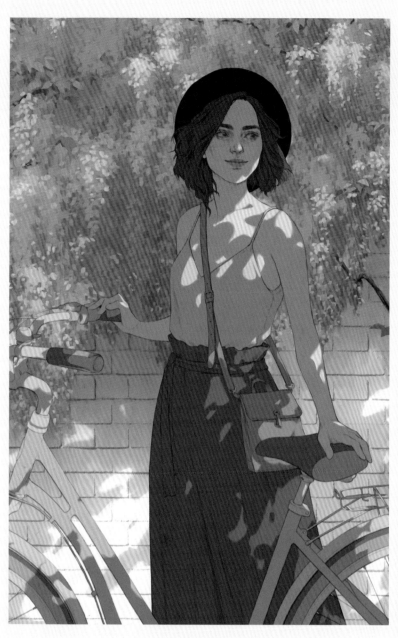

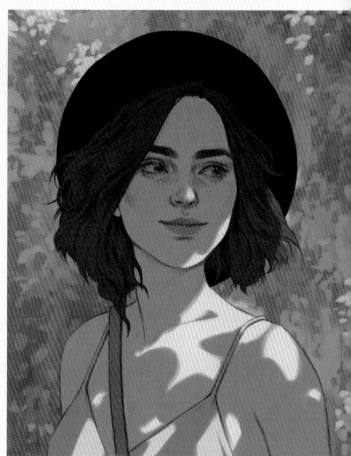

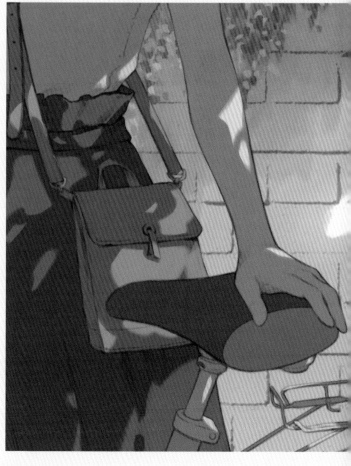

SHADING THE CHARACTER

Once the background is complete, I work on the character to ground them into the scene. Whereas the shading on the background is soft and textural, I prefer to use harder lines and shadows on characters to add realism and focus. However, I employ the same techniques to paint the characters as I use for the background development. On a new layer, I fill in the silhouette of the girl and the bike with another shade of purple and set the mode to Multiply. I create a mask over the character and use a hard-edged brush to erase out some patches of sunlight. I think abstractly here, with the goal to create an interesting shape design of varying sizes and contours, while remembering that the light source is located somewhere in the top right of the image.

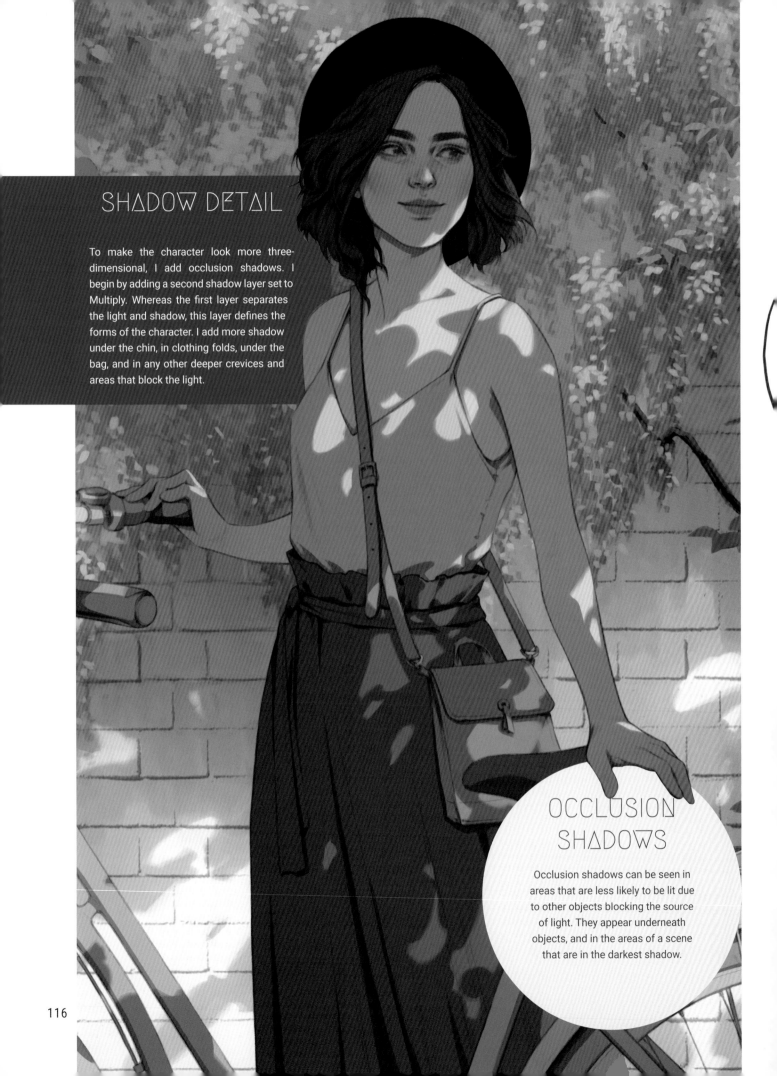

SHADOW DETAIL

To make the character look more three-dimensional, I add occlusion shadows. I begin by adding a second shadow layer set to Multiply. Whereas the first layer separates the light and shadow, this layer defines the forms of the character. I add more shadow under the chin, in clothing folds, under the bag, and in any other deeper crevices and areas that block the light.

OCCLUSION SHADOWS

Occlusion shadows can be seen in areas that are less likely to be lit due to other objects blocking the source of light. They appear underneath objects, and in the areas of a scene that are in the darkest shadow.

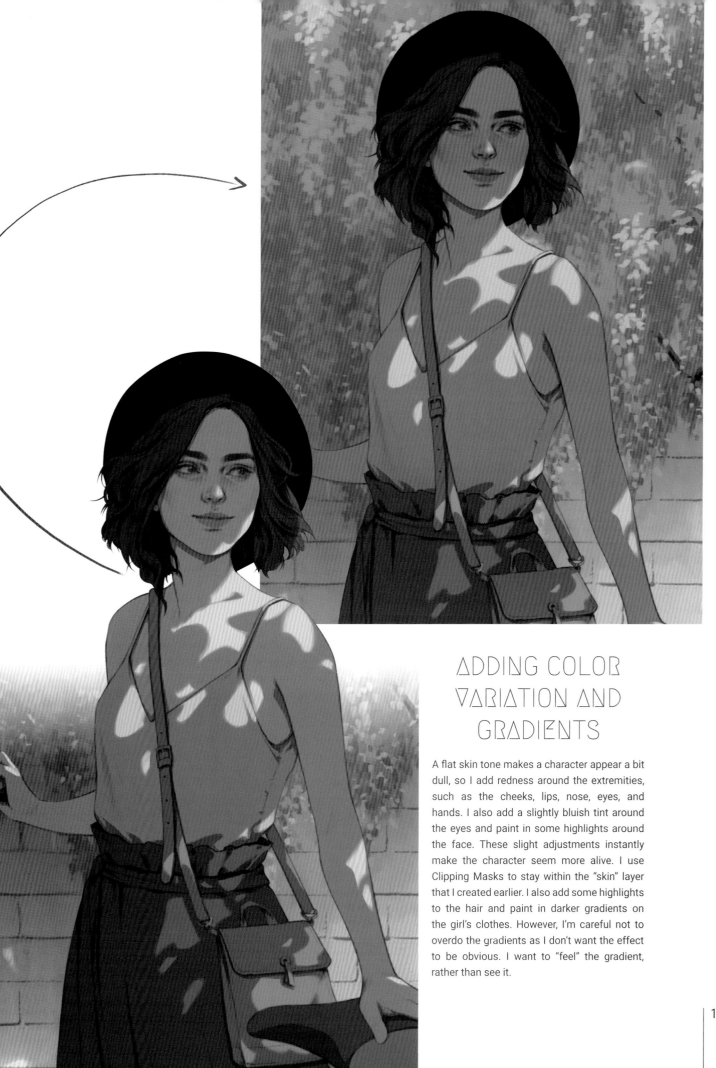

ADDING COLOR VARIATION AND GRADIENTS

A flat skin tone makes a character appear a bit dull, so I add redness around the extremities, such as the cheeks, lips, nose, eyes, and hands. I also add a slightly bluish tint around the eyes and paint in some highlights around the face. These slight adjustments instantly make the character seem more alive. I use Clipping Masks to stay within the "skin" layer that I created earlier. I also add some highlights to the hair and paint in darker gradients on the girl's clothes. However, I'm careful not to overdo the gradients as I don't want the effect to be obvious. I want to "feel" the gradient, rather than see it.

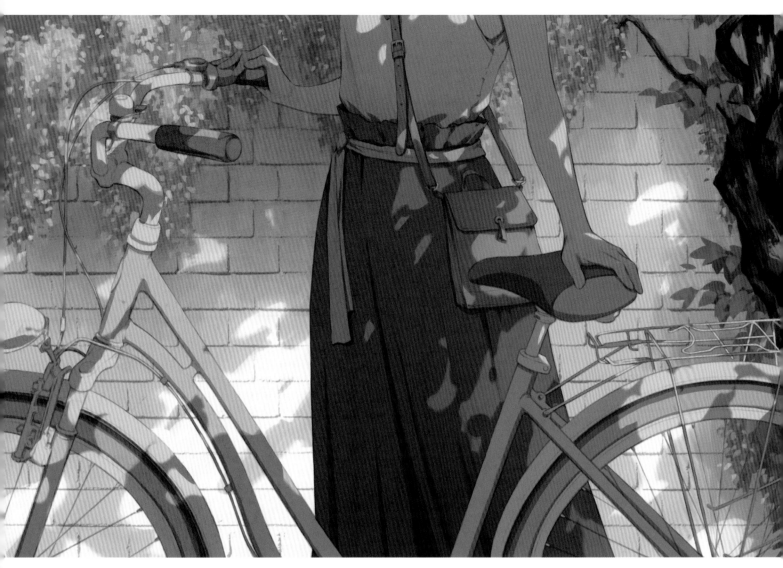

PAINTING THE BIKE

I add Clipping Masks to the bike layers and paint the shiny metal using a hard-edged brush, alternating between light-, mid-, and dark-gray areas. I also bring in a touch of purple to indicate reflections from the purple backdrop. Afterward, I add subtle gradients, just as I did with the girl.

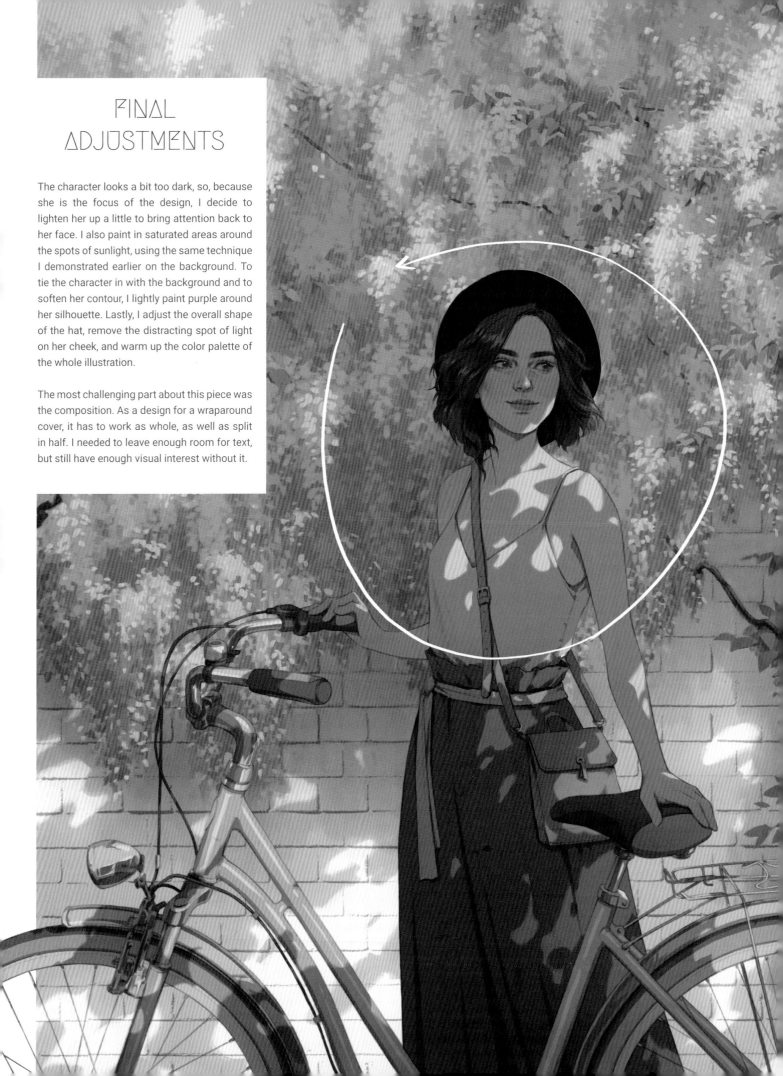

FINAL ADJUSTMENTS

The character looks a bit too dark, so, because she is the focus of the design, I decide to lighten her up a little to bring attention back to her face. I also paint in saturated areas around the spots of sunlight, using the same technique I demonstrated earlier on the background. To tie the character in with the background and to soften her contour, I lightly paint purple around her silhouette. Lastly, I adjust the overall shape of the hat, remove the distracting spot of light on her cheek, and warm up the color palette of the whole illustration.

The most challenging part about this piece was the composition. As a design for a wraparound cover, it has to work as whole, as well as split in half. I needed to leave enough room for text, but still have enough visual interest without it.

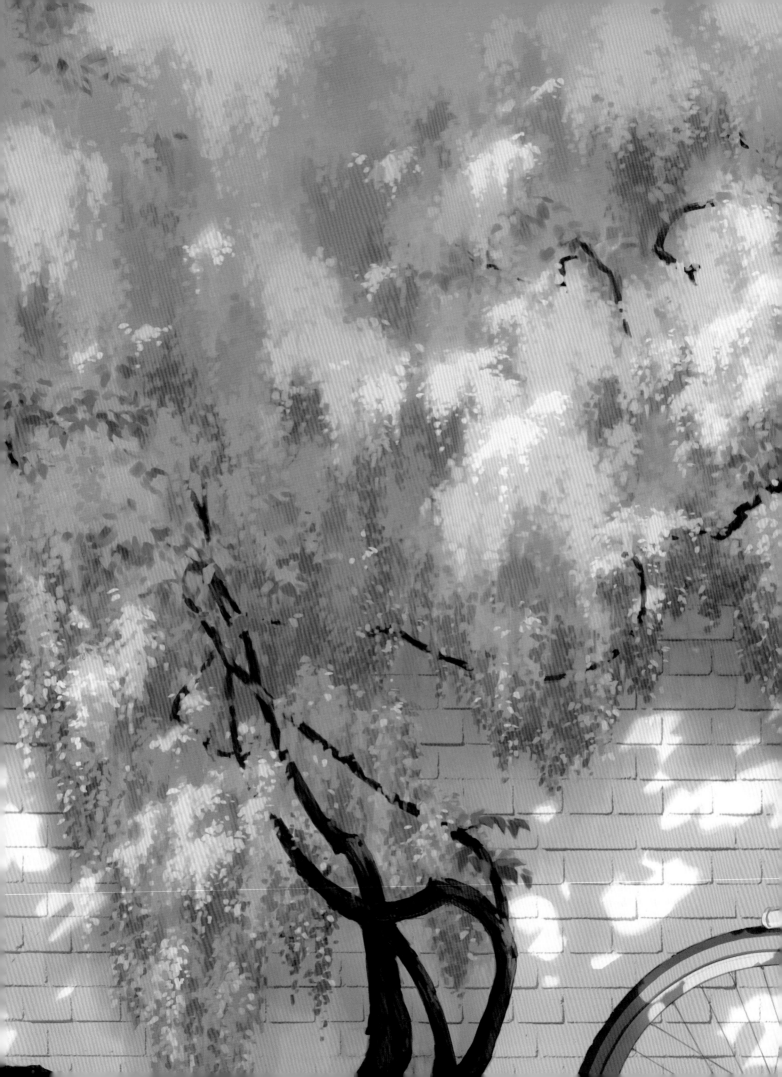

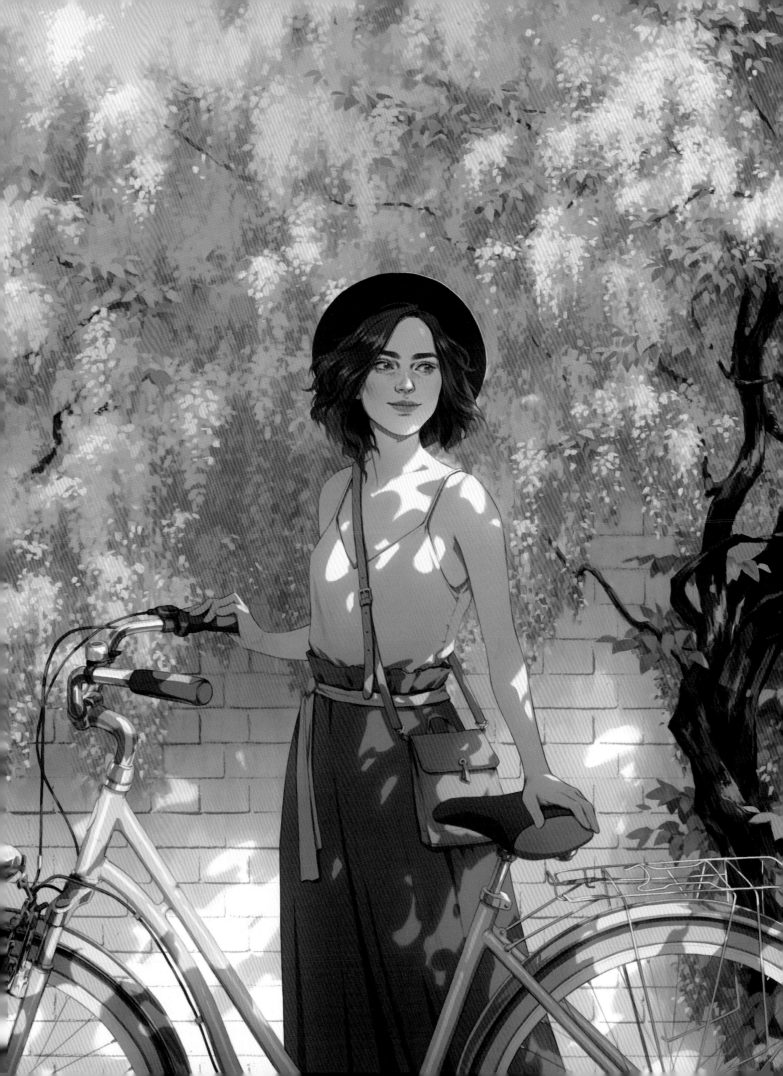

how I paint
foliage

I love nature, so trees and foliage frequently feature in my work. I am often asked about how I paint them, so I will explain my approach in this tutorial. The process shown here is by no means the only way to draw foliage. I arrived at this technique after some trial and error, and I find that the workflow works best for my designs. I will be treating the foliage as if seen from afar, so the end result is a bit looser and less defined, and I do not outline the shape of every leaf.

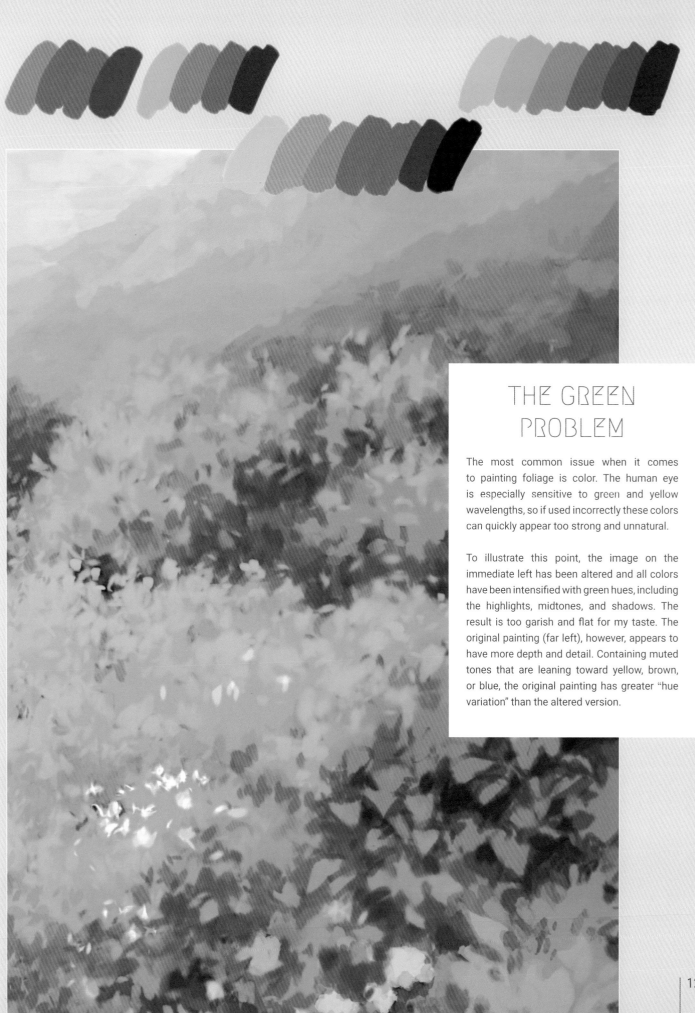

THE GREEN PROBLEM

The most common issue when it comes to painting foliage is color. The human eye is especially sensitive to green and yellow wavelengths, so if used incorrectly these colors can quickly appear too strong and unnatural.

To illustrate this point, the image on the immediate left has been altered and all colors have been intensified with green hues, including the highlights, midtones, and shadows. The result is too garish and flat for my taste. The original painting (far left), however, appears to have more depth and detail. Containing muted tones that are leaning toward yellow, brown, or blue, the original painting has greater "hue variation" than the altered version.

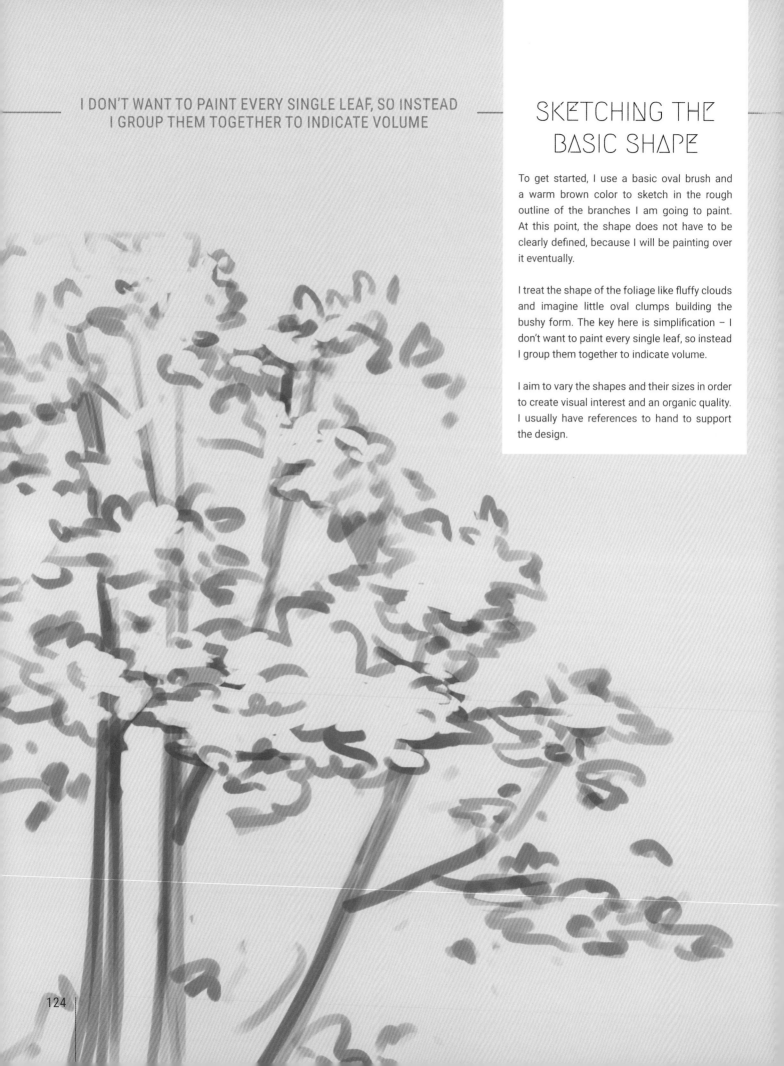

I DON'T WANT TO PAINT EVERY SINGLE LEAF, SO INSTEAD
I GROUP THEM TOGETHER TO INDICATE VOLUME

SKETCHING THE BASIC SHAPE

To get started, I use a basic oval brush and a warm brown color to sketch in the rough outline of the branches I am going to paint. At this point, the shape does not have to be clearly defined, because I will be painting over it eventually.

I treat the shape of the foliage like fluffy clouds and imagine little oval clumps building the bushy form. The key here is simplification – I don't want to paint every single leaf, so instead I group them together to indicate volume.

I aim to vary the shapes and their sizes in order to create visual interest and an organic quality. I usually have references to hand to support the design.

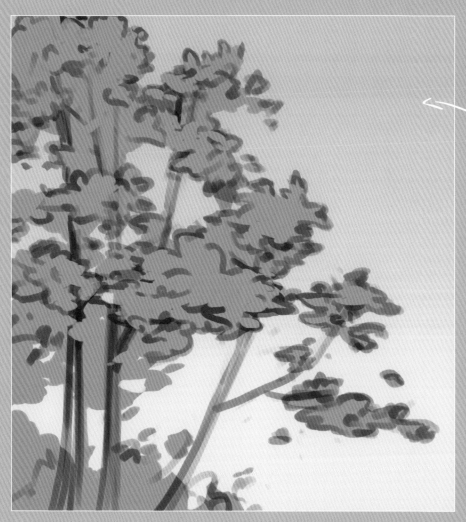

BASE COLOR

Next, I set the line layer to Multiply (see Blending Modes on page 110), fill the entire canvas underneath with a sky blue colour, and create a gradient that fades to a lighter blue toward the bottom.

I work my way from the back to the front of an image (or from the surroundings to the things that are affected by the surroundings), because the lighting situation and ambience have a major impact on the colors in any given scene. In this case, I believe the blue calls for a slightly cooler green, so that is the color I select next.

On a new layer, I paint in the base for the foliage using the green hue and an opaque brush. Instead of trying to achieve perfect outlines, I aim to indicate the distribution of the foliage. I deviate from the initial sketch and improvise to tweak the composition.

ADDING SHADOWS

I choose a slightly darker green with a hint of blue and paint in a few areas of shadow. As this is an outdoor scene and probably midday, I opt for a simple lighting situation depicting the natural sunlight offering an even light from above. I add shadows toward the bottom of the "clouds of foliage." To make it easier to stay within the lines (or shapes), I create a Clipping Mask and attach it to the foliage base layer.

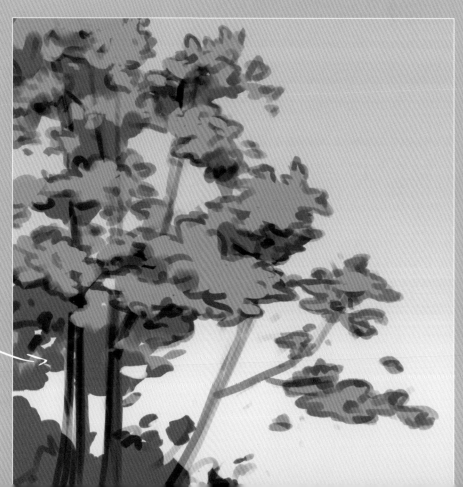

HUE VARIATION

An easy trick to bring more colors into a painting is to use a brush that has a bit of Hue Jitter added to it. That means, when you paint with it, each stroke or dot will take on a slightly different color. The effect is very subtle, but it does add a bit of visual interest and makes it easier to mix new hues.

Once more, I create a Clipping Mask and this time, attach it to my foliage base layer. I select my original green color and paint in some hue variation using random dots.

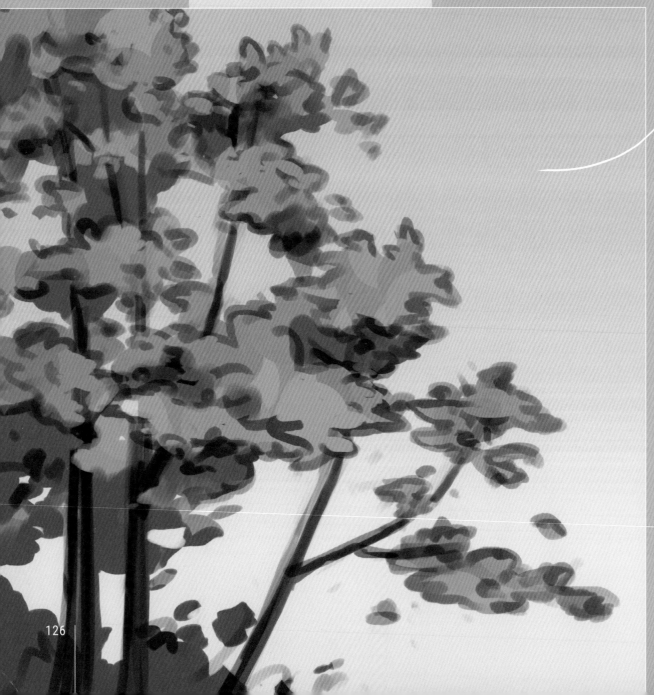

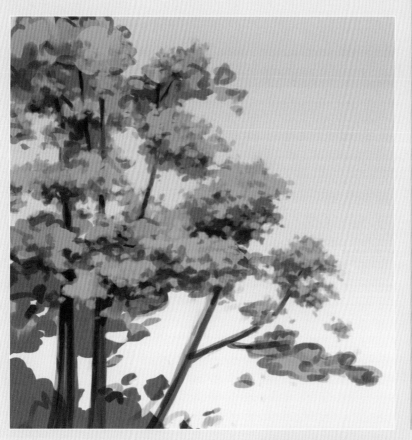

PAINTING OVER THE LINES

Using a soft brush with a lot of size variation, I start to paint in smaller shapes. Utilizing the Eyedropper tool, I select colors from the canvas and paint oval forms to represent leaves.

I go back and forth between light and shadow areas and work my way through the painting. It's an organic and instinctive process as it is a reaction to what I see on the canvas. If I see an area that needs more contrast because it looks too flat, I will add more shadows or light to balance it out. If I see something that looks too sharp, I will soften it, and so on.

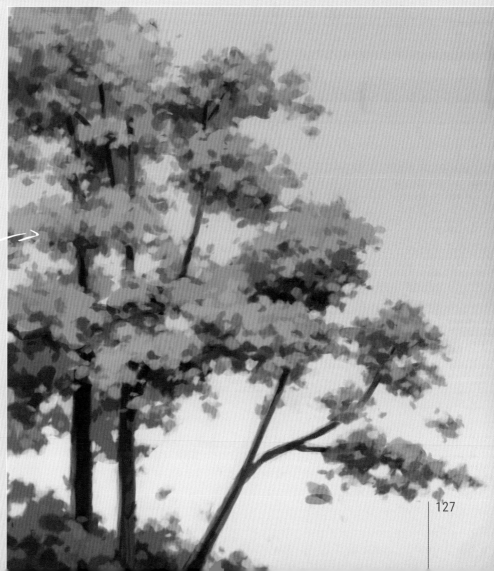

REFINING SHAPES

At the start of the rendering process, I find it easier to add details deep inside the foliage on the branches of the tree. As I progress, I work my way out toward where the leaves meet the sky. Using the same oval brush as before, I work back and forth between selecting greens and sky blues, and I keep mixing and blending the two. My goal is to soften the shapes and to break them up into smaller, more defined parts.

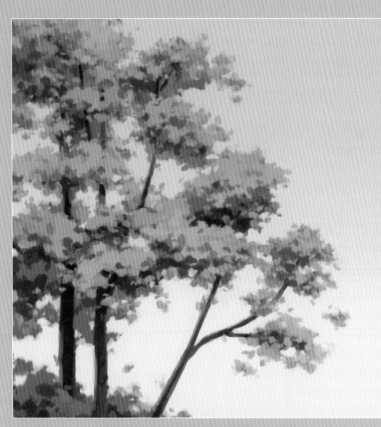

BASIC PRINCIPLES

One signature technique I like to use in my designs is to paint some pieces of foliage so that they appear to be floating in the sky. Even though they're technically not attached to a twig or branch, the eye fills in the necessary detail. Simplifications like these are especially useful when painting trees in the distance.

The key to making them fit into the scene is not to overcomplicate them with detail. The further away they are, the less attention they should be demanding, which means less detail, contrast, sharpness, and saturation of colors. Of course, the opposite applies as well: vegetation that is a foreground element in a scene will need lots of detail, contrast, sharpness, and saturation.

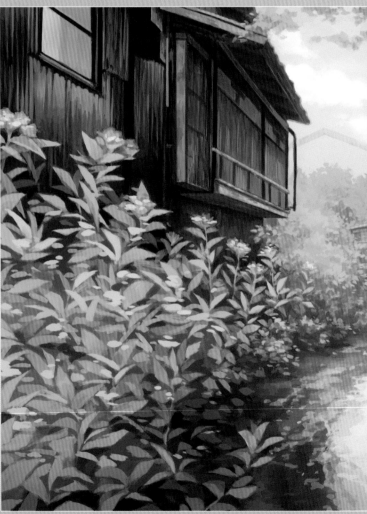

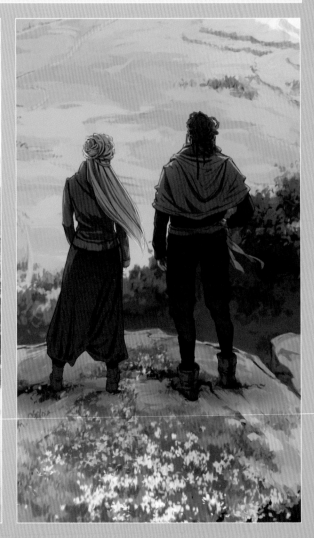

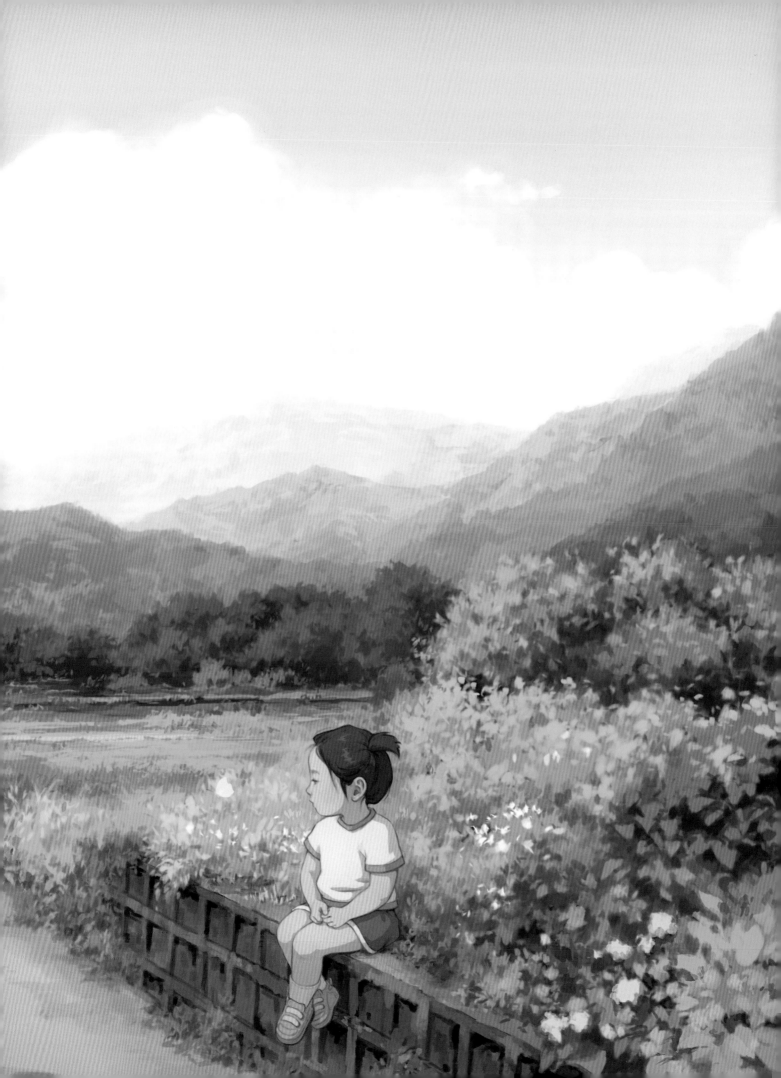

A BORING COMPOSITION

The key word I keep in mind when it comes to composition is "balance" – of shapes and sizes, contrast and details. But that doesn't mean that all elements in the image have to be equal. The opposite is actually true: variation is what creates more interesting, natural, and balanced compositions.

I personally learn by looking at bad examples and identifying what I want to avoid, so to begin, here is an example of a composition that looks lifeless and unbalanced. It is split exactly in the middle by the horizon line, and it lacks any depth and visual interest. Over the course of this tutorial I will gradually improve this composition by introducing new elements and changing the relationship between the existing ones.

improving
composition

Composition can be tricky because it covers many different components – proportion, balance, rhythm, depth, scale, and more. It includes everything to do with how elements are arranged within the frame, and their relationship to each other. More often than not, if an illustration doesn't feel quite right, the problem can be found in the composition. As it is such a complex topic, I will try my best to break it down and keep it simple. Here I will use grayscale images to illustrate my thought processes and main principles.

PROPORTION

Shifting the proportions and varying the shapes and sizes of the elements in a scene makes the composition more interesting.

To achieve this here, I moved the horizon line down so the sky would occupy more space than the sea (see image below.) I also altered and varied the sizes of the clouds and tweaked the shapes of each one, in order to reduce their uniformity. I did the same with the land in the distance, but kept this more subtle.

In my illustrations, I generally aim for a variety of big, medium, and small shapes. For the sake of readability, I group elements together and make use of repeating shapes to create rhythm. I want the viewer's eye to move effortlessly through the composition.

This piece, **Ace of Wands** (right), demonstrates how varied proportions can enhance a composition.

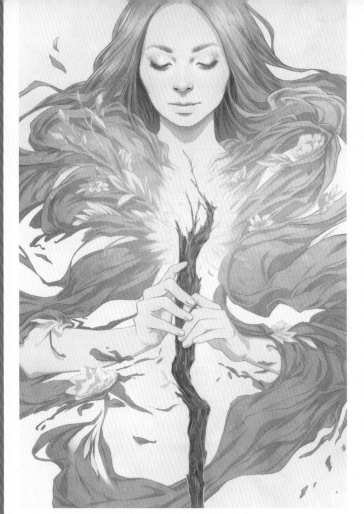

I GROUP ELEMENTS TOGETHER AND MAKE USE OF REPEATING SHAPES TO CREATE RHYTHM. I WANT THE VIEWER'S EYE TO MOVE EFFORTLESSLY THROUGH THE COMPOSITION

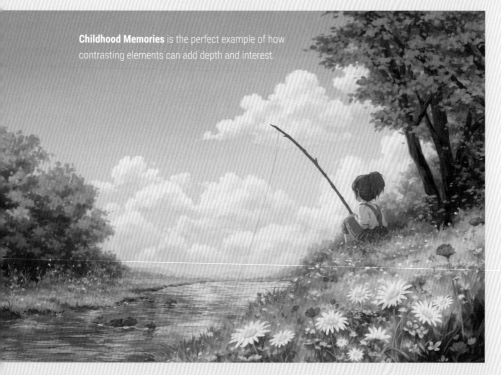

Childhood Memories is the perfect example of how contrasting elements can add depth and interest.

CONTRAST

Contrast can be achieved in many different ways, but to me the most important are "light versus dark" and "detail versus negative space."

I use contrast to lead the eye to my focal point. Areas with a strong juxtaposition of light and dark or a higher density of details naturally draw more attention. That eye-catching level of contrast is definitely what my image is missing – it looks very light and flat, with nothing to pull the viewer into the scene.

To combat that, I add a dark patch of land to the foreground (see above image.) By doing so, I introduce a new dark value. I then add a few smaller shapes along the shoreline to bring in more detail. Now, this dark area is the first thing that demands attention.

DEPTH AND OVERLAP

Although the composition is starting to look better, it still feels flat. The easiest way to introduce depth is to layer elements in front of each other, creating an overlap. This separates the scene into foreground, mid-ground, and background, and gives a sense of depth.

With this in mind, I add another shoreline on the left side, using a slightly lighter gray than in the previous step, to indicate distance. I also layer the clouds to give the impression there are smaller ones receding in the background.

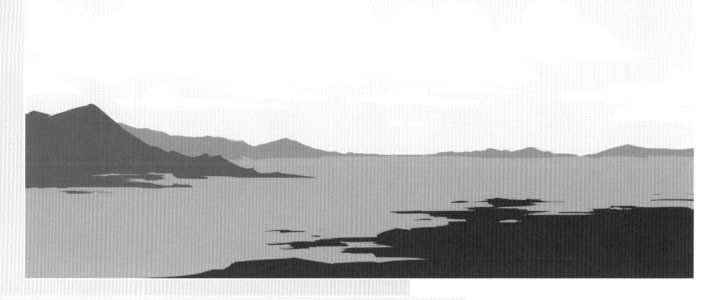

DETAIL

Without detail, an image offers nothing that will hold a viewer's attention for longer than a second. So, here I add a cliff and some vegetation to the foreground to create more visual interest.

The right-hand side of the scene is now the busiest area. Not only does it have the most contrast in terms of detail, it also contains the highest value contrast, as the lightest and darkest elements of the composition are placed against each other (the clouds and branches in the foreground.)

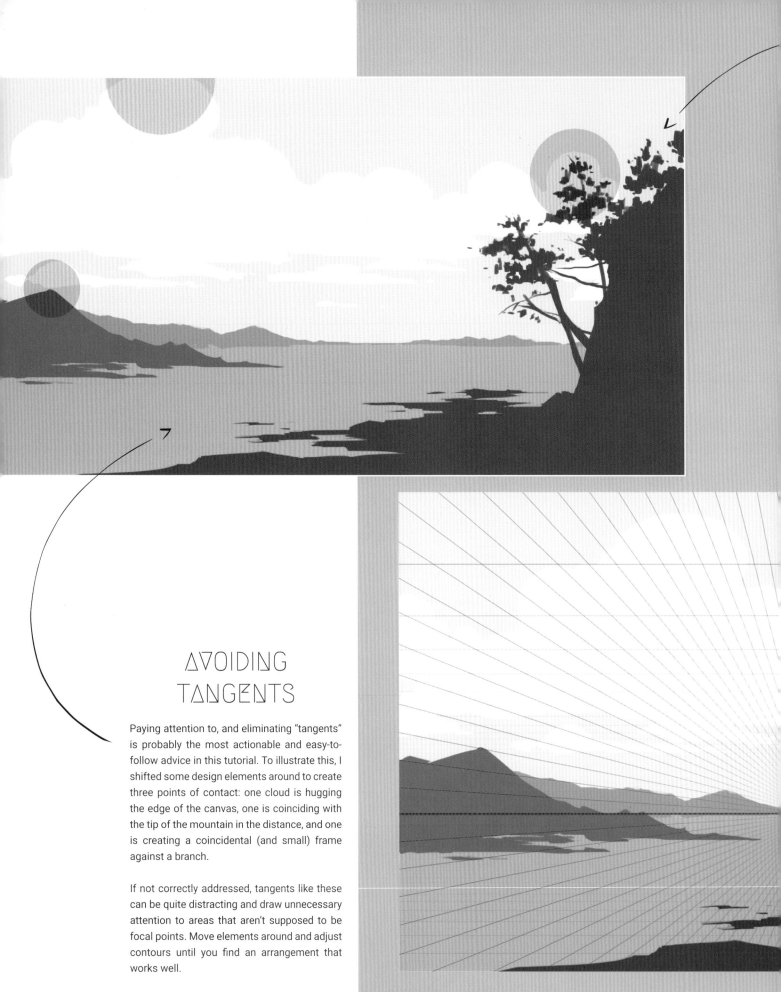

AVOIDING TANGENTS

Paying attention to, and eliminating "tangents" is probably the most actionable and easy-to-follow advice in this tutorial. To illustrate this, I shifted some design elements around to create three points of contact: one cloud is hugging the edge of the canvas, one is coinciding with the tip of the mountain in the distance, and one is creating a coincidental (and small) frame against a branch.

If not correctly addressed, tangents like these can be quite distracting and draw unnecessary attention to areas that aren't supposed to be focal points. Move elements around and adjust contours until you find an arrangement that works well.

TANGENTS

When you're creating an image, elements sometimes touch in awkward ways, hug the edge of the canvas, or end in the exact same point. These areas are called tangents, and they can be easily identified and avoided, once you know what to look for.

PRACTICAL APPLICATION

When planning the composition for an illustration, the first thing I do is take stock of all the elements I want to include. What shape does each element have? Is it fixed or can it be changed? Natural elements such as clouds, vegetation, and so on are more "malleable," whereas structural elements like architecture come with more constrictions.

I also decide on the viewpoint for my scene early on, because it will play a huge role in terms of depth and scale. Then it's all about implementing the principles I've talked about. If I ever need a more abstract view of the shapes I'm using, I flip the image on its head. If perspective is involved, I don't start by drawing a grid – instead, I sketch the scene first, even if it's not accurate. Only after I have completed a rough sketch do I introduce a grid that allows me to be more accurate, add structure, and clean up my image.

In reality, creating an effective composition is also about trial and error, and going with your gut. It is about moving elements around and resizing them until the result is visually engaging and feels comfortable to view.

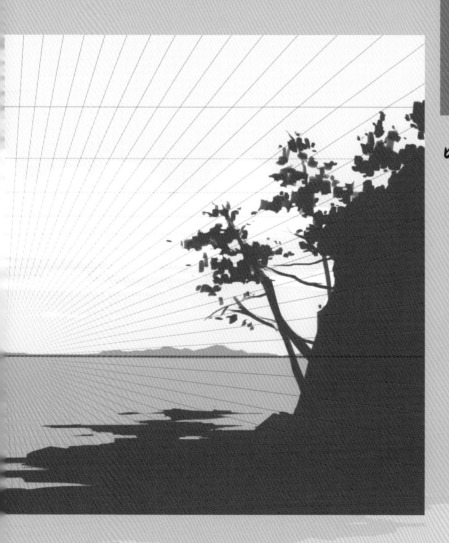

developing color palettes

Color has a strong impact on our emotions, so of course it also plays an important role in how we perceive art.

For me, the story I'm trying to tell in a painting usually determines my palette. I like to play around with a couple of options until I feel I have captured the mood I had in my mind.

Color and light are very much intertwined and build upon each other, but I still like to approach them one after the other because it's easier to manage. Overall, my approach is pretty intuitive and I generally aim for appeal, rather than realism. In this tutorial, I'll take you through my thought processes in selecting, manipulating, and combining colors to create palettes that I find visually pleasing.

HOW I THINK ABOUT COLOR

Before we jump in, I want to explain three terms I use to describe the quality of a color: hue, value, and saturation. "Hue" tells you what color you're looking at: blue, purple, pink, and so on. "Value" refers to how light or dark the color is. And "saturation" describes how vibrant or dull the color is. Saturated colors are richer, while less saturated colors lean more toward gray.

I won't go into detail about color theory specifics – the only thing I pay close attention to is "harmony and contrast." In creating my palettes, my main goal is to maintain a balance between them by controlling the hue, value, and saturation of the colors I use.

LIMITED PALETTES

I love limited palettes, so to begin I select three colors that I like in combination – in this case, lavender, blue, and teal. The blue is rich, whereas the teal is quite desaturated. On the color wheel, these two would be friendly neighbors, living in harmony. The odd one out is lavender. It sits a bit further away on the color wheel, but still works with the other two because it is quite light and pastel-like. It also introduces a comfortable contrast in hue and value. A darker purple, on the other hand, would have been too similar in value.

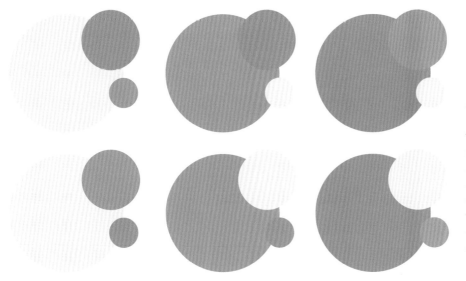

I have chosen my three colors, but there is still a lot of room for experimentation. For example, I can achieve different effects by varying their relationship to each other in terms of proportion. If the lavender takes up the largest space on the canvas, that creates a light and airy effect. If the teal is the dominant color, the overall look is denser and duller. Even though the palette is the same, unexpected differences can be achieved by balancing one dominant color against smaller accents.

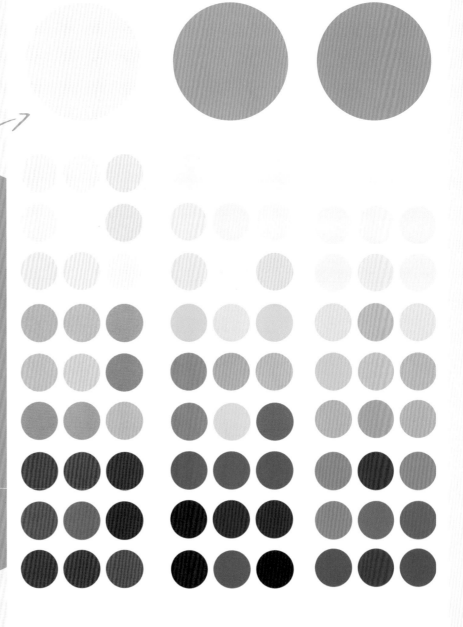

BRANCHING OUT

While these three colors are a good starting point, they're not versatile enough for my taste. This is where hue variation plays an important role. By shifting the slider on the color wheel in Photoshop away from the original color, and manipulating the value and saturation, a multitude of new colors can be generated. Things are starting to look a lot more colorful and interesting!

Note: In reality, I don't create a big palette like this. I just wanted to show you the variety of colors you can achieve, even if you don't branch out very far.

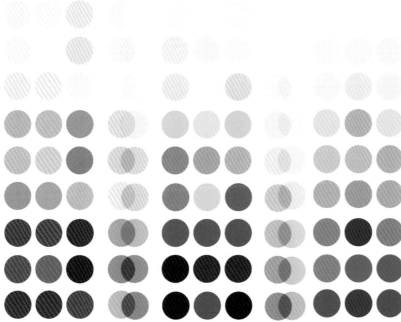

MIXING COLORS

My favorite way to create new colors is to mix them on the canvas. I use low-opacity brushes to subtly paint one color over the other, to create a third. It is a very organic process that leaves me with even more options to play with. Now I can create even more palettes and experiment with dominant colors and accents – all while maintaining that balance between hue, value, and saturation. My main goal is to create visual interest, even though I'm only working with circles.

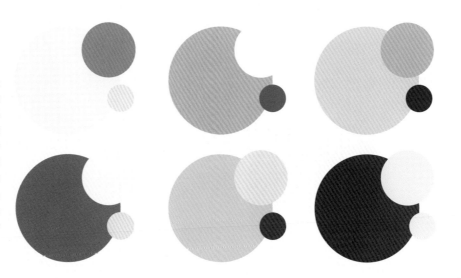

COLOR COMBINATIONS

There are no hard-and-fast rules when it comes to combining colors. It is very much personal preference — while one person might enjoy a bold palette, the next person may think it's too garish. Generally, I find light pastel tones go well together, even if you include a lot of different hues.

Adding contrast by introducing a complementary color as an accent can also be a way to liven up a palette. My go-to are color schemes that are almost entirely harmonious — meaning I will almost exclusively use cool tones and just introduce a few warm accents here and there, or vice versa. I prefer to introduce contrast through value, rather than with lots of different colors. I paint a lot of landscapes, so naturally you'll find quite a bit of green and blue in my work.

PRACTICAL APPLICATION

I can talk about theory all day, but I think it's better to actually show you how I build a palette right on the canvas. As an example, here is a rough sketch I created a while ago. It offers a good starting point for this demonstration because there are no plants or sky, or any other elements that have a certain local color that I need to maintain — apart from needing the girl's skin to look somewhat human.

To begin, I fill the background with a purple tone, and set the sketch layer to Multiply, so the red hue can blend with the background.

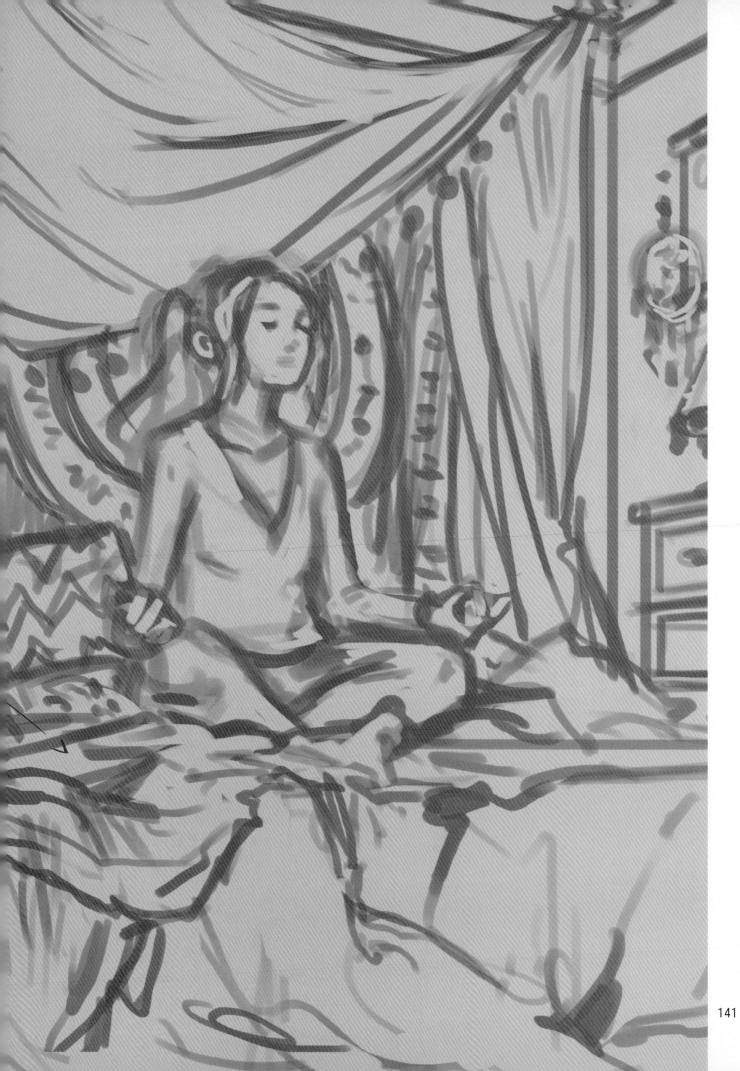

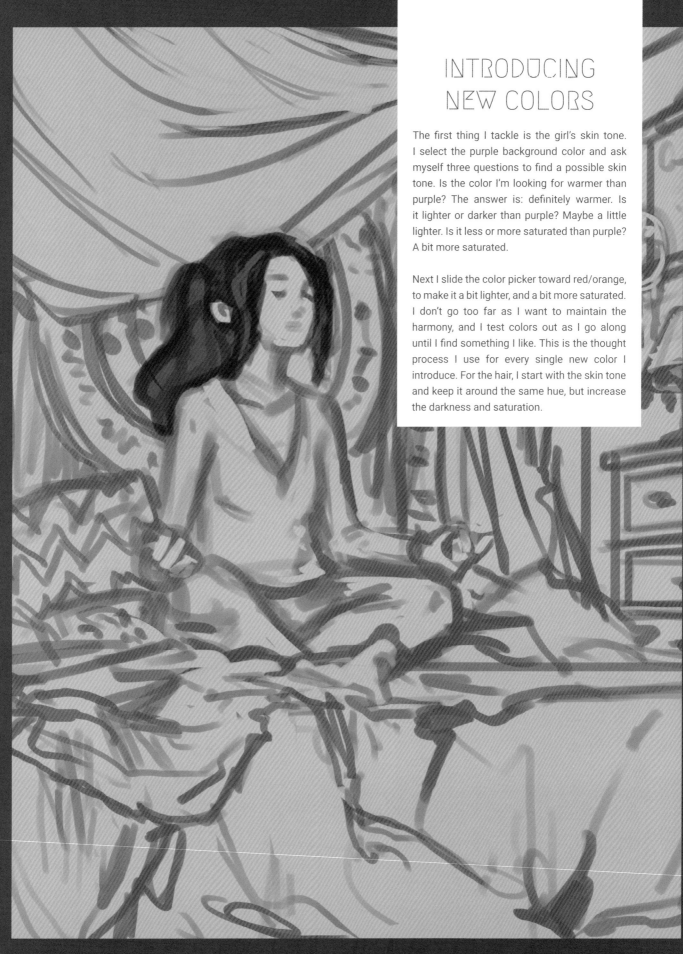

INTRODUCING NEW COLORS

The first thing I tackle is the girl's skin tone. I select the purple background color and ask myself three questions to find a possible skin tone. Is the color I'm looking for warmer than purple? The answer is: definitely warmer. Is it lighter or darker than purple? Maybe a little lighter. Is it less or more saturated than purple? A bit more saturated.

Next I slide the color picker toward red/orange, to make it a bit lighter, and a bit more saturated. I don't go too far as I want to maintain the harmony, and I test colors out as I go along until I find something I like. This is the thought process I use for every single new color I introduce. For the hair, I start with the skin tone and keep it around the same hue, but increase the darkness and saturation.

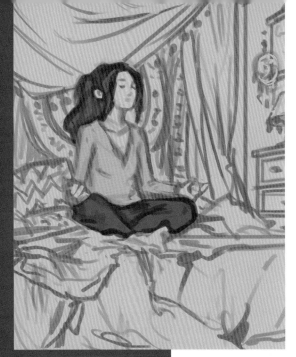

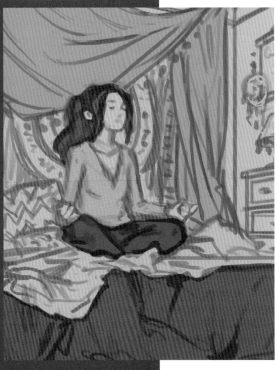

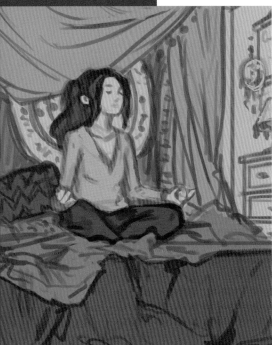

LOCAL COLORS

Now I can start adding even more colors into the scene. I decide to use a spectrum from purple to green, with a bit of blue in between. One by one, I assign local colors to the different elements: a purple sweater, green pants, a blue pillow, and so on.

Every time I introduce a new color, I base it on another that is already on the canvas. If something stands out too much, or not enough, I use the Hue and Saturation sliders to adjust it until it fits. This part is very intuitive and I settle on colors that feel right to me. I continue until I have filled the entire canvas.

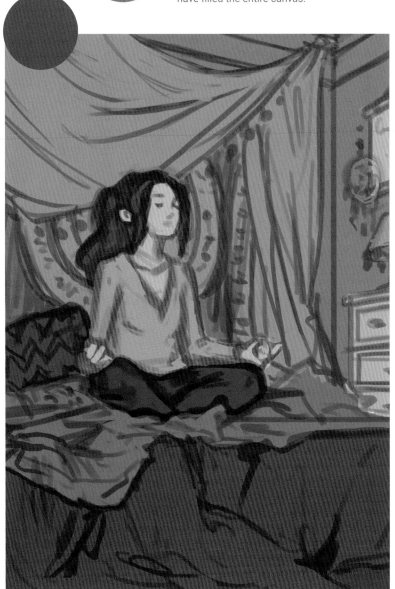

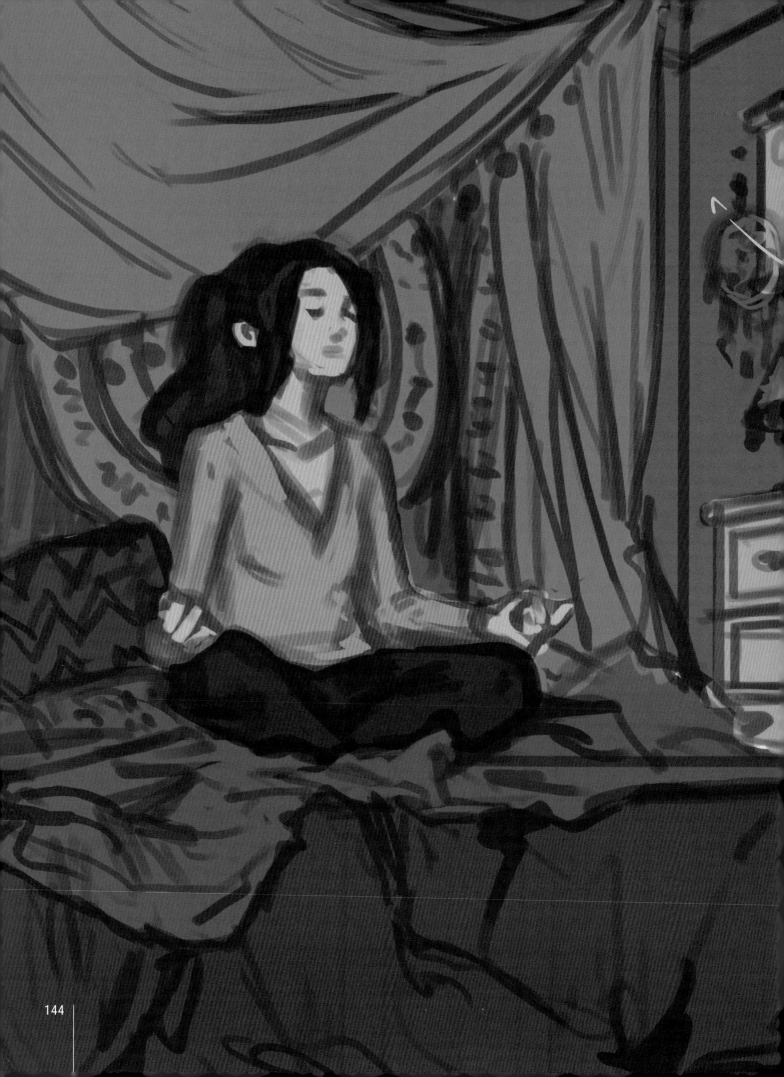

TYING IT TOGETHER

The color scheme is looking fine, but it is not quite harmonious enough. Also, there is no indication of lighting yet, so it's time to change that.

One of my favorite adjustments in Photoshop is the Gradient Map. It creates a pleasing, often unexpected, color gradation across an image. I have a lot of fun combinations in my library and I love playing around with different colors, layer modes, and opacities to achieve certain effects.

For this sketch, I apply a purple gradient to tie the colors together, and because I set the mode to Multiply, it darkens the whole image.

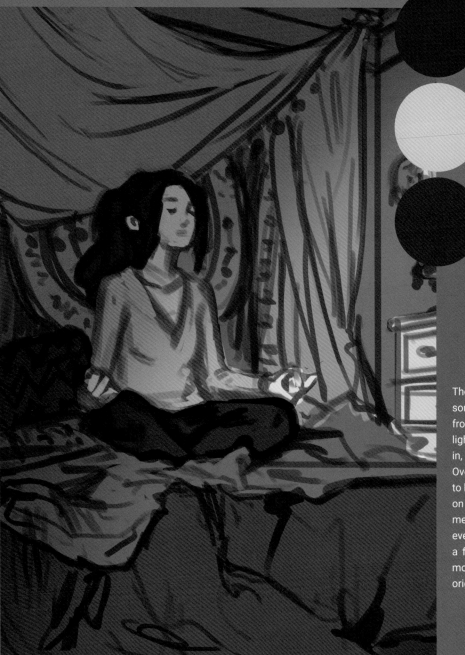

INTRODUCING LIGHTING

The scene is still looking a bit flat, so I add some blue lighting from the right – perhaps it's from a computer screen or television. I use a light blue color and a big soft brush to paint it in, and set the layer mode to blending mode, Overlay. Then I add another layer on top, set it to blending mode Screen (see Blending Modes on page 110), and repeat the process. This method is a quick and easy way to introduce even more color variation to the piece. In just a few steps, the piece now has more depth, mood, and atmosphere, compared to the original palette.

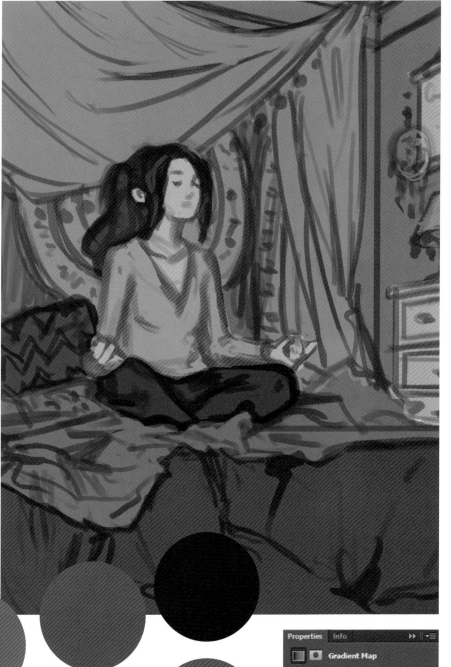

ΛLTERNΛTIVE PΛLETTE

My favorite thing about this process is its versatility. Once everything is painted in, it is extremely easy to make changes and experiment. In order to try out a different palette, I go back to the local colors I painted before I added the Gradient Map and lighting.

This time, I opt for a warmer color scheme, and fill a whole layer with desaturated magenta set to blending mode Multiply. Next, I pick a light peach color and paint in some light on a layer set to blending modes Overlay and Screen. Lastly, I apply another Gradient Map and set it to blending mode Soft Light, at 33% opacity. The overall result is a design with a glowing warmth and cozy atmosphere.

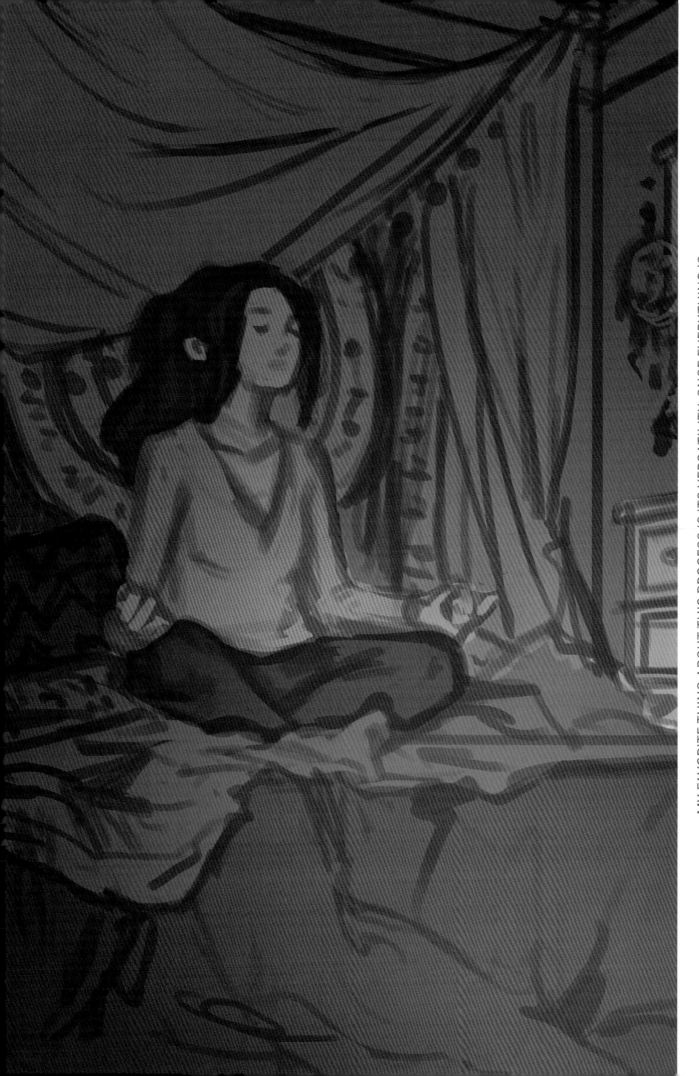

MY FAVORITE THING ABOUT THIS PROCESS IS ITS VERSATILITY. ONCE EVERYTHING IS PAINTED IN, IT IS EXTREMELY EASY TO MAKE CHANGES AND EXPERIMENT

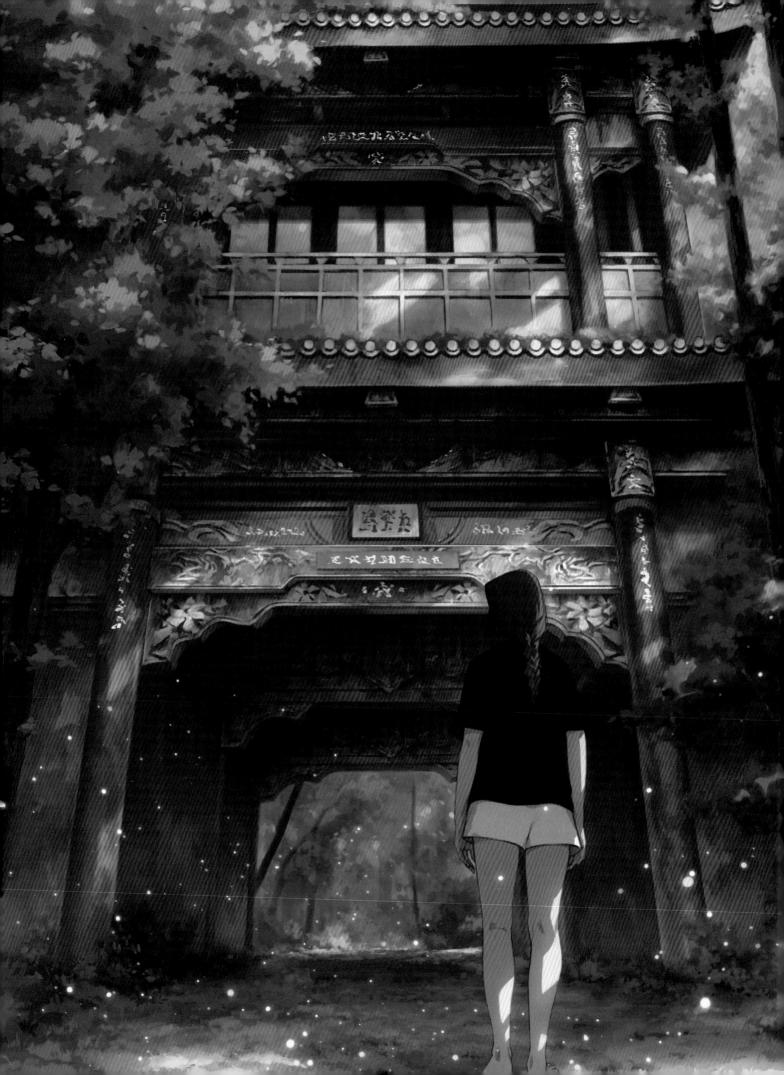

thank you

If someone had told me five years ago that I could make a living doing what I do now, I wouldn't have believed them. I spend my days making art and products, and sharing them with people.

The most amazing part for me is that I can paint whatever I want, with no compromises. No one can tell me to make changes or steer me into a direction that I'm not comfortable with. It has been a bumpy road for sure, but through everything, the people who I could always rely on were my fans and followers. They have believed in me and continuously supported me through Patreon, conventions, and my online store, and by taking my classes, and by sharing my work on social media.

The fact that you are holding this book in your hands right now means that you are one of those very supportive people too. Thank you. I don't know where my creative journey will lead me, but I know now that it is not finished and that I am not alone!

DJAMILA

ABOUT
3DTOTAL

3dtotal Publishing is a trailblazing, creative publisher
specializing in inspirational and educational resources for
artists. Our titles feature top industry professionals from
around the globe who share their experience in skillfully
written step-by-step tutorials and fascinating, detailed
guides. Illustrated throughout with stunning artwork, these
best-selling publications offer creative insight, expert
advice, and essential motivation. Fans of digital art will find
our comprehensive volumes covering software including
Procreate, Adobe Photoshop, and Pixologic's ZBrush.
The dedicated, high-quality blend of instruction and
inspiration also extends to traditional art. Titles covering
a range of techniques, genres, and abilities allow your
creativity to flourish while building essential skills.

Well-established within the industry, we now offer
over 60 titles and counting, many of which have been
translated into multiple languages around the world. With
something for every artist, we are proud to say that our books
offer the 3dtotal package:

LEARN | CREATE | SHARE

Visit us at 3dtotalpublishing.com

3dtotal Publishing is part of 3dtotal.com, a leading website for
CG artists founded by Tom Greenway in 1999.

WONDER · BEATRICE BL...

SKETCH EVERY DAY · WITH SIMONE GRÜNEWAL...

COZY DAYS The Art of Iraville

the art of heikala · works and thoughts

Sketch with Asia · MANGA-INSPIRED ART AND TUTORIALS BY ASIA LADOWSKA

STILL JUST KIDDING · BY CASSANDRA CALIN...

the sketchbook of loish

the art of loish

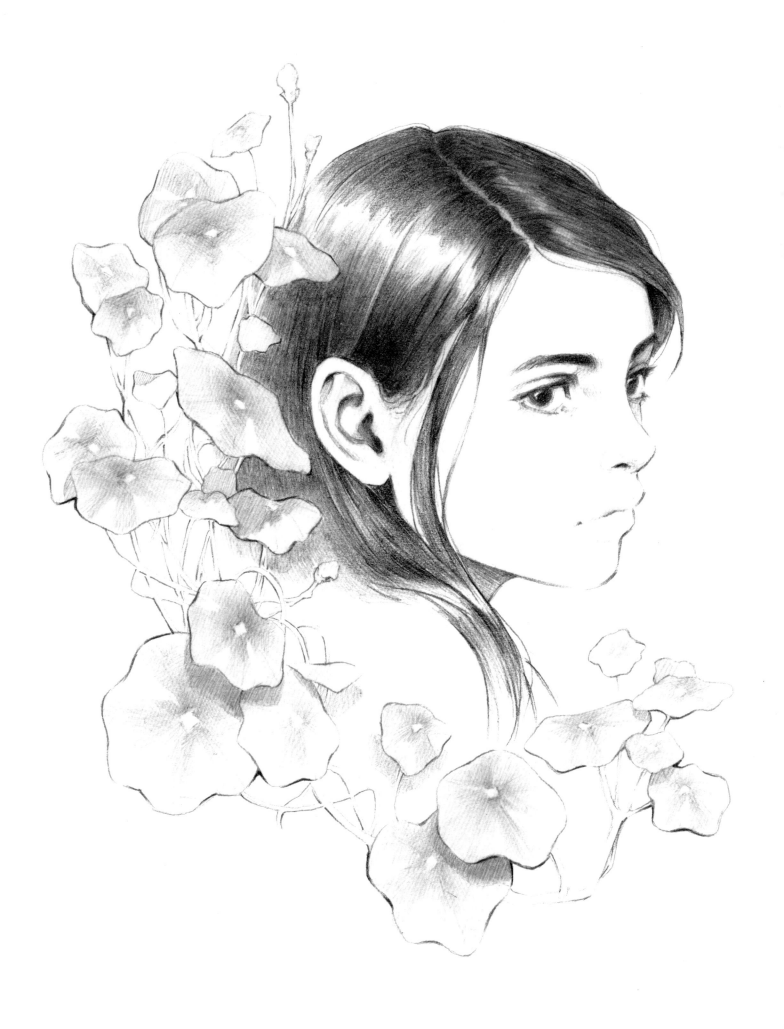